FRAGILE PLANET

Published by **Collins**
An imprint of HarperCollins Publishers
Westerhill Road
Bishopbriggs
Glasgow G64 2QT
collins.reference@harpercollins.co.uk
collins.co.uk

Originally published as Fragile Earth 2006
Second edition 2020

© HarperCollins Publishers 2020
Photographs © see acknowledgements page 256

Collins® is a registered trademark of HarperCollins Publishers Ltd

A catalogue record for this book is available from the British Library.

ISBN 9780008409319

10 9 8 7 6 5 4 3 2 1

Printed in China

Carefully made with responsibly
sourced paper and soy ink.

Cover image:
Rick Rycroft / AP / Shutterstock

Inside flaps:
vladsilver / Shutterstock

MIX
Paper from
responsible sources
FSC™ C007454

FSC
www.fsc.org

This book is produced from independently certified FSC™ paper
to ensure responsible forest management.

For more information visit: www.harpercollins.co.uk/green

FRAGILE PLANET

THE IMPACT OF CLIMATE CHANGE

CONTENTS

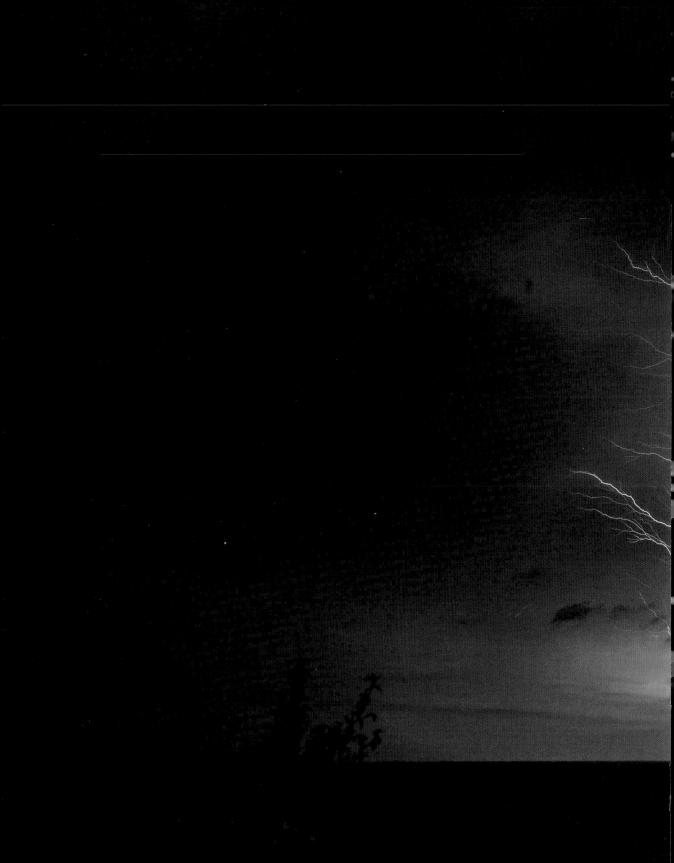

TROPICAL STORMS

severe and highly destructive storms created by intense low pressure weather
systems in tropical oceans, also known as cyclones, hurricanes or typhoons

Caribbean storm

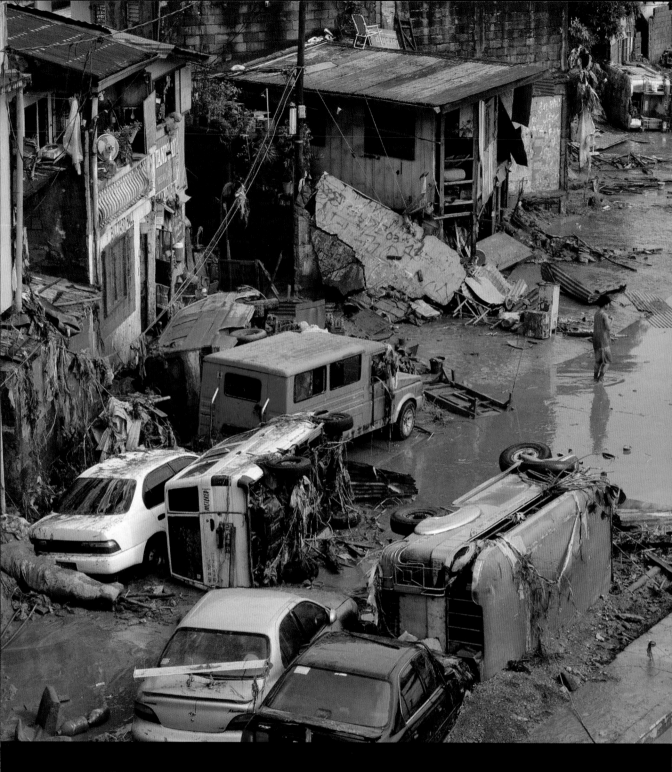

PHILIPPINES 2009

On average, the Philippines are hit by 20 typhoons each year. In September 2009, Typhoon Ketsana brought 144 km/h (90 mph) winds and more than a month's rainfall to Manila in a six-hour period. Floodwaters in some areas of Manila and Marikina City reached the second floor of homes, forcing people to clamber onto roofs. Millions of people were affected by the storm and hundreds of people lost their lives.

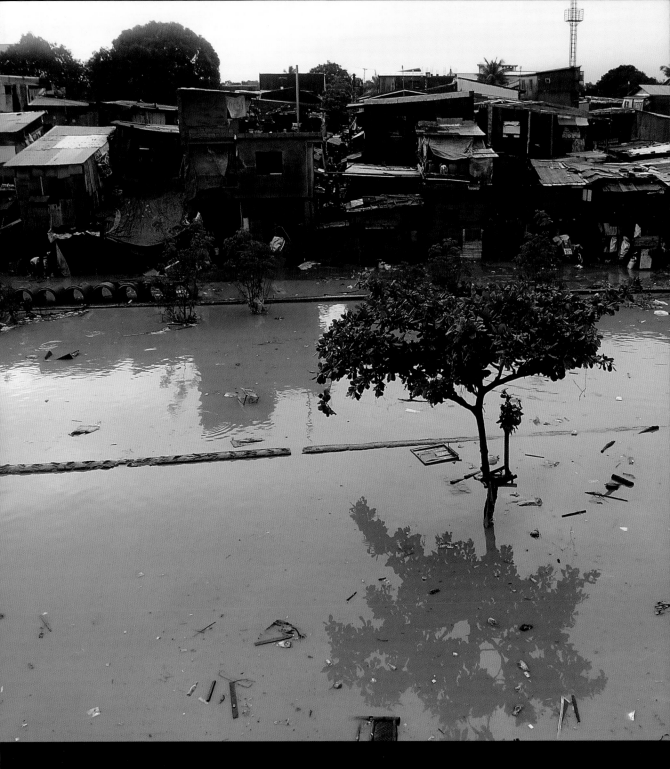

2018

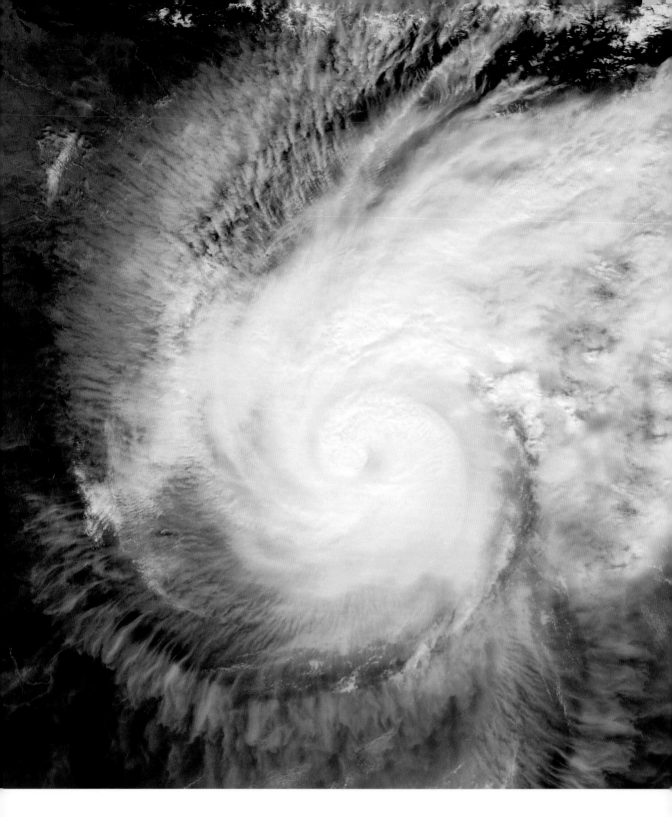

BANGLADESH 2019

With its 120 km/h (75 mph) winds and torrential rain, Cyclone Bulbul caused mass disruption and damage, forcing airports and ports in Bangladesh and India to close.

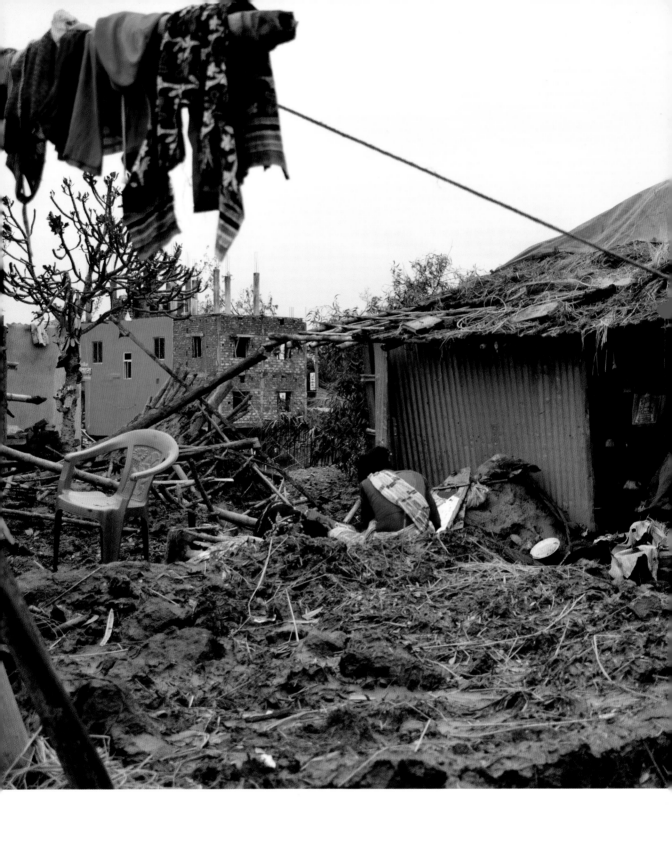

41 people died and over two million people were forced to evacuate and shield themselves from Cyclone Bulbul's danger in storm shelters overnight.

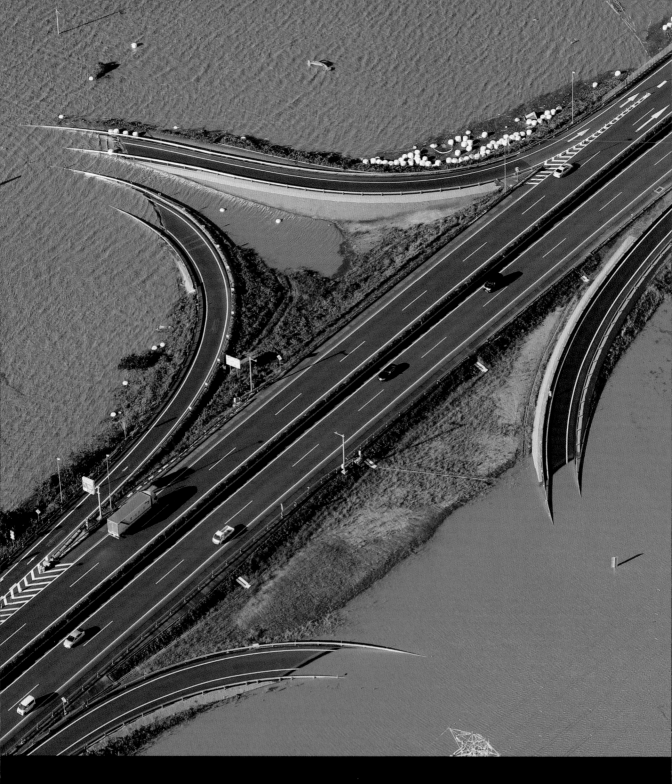

JAPAN 2019

In October 2019, Japan witnessed one of its most powerful storms in decades – Typhoon Hagibis. Winds reached 225 km/h (140 mph) and multiple rivers across the country burst their banks, flooding many communities. When the typhoon made landfall on 12 October in the Izu Peninsula, around half a million homes experienced power cuts.

Hakone, a town near Mount Fuji, saw more than a metre of rain fall on 11 and 12 October – the highest total rainfall to have ever been recorded in Japan over a 48-hour period. Around 70 people were killed by Typhoon Hagibis, mostly as a result of the landslides created by the storm. Others were trapped in cars as the floodwaters surged

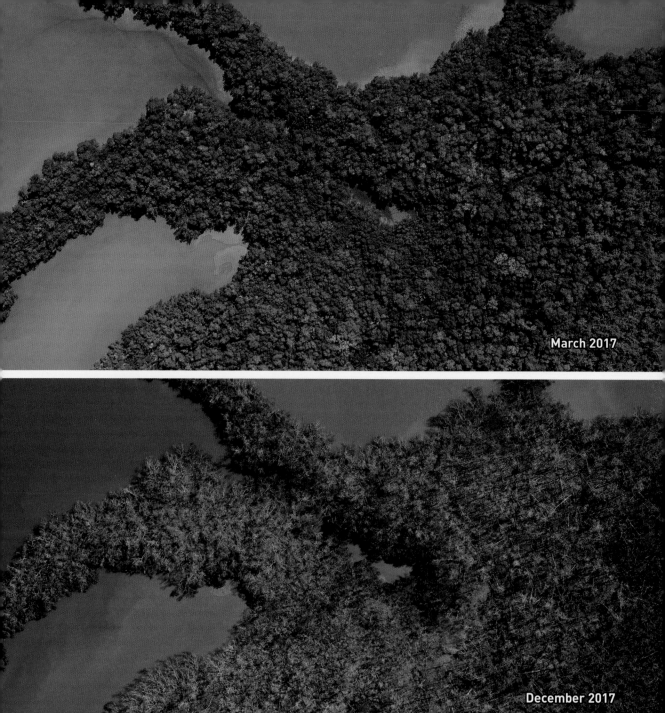

March 2017

December 2017

THE EVERGLADES, FLORIDA, US 2017

Hurricane Irma was a category 5 hurricane in the year 2017, created by a tropical depression in the Cape Verde Islands. The first image shows the Ten Thousand Islands mangrove ecosystem in the Everglades, before Irma (and later Hurricane Maria) destroyed the area in September that year. The second image shows the aftermath of the hurricanes. If mangrove habitat does not recover after being damaged, ecosystems nearby are threatened by a higher risk of storm surges and saltwater intrusion.

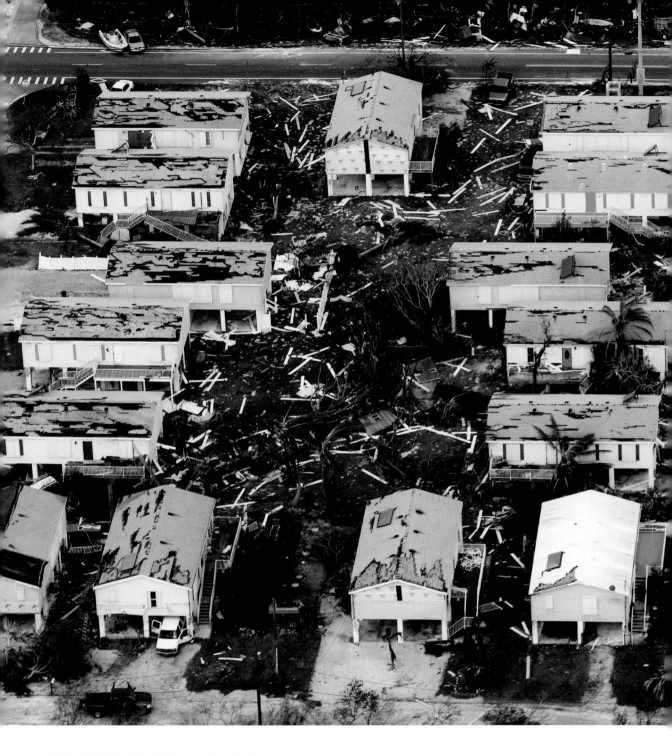

KEY WEST, FLORIDA, US 2017

Around 160 km (100 mi) south of the Everglades, Key West also experienced huge destruction from Hurricane Irma, as the storm ripped roofs off buildings and flattened homes. The damage caused by the tropical storm is reported to have cost the US and affected Caribbean Islands over $75 billion, and Hurricane Irma caused over 130 deaths.

ARECIBO, PUERTO RICO 2017

Hurricane Maria – a category 5 major hurricane – passed through Puerto Rico, Dominica and St Croix in September 2017, devastating many Caribbean communities.

This photo was taken prior to the hurricane as part of a study into the regrowth of tropical forests on abandoned agricultural land.

2018

This image was taken after the hurricane had passed Puerto Rico. Scientists looking into the damage caused to the island's forests said that 'the dense, interlocking canopies that blanketed the island before the storm were reduced to a tangle of downed trees and isolated survivors, stripped of their branches'.

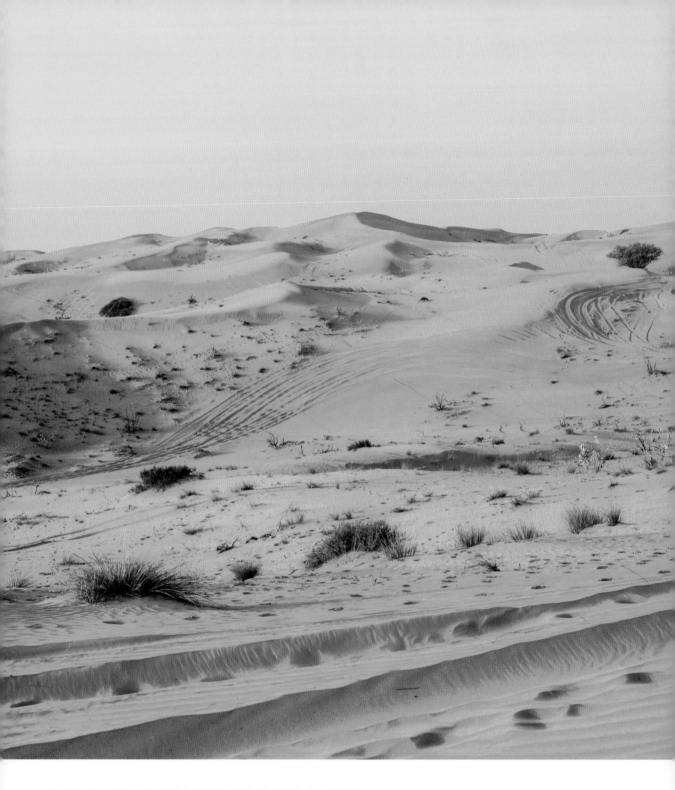

RUB' AL-KHALI, ARABIAN PENINSULA 2017

The Rub' Al-Khali covers the majority of the southern third of the Arabian Peninsula. It is the world's largest continuous sand desert and forms part of the Arabian Desert.

It covers around 650 000 km^2 (250 000 mi^2) and is one of the driest places on the planet. The desert very rarely sees rain.

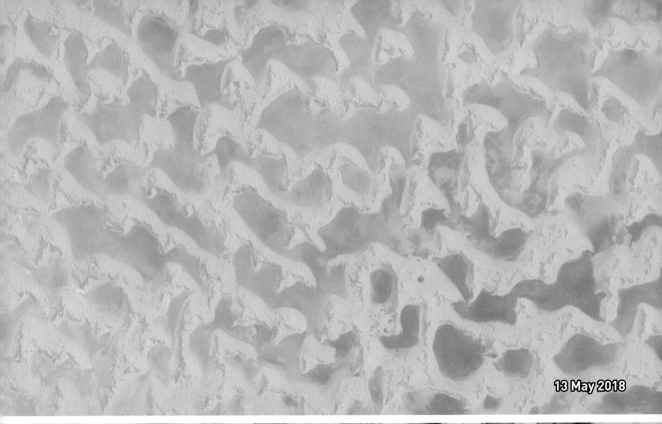

13 May 2018

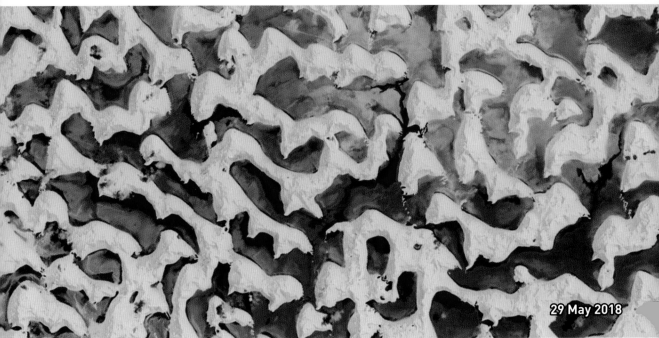

29 May 2018

2018

In 2018, however, Tropical Cyclone Mekunu passed over the region. As a result, rainwater collected between the sand dunes – the first time this had happened in 20 years. The first image, from 13 May 2018, shows the desert in its usual state. The second image taken two weeks later shows the pools of rainwater after the storm.

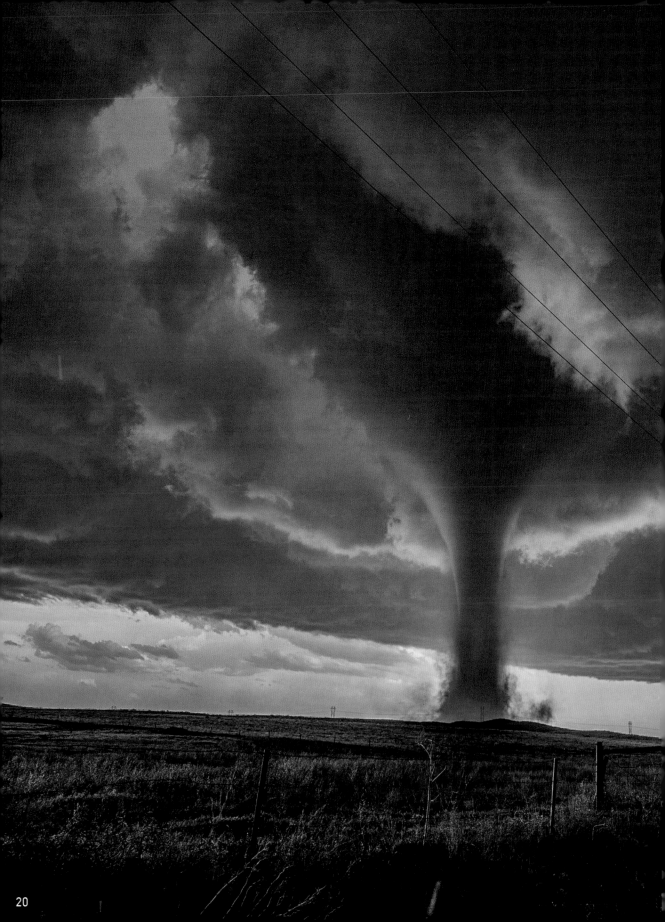

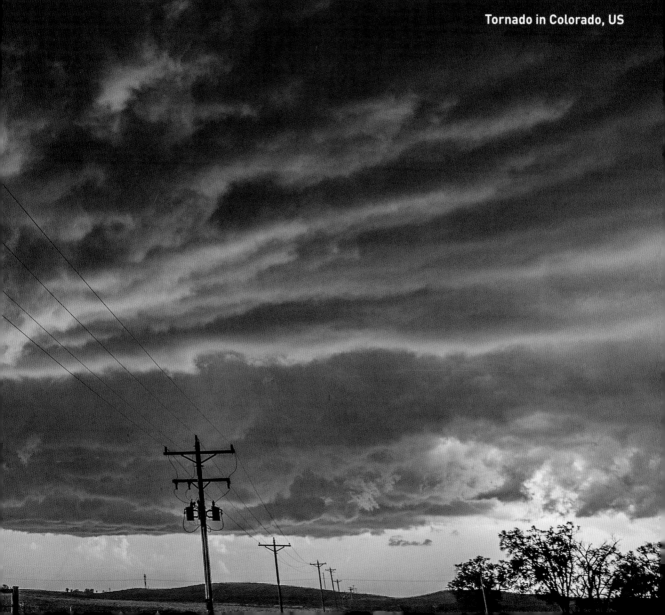

TORNADOES

violent storms with very strong winds circling around small areas of extremely low pressure, characterised by tall, funnel-shaped clouds

Tornado in Colorado, US

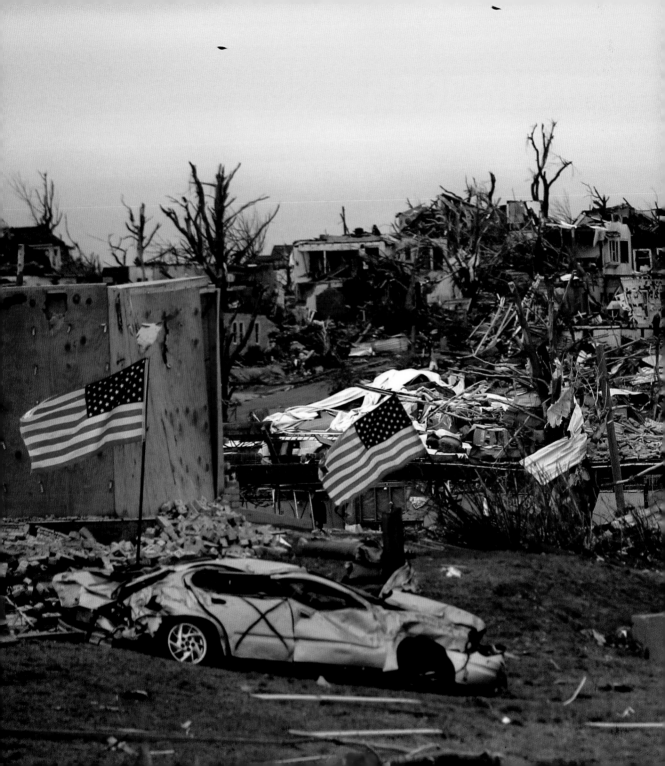

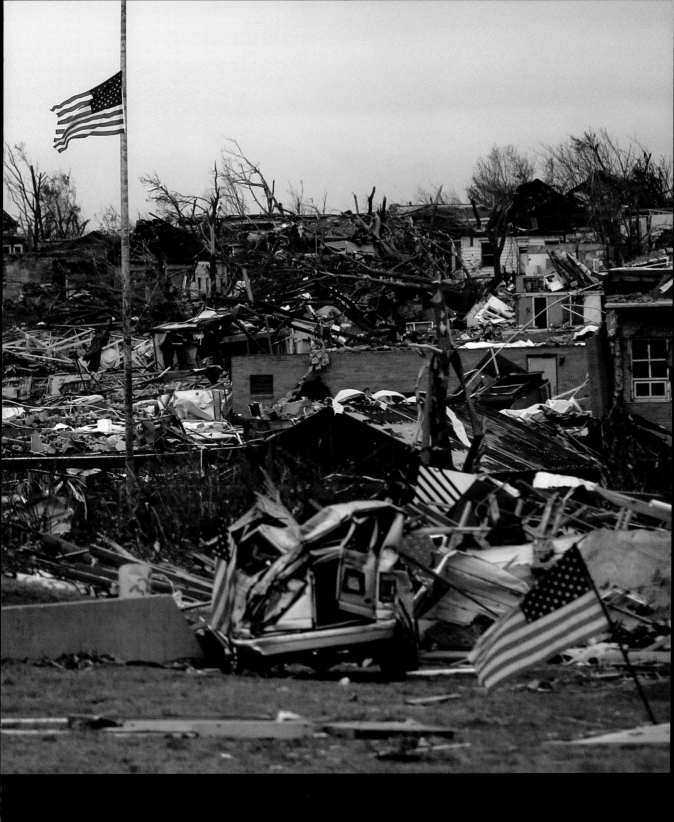

This tornado is thought to be the most deadly since records began in the US in 1950, and has been classified as one of the most deadly US tornadoes ever. Over 1000 people were injured, and 158 killed.

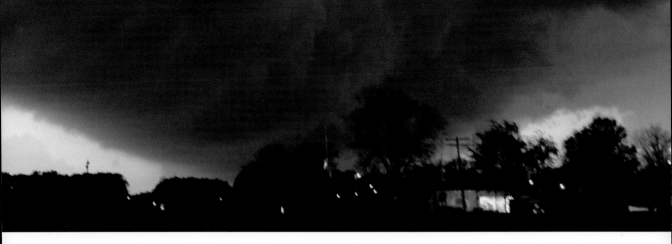

BEARDEN, ARKANSAS, US 2014

In late April 2014, parts of Arkansas were flattened by a huge tornado. Thunderstorm supercells like the one shown above usually precede a tornado. This one on 24 April 2014 warned of the tornadoes to come – over 80 tornadoes across ten states were witnessed in the window between 27 and 30 April 2014.

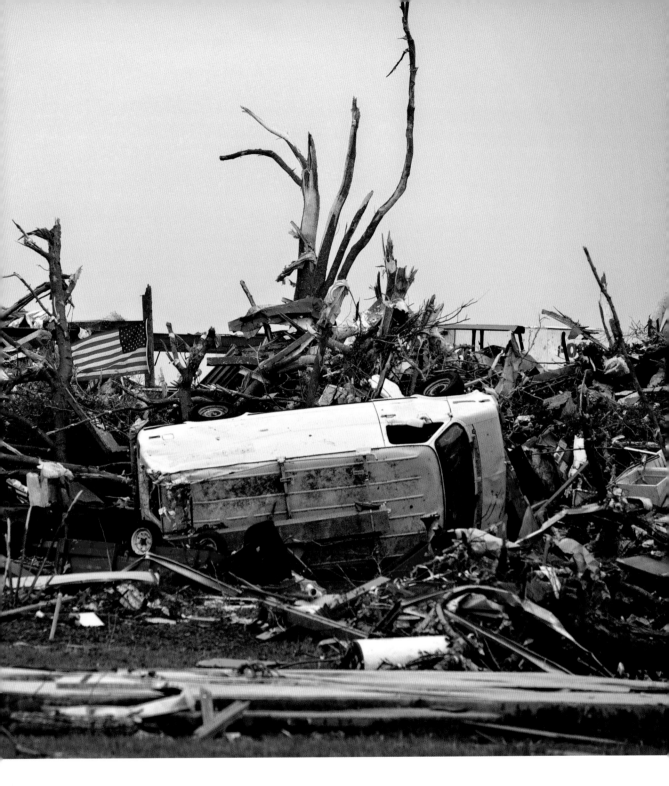

VILONIA, ARKANSAS, US 2014

On 27 April 2014, a tornado struck Vilonia, a town in Arkansas, and almost completely flattened it, killing at least 15 people. The town was unrecognisable and many landmarks were destroyed. Some of the demolished homes had only just been rebuilt after the town was hit by a tornado in 2011.

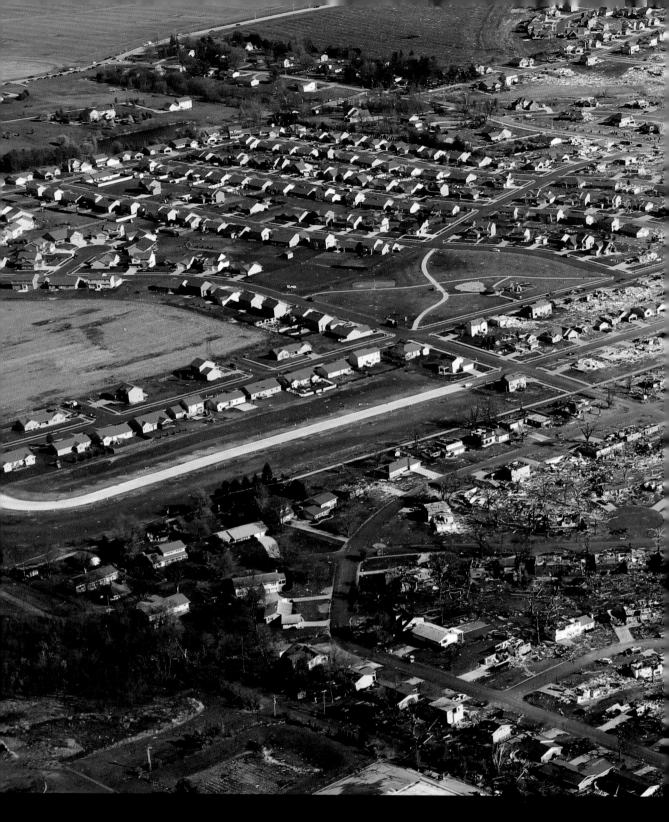

WASHINGTON, ILLINOIS, US 2013

In the middle of November 2013, entire
neighbourhoods, like this one in Illinois,

were destroyed by a tornado that swept
through the US's Midwest states.

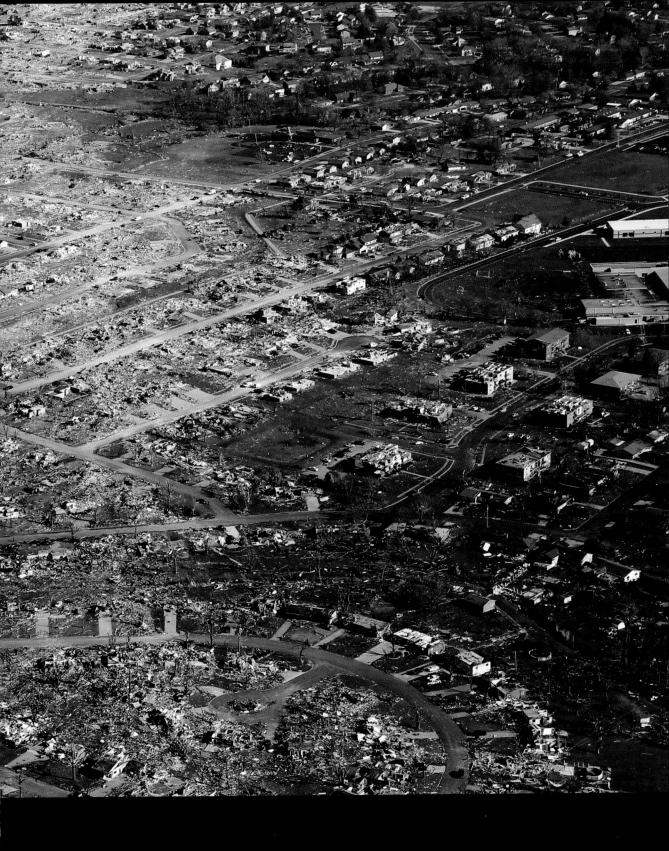

Residents took shelter in their basements, and once the tornado had passed and it was safe to emerge, many reported that surrounding streets were unrecognisable.

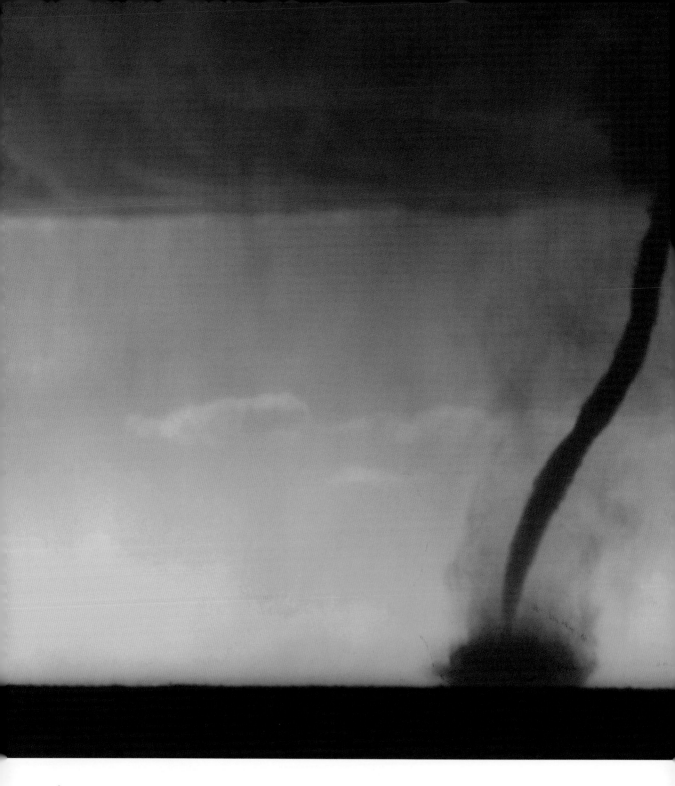

CÔTE D'AZUR, FRANCE 2011

This waterspout was seen in the Mediterranean Sea, just off the Côte d'Azur in France. Waterspouts are formed when the air within a cloud rotates, and then emerges from it as a funnel. Gradually the funnel extends downwards until it reaches the surface of the sea and a waterspout is formed.

If this had taken place over land it would have become a tornado with the likelihood of damage occurring. It is common for one weather system to spawn a number of tornadoes, resulting in damage over a considerable area as the system tracks across country.

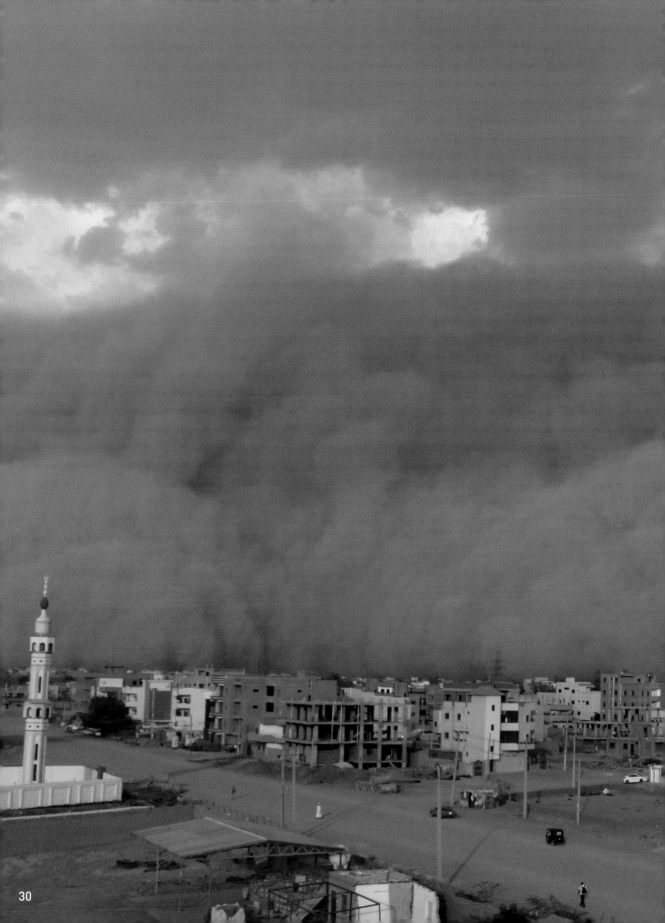

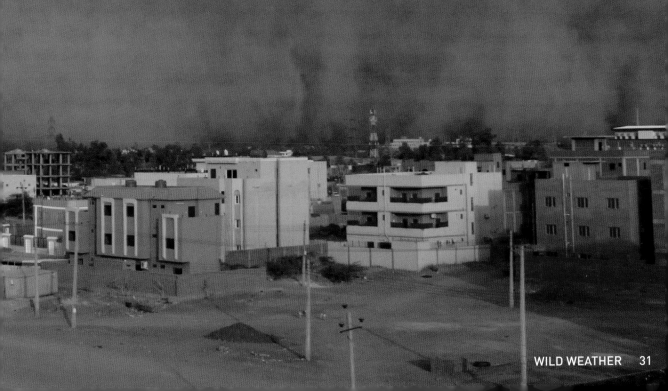

DUSTSTORMS

storms carrying fine particles into the atmosphere, common in areas
of severe drought, causing poor visibility and loss of farmland

Sandstorm, Khartoum, Sudan

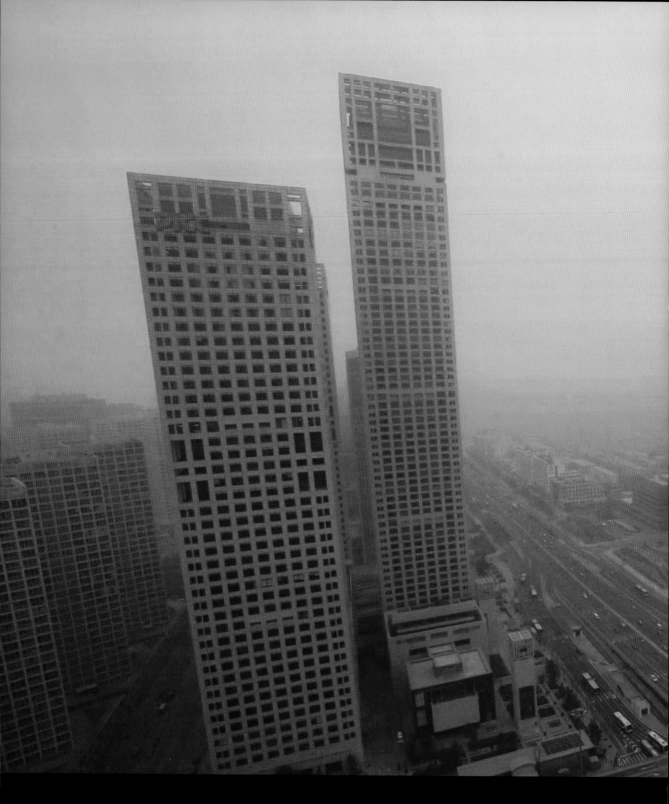

BEIJING, CHINA 2010

When the spring winds blow in from the Gobi Desert, they often carry large amounts of sand dust eastward towards Beijing and onwards to the Korean Peninsula, and even as far as Japan.

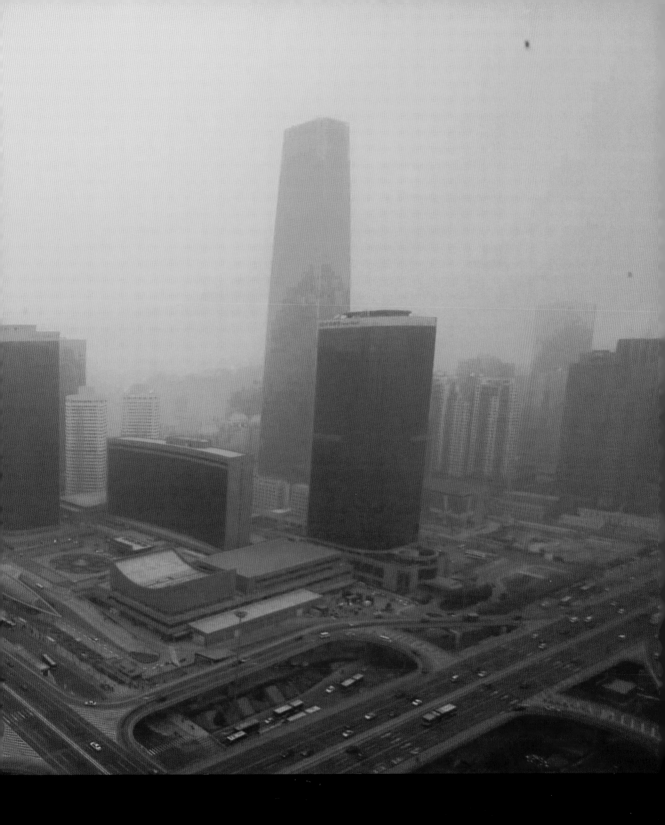

In Beijing, the sky turns yellow with the dust in the atmosphere, visibility is greatly reduced and its inhabitants are advised to stay indoors, or wear masks to avoid breathing in the particles.

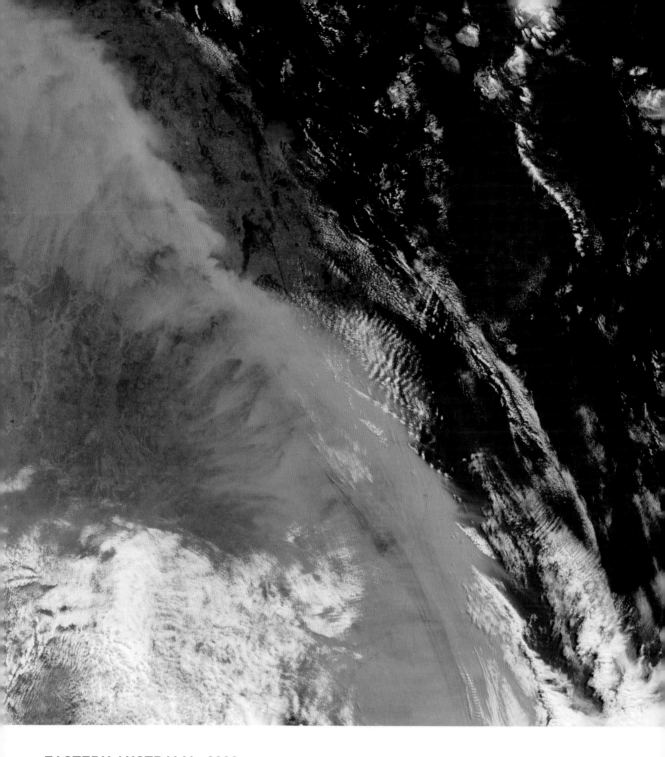

EASTERN AUSTRALIA 2009

In September 2009, New South Wales and Queensland in Australia were blanketed in dust after experiencing the worst duststorm since the 1940s. The dust cloud was more than 500 km (311 mi) wide and 1000 km (621 mi) long, making it visible from space.

According to the Bureau of Meteorology, 'the duststorm was created as a result of 'an intense north low-pressure area' that then picked up a lot of dust from the very dry interior of the continent'. Winds then increased to over 100 km/h (60 mph).

At the peak of the duststorm, air particle concentration levels hit 15 400 mg/m^3 of air. To put this in context, normal days register around 20 mg/m^3 and bushfires can produce 500 mg/m^3. It was estimated that around 16 million tonnes (15.7 million tons) of dust were picked up from Australia's deserts, and during the worst parts of the duststorm, around 75 000 tonnes (73 815 tons) of dust were being lost off the New South Wales coast every hour.

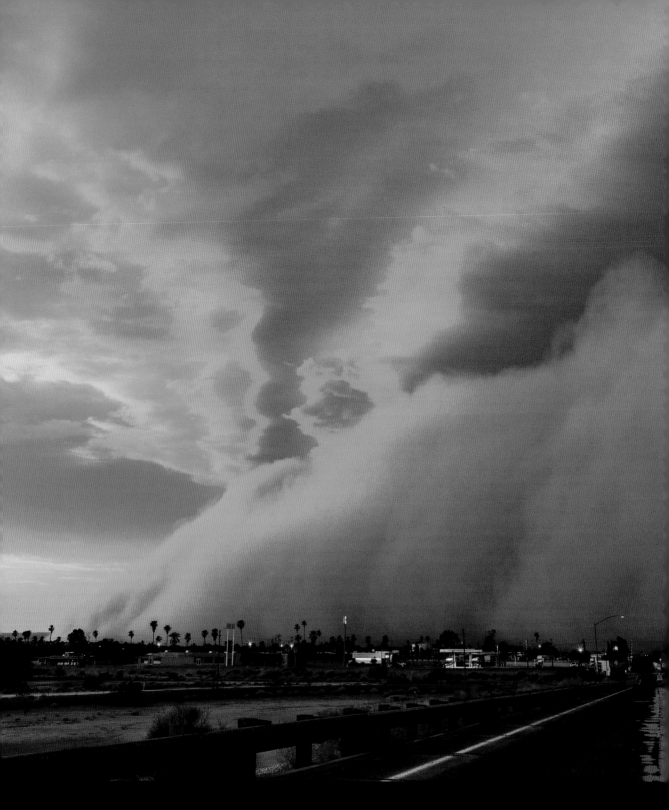

ARIZONA, US 2018

On 9 July 2018, a huge cloud of dust passed through south Arizona. The haboob – an

of a collapsed thunderstorm – created incredibly low visibility across the state's

The storm brought a dangerous combination of high winds, walls of dust, thunder, lightning, heavy rain and hail. While haboobs are common in the area, this one was particularly large and was likened to the global duststorms that occur on Mars.

GARDEN CITY, KANSAS, US 1935

Duststorms are by no means a new phenomenon. In the 1930s the Great Plains region of North America was notorious for its frequent duststorms and became known as the 'Dust Bowl'. As a result of poor farming techniques and drought, the soil turned to dust and was carried away eastward by the wind, reaching as far as the Atlantic Ocean.

In 1935 these two photographs were taken in Kansas, one of the many states to suffer during the Dust Bowl era. Taken only 15 minutes apart, it is only the street lights which confirm that the images are of the same scene. After the government promoted soil conservation programmes the area slowly began to rehabilitate.

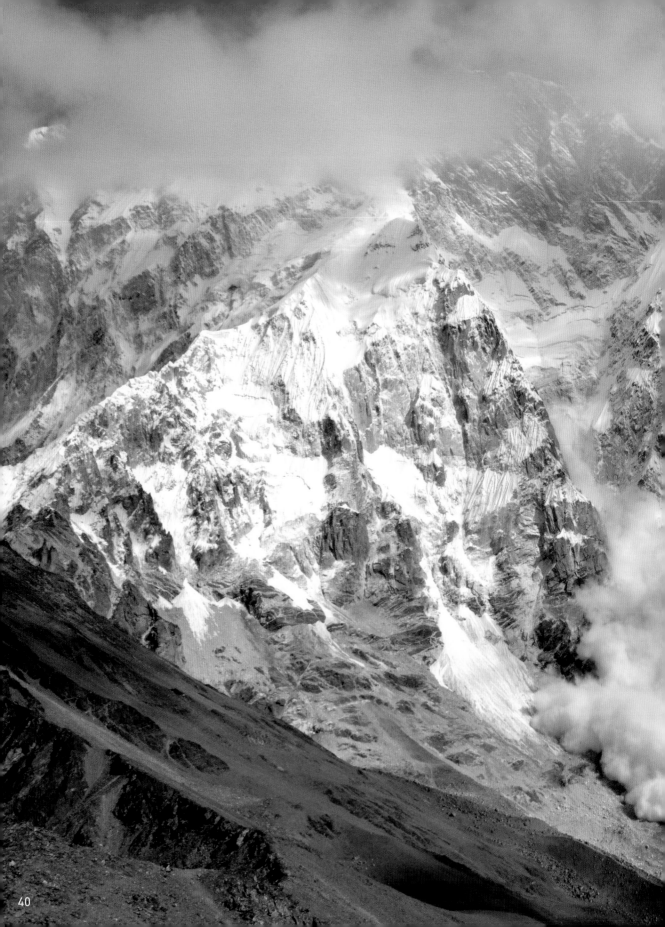

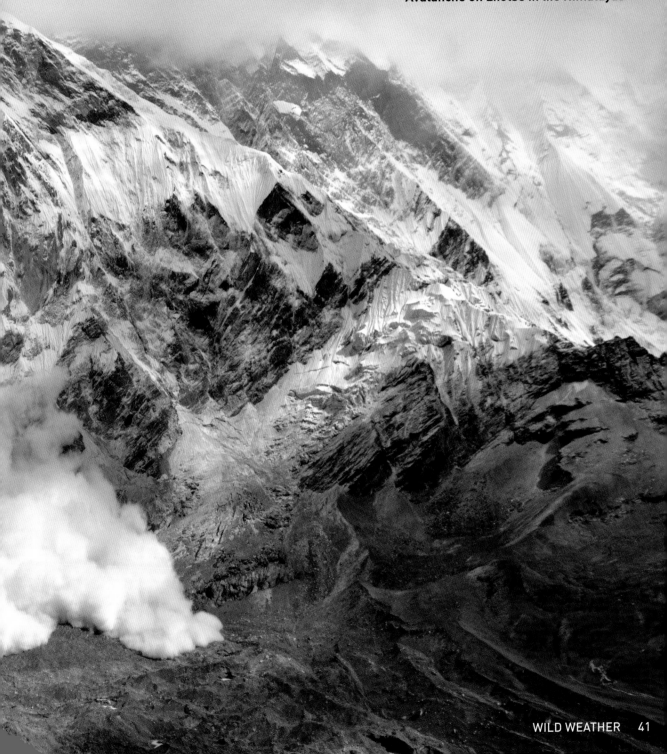

SNOW

precipitation in the form of flakes of ice crystals, formed in clouds,
that remain below freezing point until they reach Earth

Avalanche on Lhotse in the Himalayas

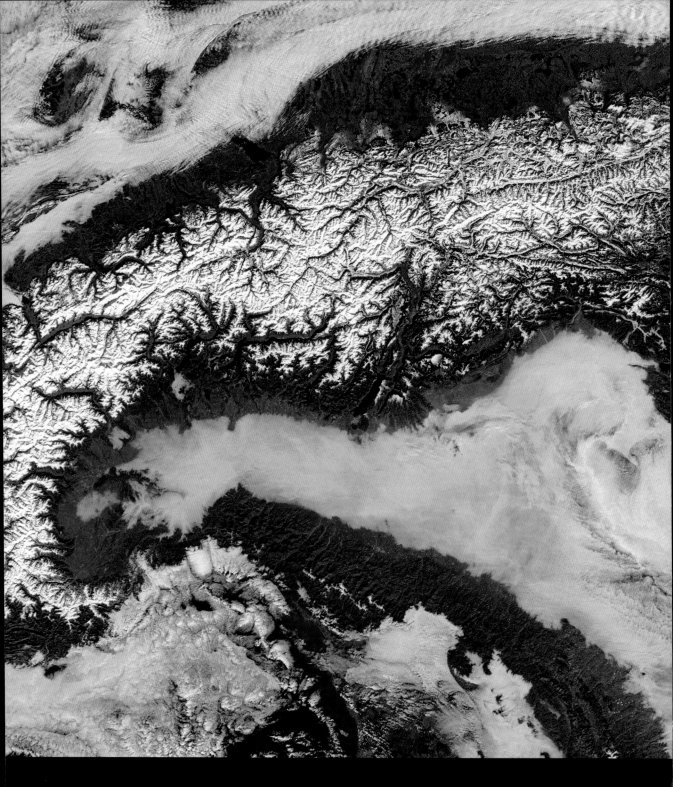

THE ALPS, EUROPE 2018

When this photo was taken on 29 January 2018, snow had been falling heavily in the Alps since the start of December 2017, and many alpine ski resorts were buried by the snow. At the same time, however, other parts of Western Europe were experiencing record-breaking warm temperatures, exceptional rainfall and severe winds.

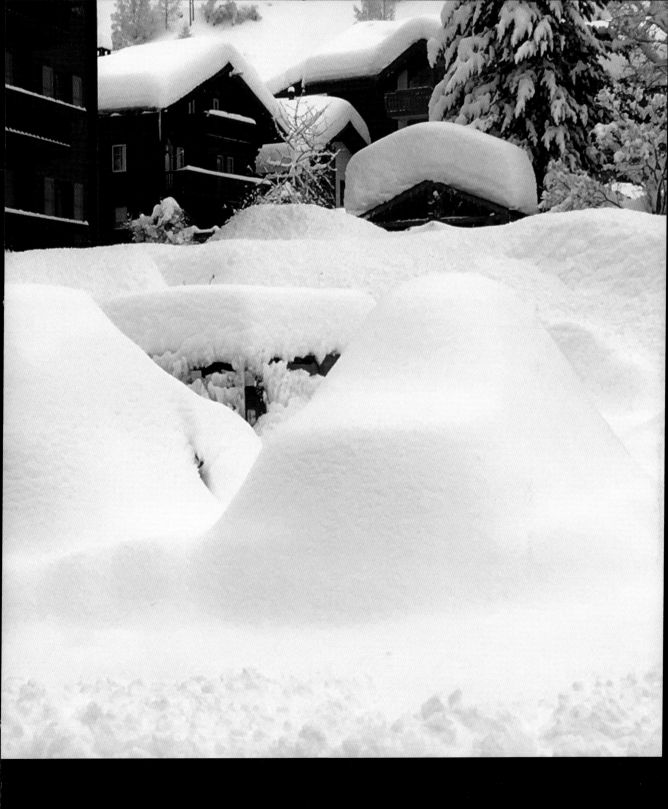

In Zermatt, Switzerland, pictured above, around 2 m (7 ft) of snow fell in 36 hours. Other resorts like Tignes, France, reported over 5 m (17 ft) of snow in a week. Some resorts reported a 5 m (17 ft) base layer of snow, and many experienced at least a metre or two more of snow than witnessed in previous years.

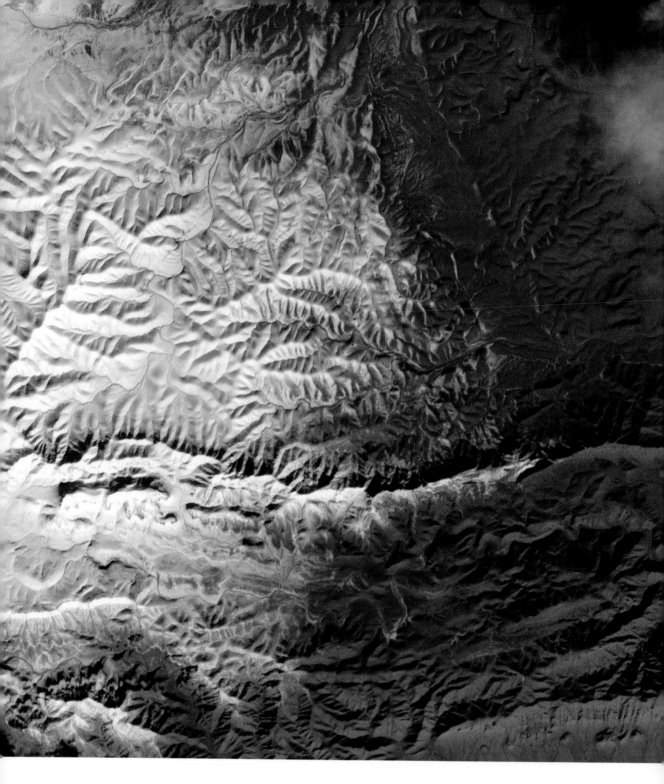

AÏN SÉFRA, ALGERIA 2016

The image above shows the area near the Morocco–Algeria border, south of the city of Bouarfa and southwest of Aïn Séfra. Aïn Séfra is a Saharan town in Algeria that is located between the Atlas Mountains and the northern edge of the Sahara. It is also known as the gateway to the desert so it is unusual to see snow here.

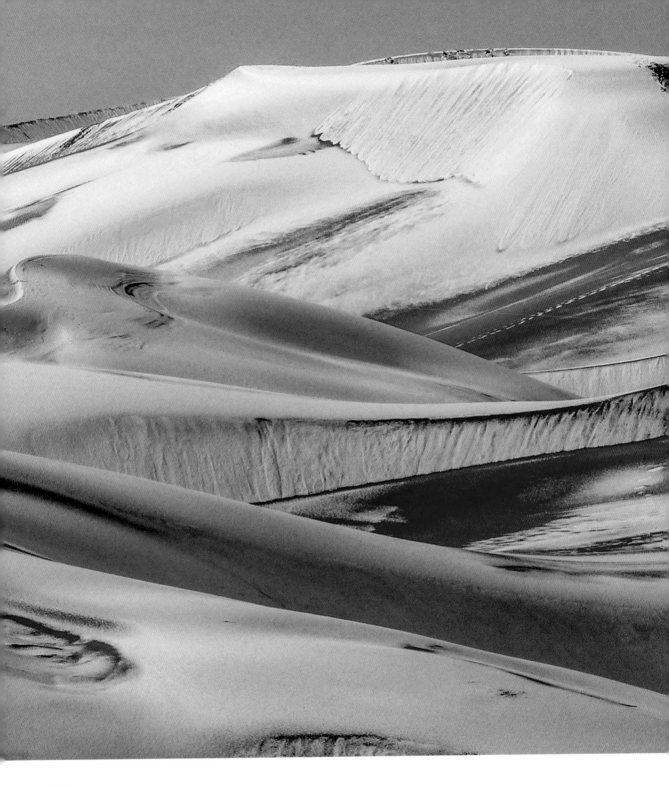

2018

Snow in the Sahara Desert, is indeed rare.
The last recorded snowfall there was in
1979, but in December 2016 (left) and then
twice just over a year later in January and

February 2018 (above), the sand dunes near
Aïn Séfra were blanketed in snow.

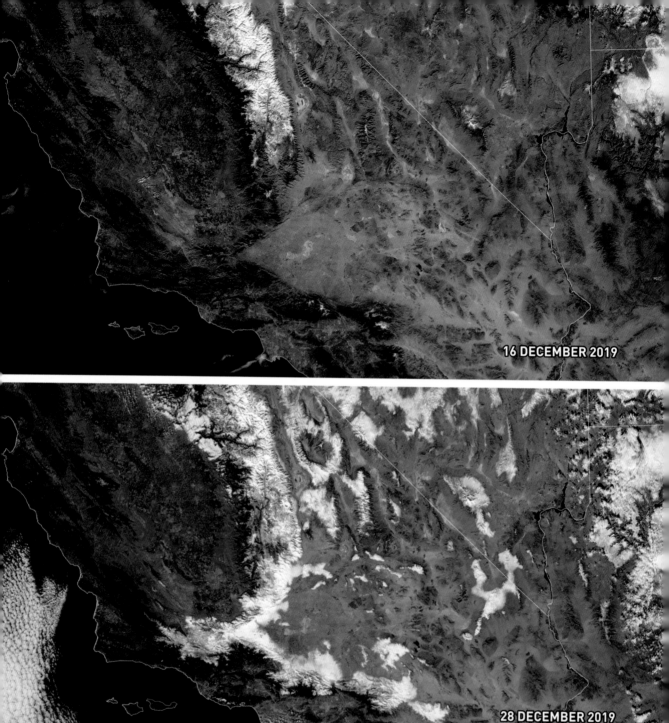

16 DECEMBER 2019

28 DECEMBER 2019

SOUTHERN CALIFORNIA, US 2019

In December 2019, a winter storm battered southern California, bringing heavy rain, snow and a tornado. Ironically, the Mountain High Resorts in Los Angeles County were inundated with around a metre (36 in) of snow and had to temporarily close. Big Bear Lake in the San Bernardino Mountains nearly broke its all-time record for snowfall when it saw 45 cm (18 in) of snow.

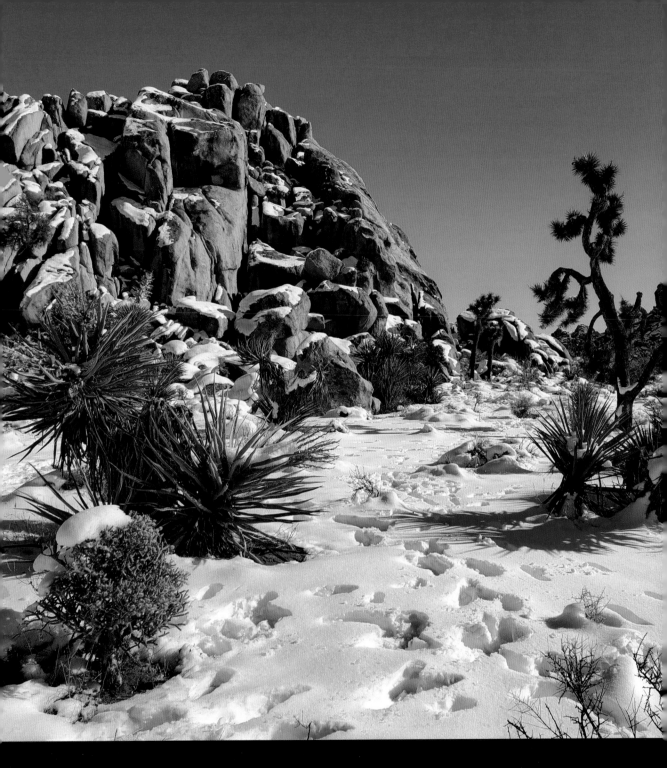

JOSHUA TREE NATIONAL PARK, CALIFORNIA, US 2019

When snow fell in Joshua Tree National Park in December 2019 it was thought to be the most snow the park had received since 2010. It is not uncommon for temperatures to drop but precipitation, on the other hand, is uncommon, so to see the park's Joshua trees, prickly yucca plants and cacti covered in a blanket of snow was a rare sight.

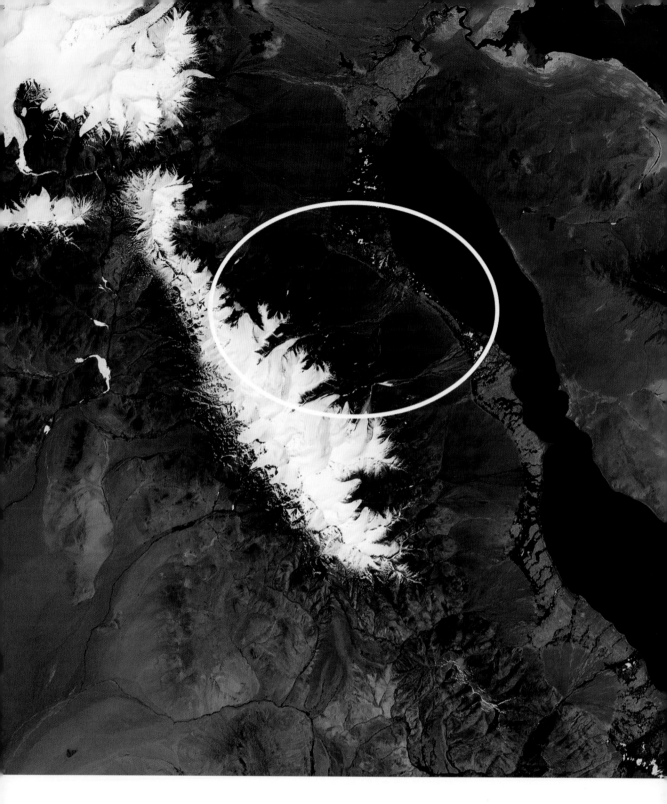

ARU RANGE, CHINA 2016

In July 2016, a glacier in the Aru mountain range collapsed. This satellite image shows the area before the collapse. In contrast, the image on the right captures the collapse and the resulting ice avalanche in action.

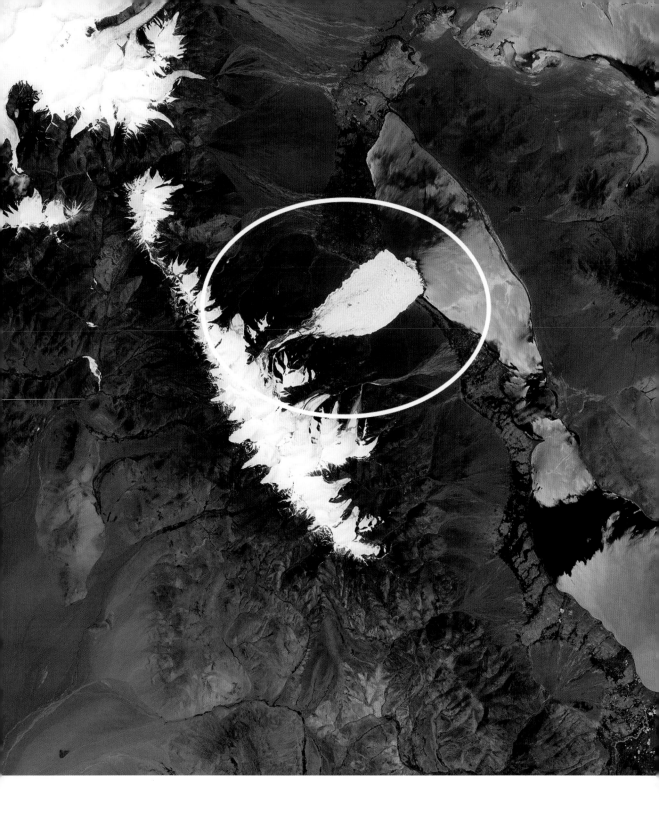

The avalanche of ice was one of the biggest ever recorded. It devastated anything in its path and left debris as thick as 30 m (98 ft) covering an area of 10 km² (4 mi²). Nine people from the village of Dungru lost their lives along with hundreds of sheep and yaks.

NEW YORK, US 2016

On 23 January 2016, the east coast of the US was battered with one of the worst snow storms it had seen in years – dropping the

deepest snow in New York City since records began in 1869. In Central Park, 69.85 cm (27.5 in) of snow was recorded

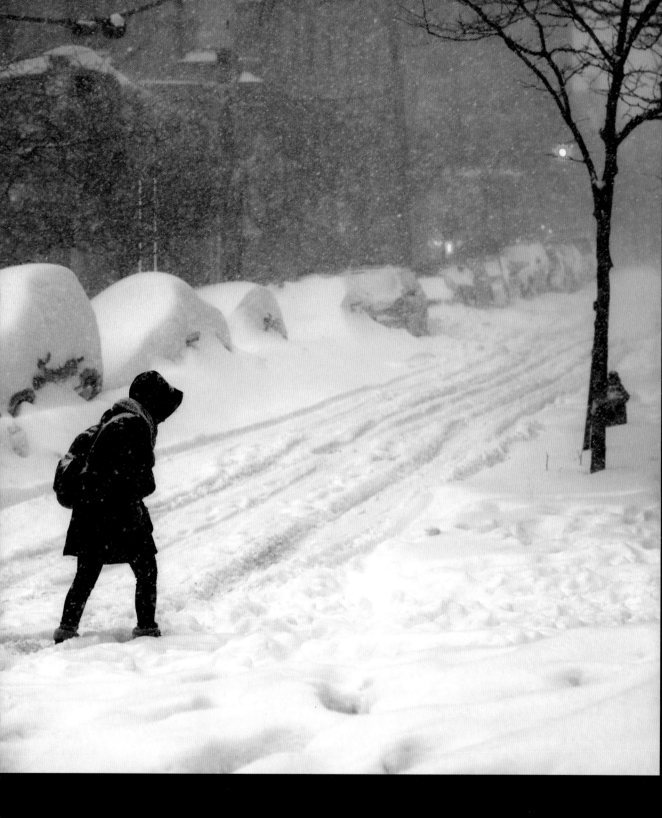

Some states like West Virginia saw over 107 cm (42 in) of snow, many homes experienced power cuts, 12 000 flights had to be cancelled, travel bans were put in place on roads, and around 50 people were killed.

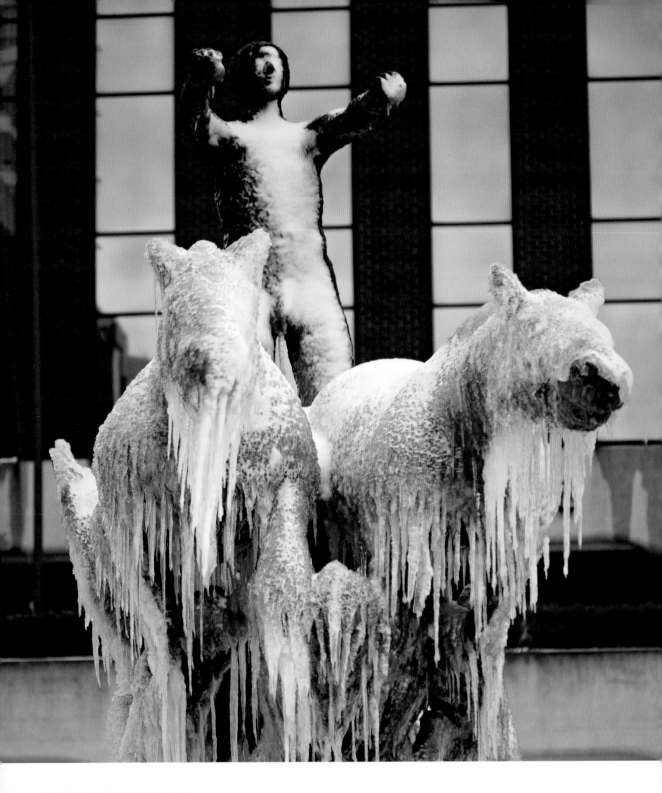

BRITISH ISLES 2018

The intensely cold weather system colloquially known as the 'Beast from the East' combined with Storm Emma in March 2018 to cause widespread disruption across the whole of the British Isles. In Dublin, Ireland, the Chariot of Life fountain on Abbey Street (above) was covered in icicles and snow.

The cold snap was characterised by blizzards, strong winds, snow drifts and bitter cold. Around 50 cm (20 in) of snow fell in some places, making travel and everyday life difficult. Motorists were left stranded on roads, and rural areas like Lancashire, England (above) saw snow drifts up to 6 m (20 ft).

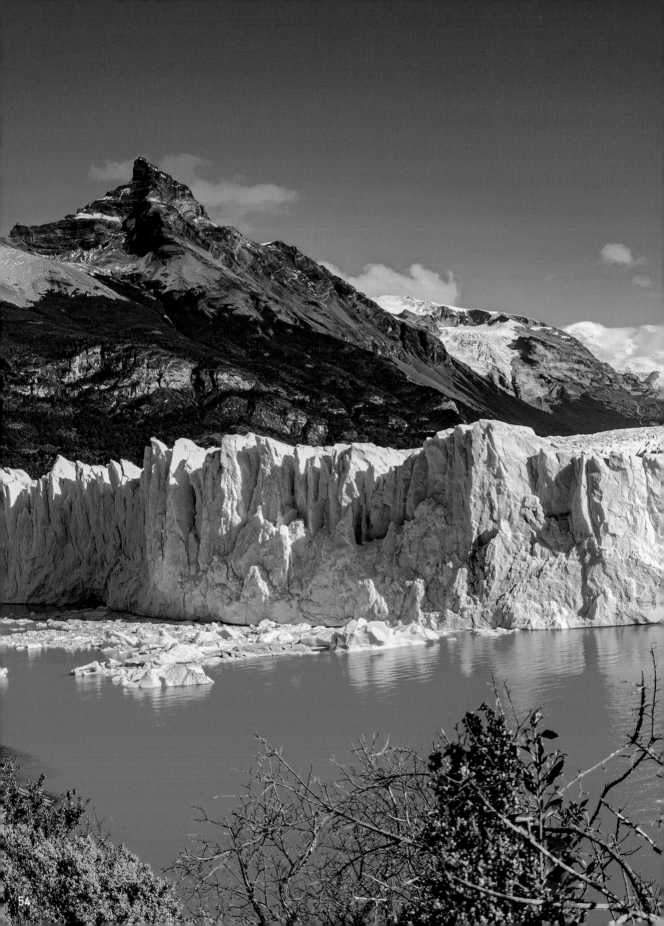

SHRINKING GLACIERS

masses of ice flowing slowly down valleys, whose extent and rate
of movement are affected by climate change

Perito Moreno Glacier in Patagonia, Argentina

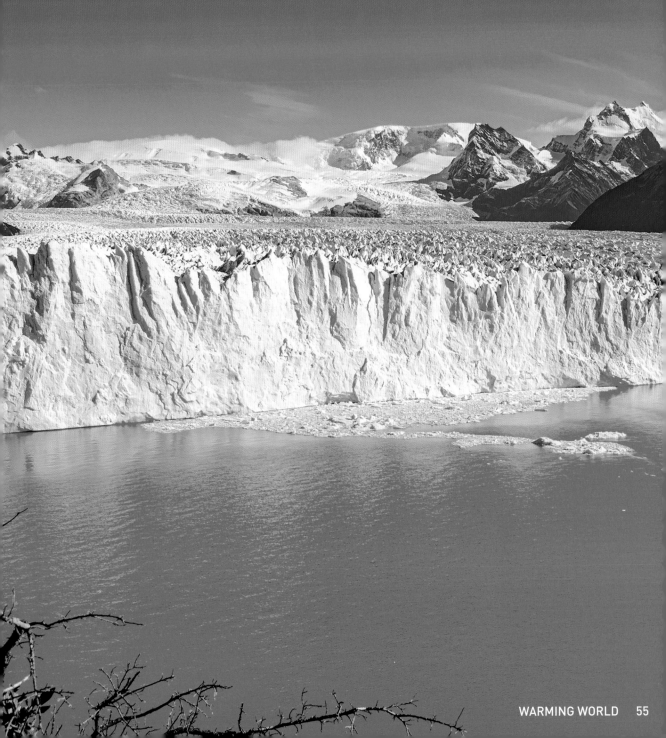

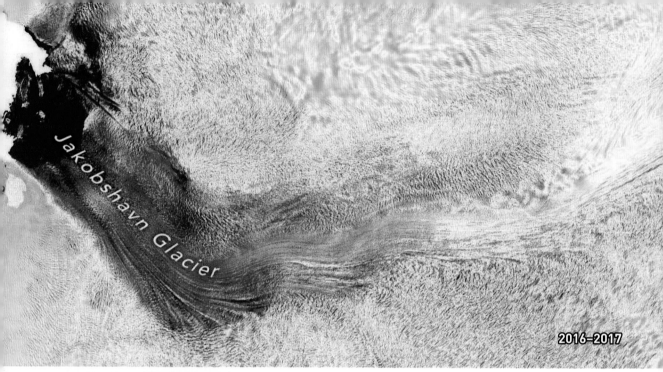

2016–2017

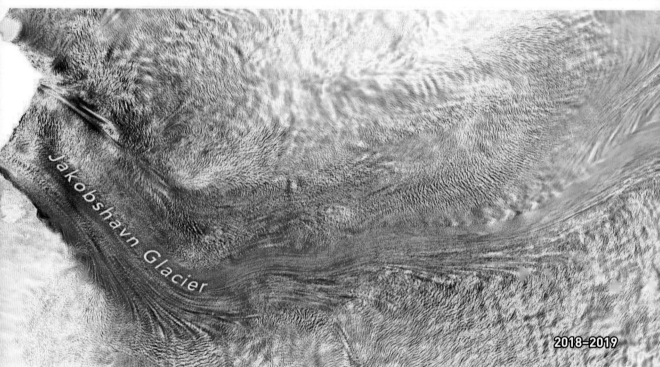

2018–2019

JAKOBSHAVN GLACIER, GREENLAND 2016–2017, 2018–2019

Until recently, the Jakobshavn Glacier has been Greenland's fastest-moving and fastest-thinning glacier for most of the 2000s. However, from 2016 the glacier actually started gaining. Areas with most growth are shown in dark blue, and the red areas represent thinning. Each year between 2016 and 2019, the glacier grew between 20 and 30 m (66 and 98 ft).

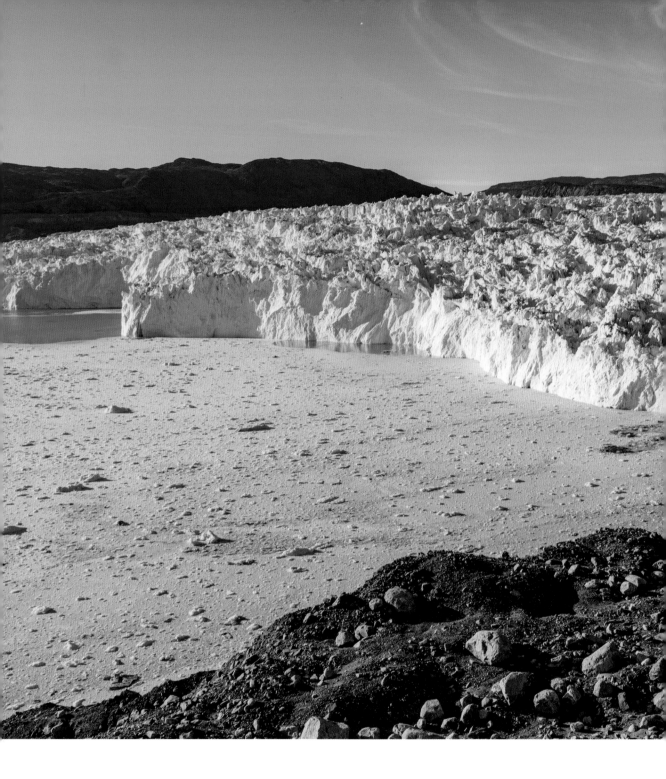

While the growth of the glacier might seem positive, the temperature change of the current's water is consistent with a recognised climate pattern, and one that is expected to switch, meaning more of the glacier will melt. Even though the rate at which the glacier is melting has decreased, the glacier will continue to contribute to the rising sea level.

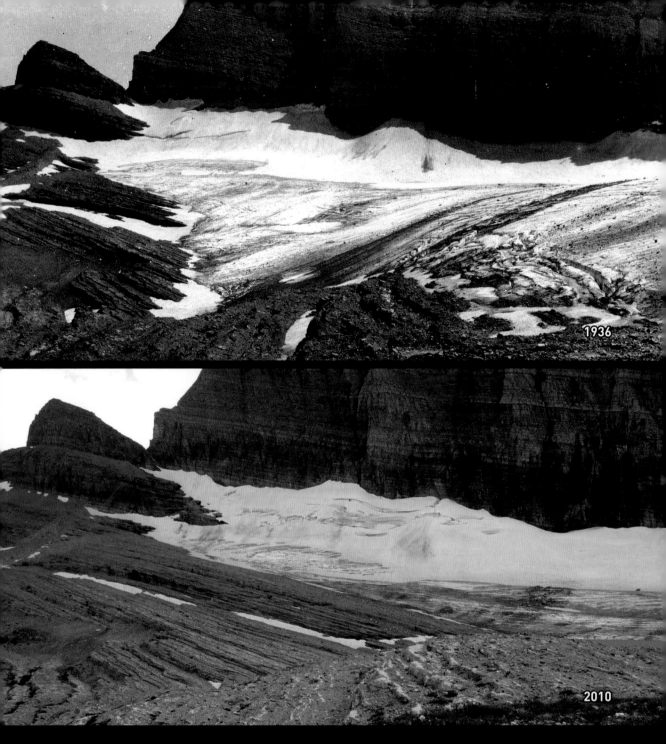

1936

2010

GRINNELL GLACIER, MONTANA, US 1936, 2010

These images show the Grinnell Glacier in Glacier National Park in Montana, US in 1936 and 2010. The 2010 image shows the volume of glacial ice has significantly decreased. In 2010, the glacier's terminus was visible – not shown in the 1936 image because it did not exist. Scientists who are tracking the glacial retreat predict that all of Glacier National Park's glaciers will have melted by 2080, with some disappearing by as early

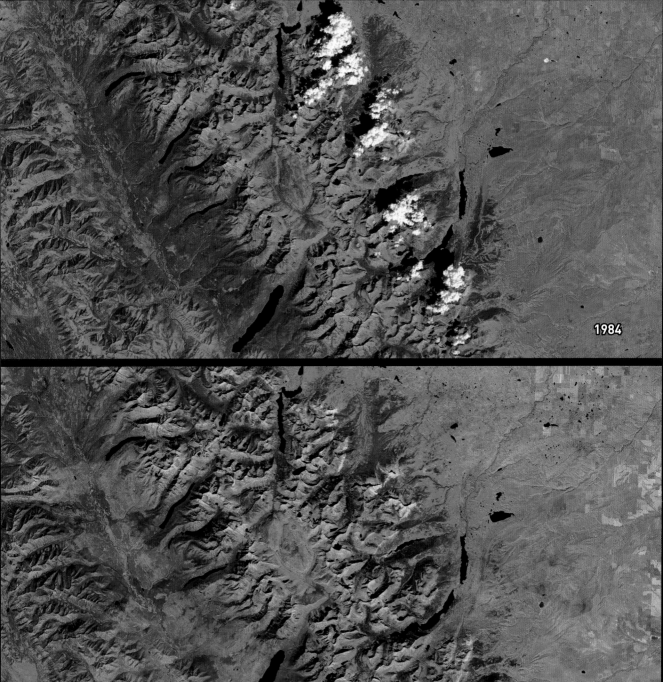

1984

2015

BLACKFOOT-JACKSON BASIN, MONTANA, US 1984, 2015

The images here are also from Glacier National Park, 31 years apart. In 1850, the park was home to around 150 glaciers. By 1966, there were only 35 active glaciers, and there's now thought to be only around 26 left. The blue patches show a reduction in permanent ice and snow, but also visible in the 2015 image are the red burn scars from wildfires ignited after periods of intense dry heat. The Blackfoot and Jackson Glaciers only occupied around 2.26 km² (0.87 mi²) in 2015 compared to 8.06 km² (3.11 mi²) in 1850.

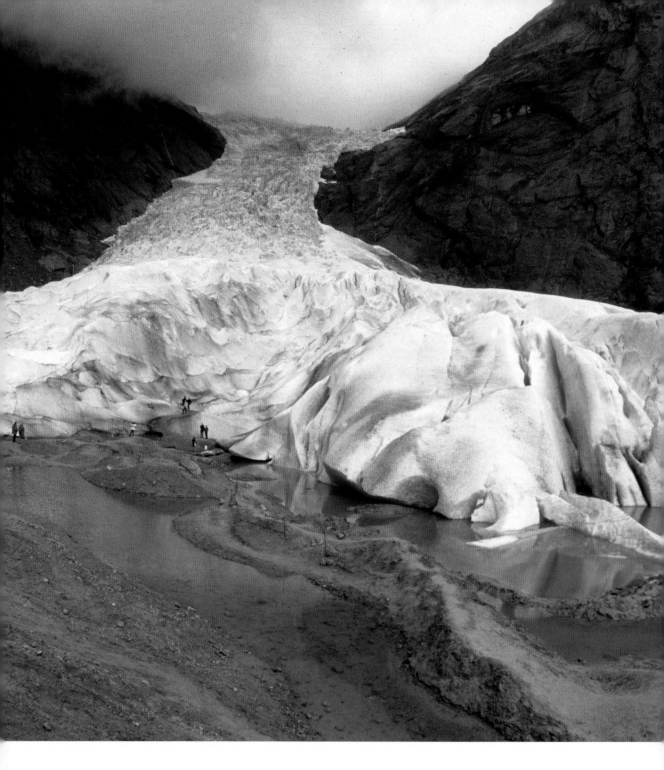

BRIKSDAL GLACIER, VESTLAND, NORWAY 2002

Briksdalsbreen (known in English as the Briksdal Glacier) branches off the Jostedalsbreen Glacier in Jostedalsbreen National Park in Norway. Briksdalsbreen's terminus is in a glacial lake, Briksdalsvatn, which is around 346 m (1135 ft) above sea level. Many of Norway's glaciers are very vulnerable to rising global temperatures.

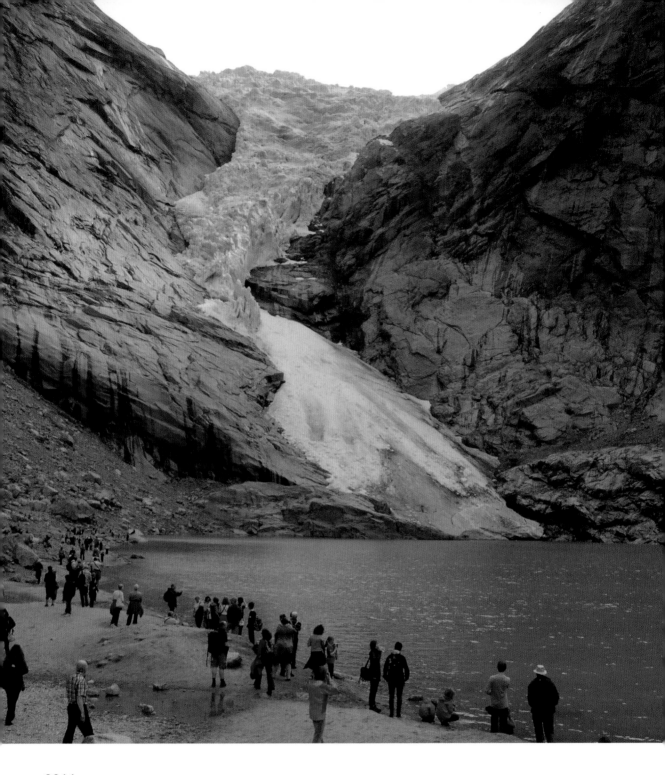

2011

The glacier first receded between 1934 and 1951, with a total retreat of around 800 m (2600 ft), which exposed the lake below it. The glacier then expanded and attracted lots of attention as it was growing during a period when most others were retreating. However, after 2000 the glacier started receding again and by 2007 the front of the glacier had retreated so far back that it sat on dry land rather than in the glacial lake.

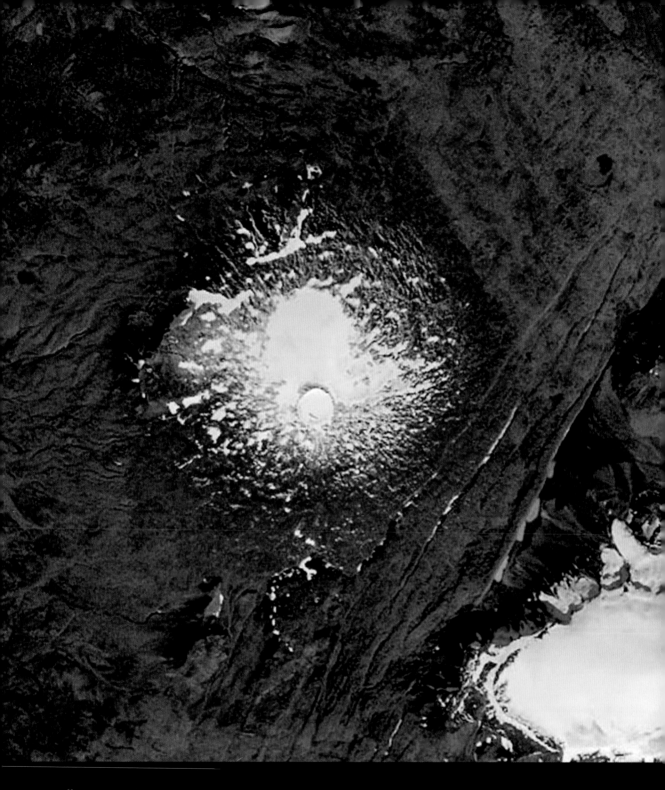

OKJÖKULL GLACIER, ICELAND 1986

Okjökull (Ok Glacier), on the top of the
Ok volcano in western Iceland has been in
decline since the early part of the twentieth

Okjökull covered around 38 km² (15 mi²).
In 1978, the glacier had retreated to around
3 km² (1 mi²), and today, it is barely visible

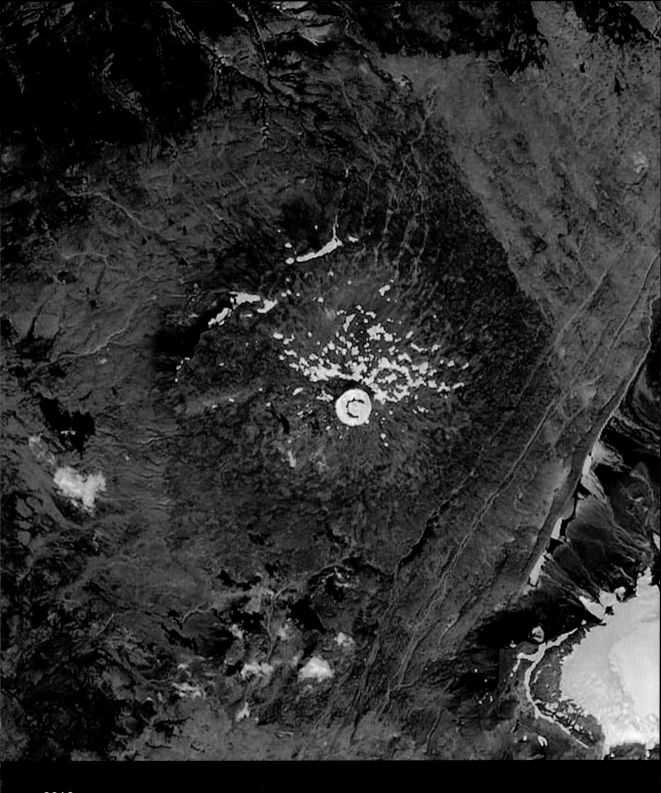

2019

In 2014, the glacier was not thick enough to move anymore and it was officially declared dead. It was the first Icelandic glacier to lose its glacial status and a memorial plaque commemorating Okjökull was added to the top of the volcano. Scientists predict that within the next 200 years, all Icelandic glaciers will have disappeared.

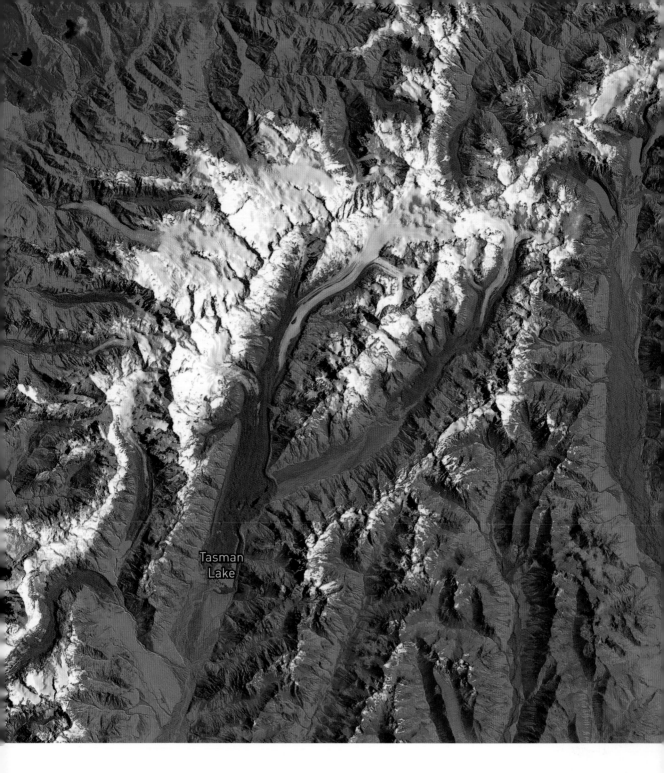

Tasman
Lake

TASMAN GLACIER, NEW ZEALAND 1990

The Tasman Glacier, situated in Mount Cook National Park is the biggest glacier in New Zealand, measuring around 23 km (14 mi) long and 4 km (2.5 mi) wide. It is around 600 m (2000 ft) thick. The false-colour image above shows the glacier in 1990. The image on the right is from the same location but 27 years later. In both images, snow and ice are shown in white and water in blue.

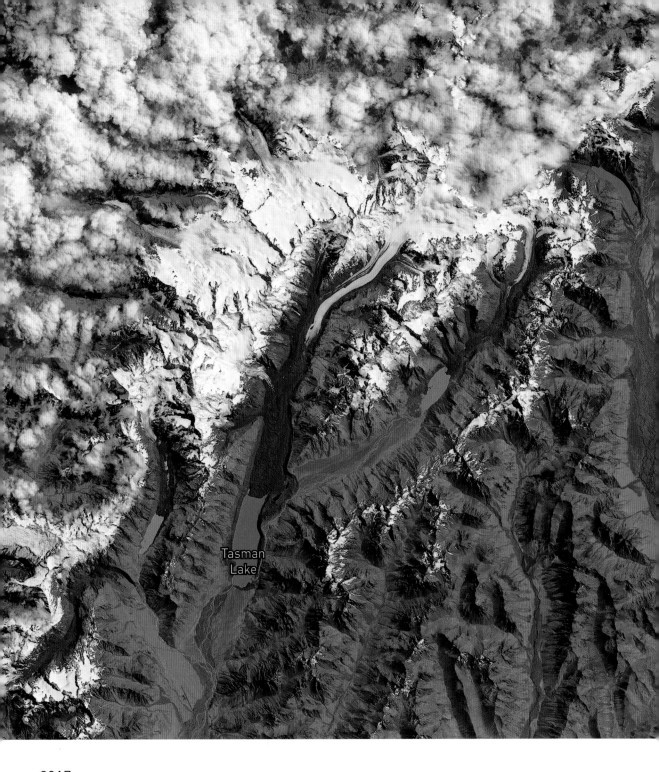

Tasman
Lake

2017

When both images are examined carefully, the shrinking glacier is evident. Before 1973, Tasman Lake was not a feature in this glacial landscape, but the lake's creation and growth is due to the glacier's retreat.

Scientists estimate that in the time between the two photos being taken, the glacier has retreated by around 180 m (590 ft) each year, and between 1990 and 2015, the glacier retreated by a total of 4.5 km (2.8 mi).

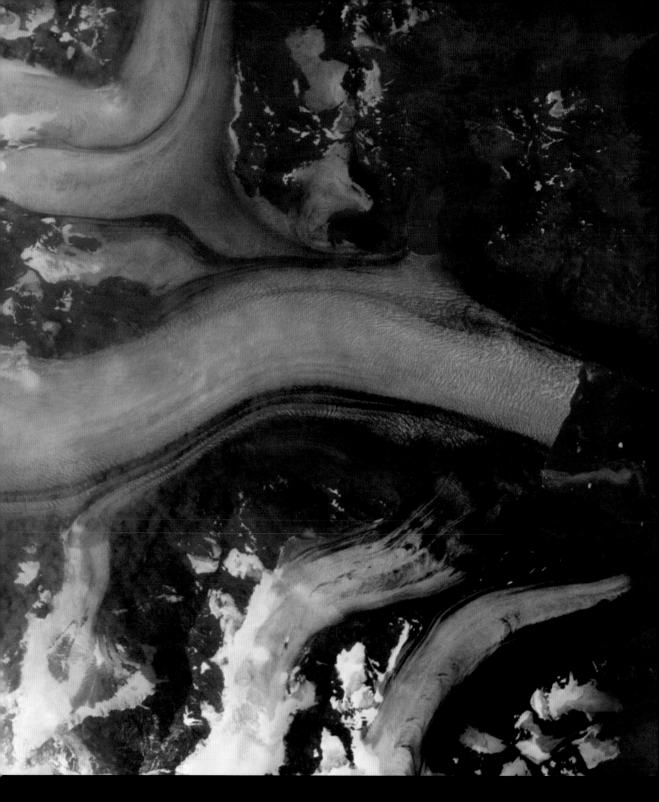

NEUMAYER GLACIER, SOUTH GEORGIA 2005

The Neumayer Glacier can be found on the east coast of South Georgia – an island east of South America's most southerly point.

Before 1970, the changes to the glacier were not drastic, and it had suffered a retreat of less than 100 m (330 ft).

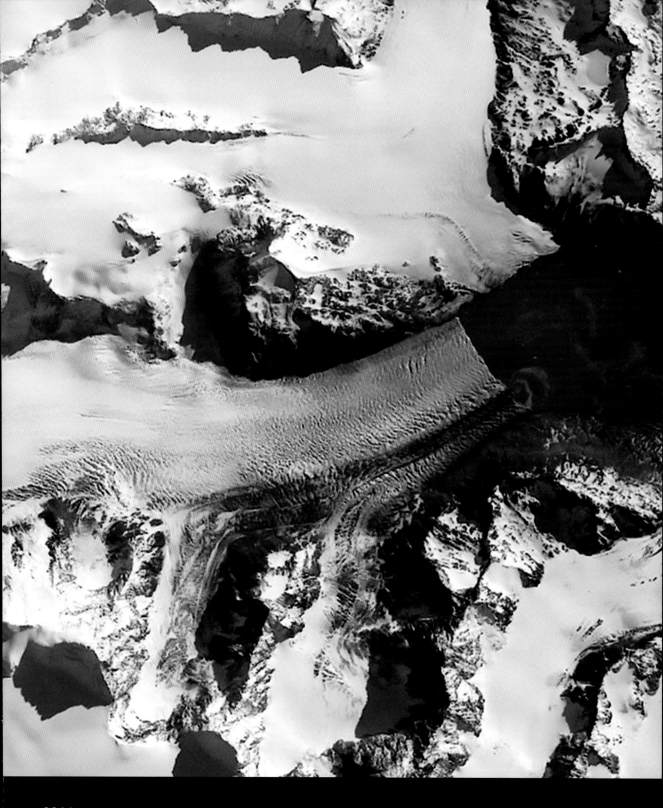

2016

After 1970, however, its decline began to accelerate drastically, and in the period between 1970 and 2002 the glacier lost around 2 km (1.2 mi) of its length. Between 2000 and 2016 (pictured above), it retreated 4 km (2.5 mi).

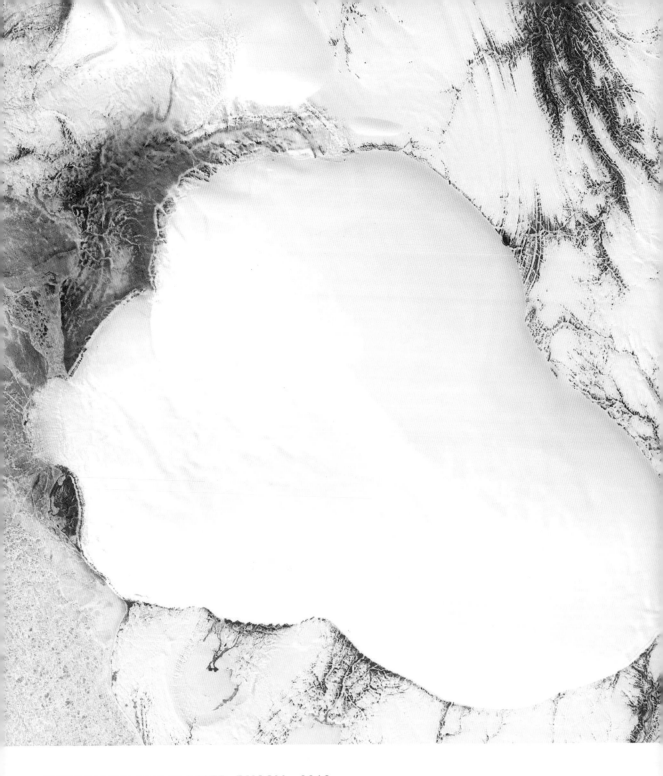

VAVILOV ICE CAP GLACIER, RUSSIA 2013

This is a glacier on the Vavilov Ice Cap in the Russian Arctic. The glacier had been gradually moving into the Kara Sea at a rate of around 5 cm (2 in) a day. In 2010, however, the rate suddenly picked up, and some days, by 2015, it was moving up to 25 m (82 ft) a day, meaning that in the 12 months between April 2015 and April 2016, the glacier had advanced by more than 5 km (3 mi).

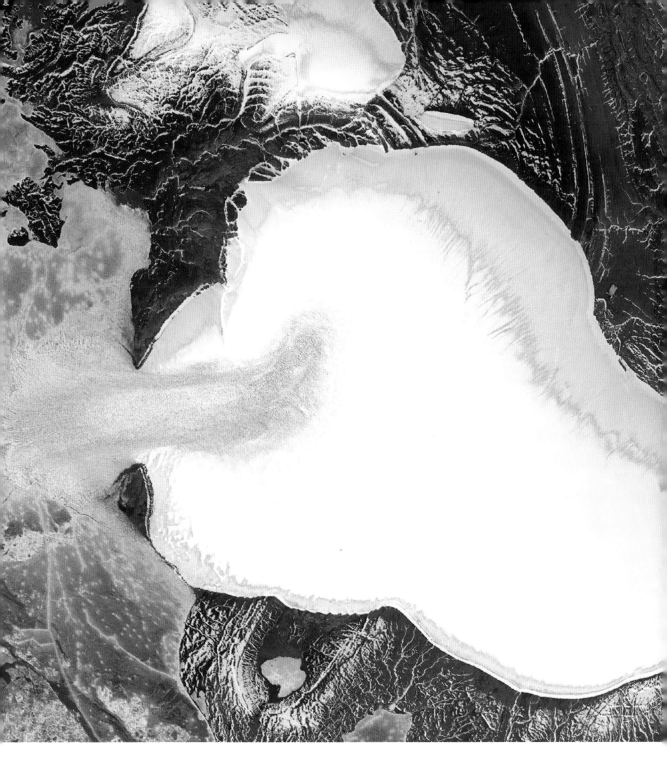

2018

This alarming rate of advance has concerned scientists. When glaciers move into the sea at such speed, the rate at which the sea levels rise as a result accelerates. Scientists are questioning whether this dramatic increase in speed might require them to look at other glaciers to see if they are similarly unstable, and therefore how they will affect the already-rising sea levels.

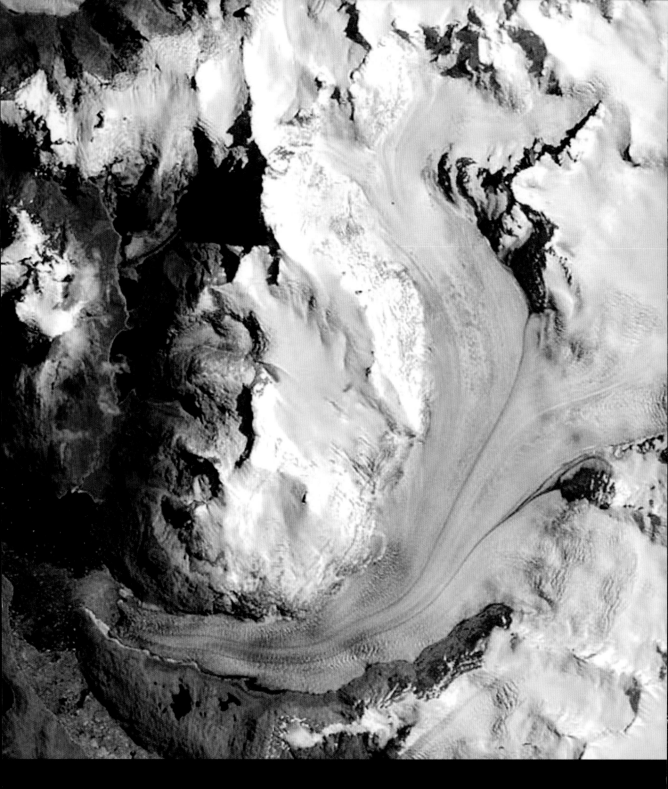

HPS-12, SOUTH PATAGONIAN GLACIER 1985

Extending over Chile and Argentina, the South Patagonian Icefield is the southern hemisphere's biggest icefield outside of Antarctica, standing at approximately 13 000 km² (5000 mi²). Most of its glaciers have retreated over the years and some are in grave danger.

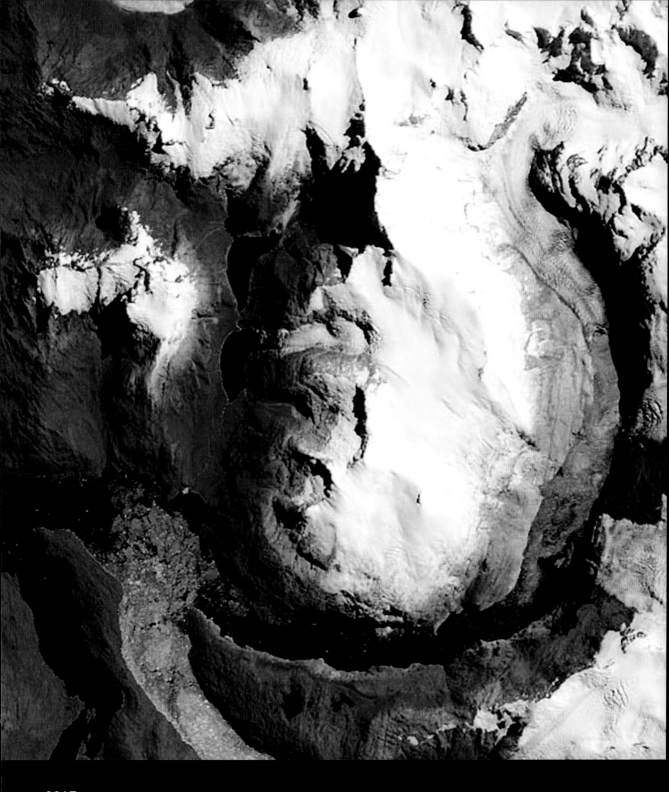

2017

The glacier above, named HPS-12, has experienced catastrophic retreat. In 1985, it was around 26 km (16 mi) long, but in 2017 it was only 13 km (8 mi) long, meaning that in the 33 years between the two images, the glacier lost about half its volume and detached from three other glaciers at the same time.

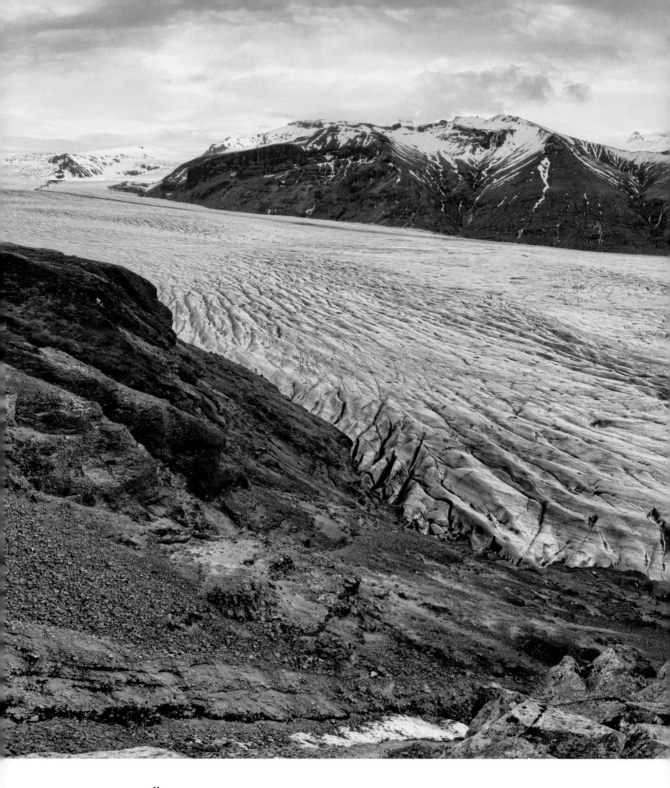

SKAFTAFELLSJÖKULL, SKAFTAFELL NATIONAL PARK, ICELAND 2013

Skaftafellsjökull, in Iceland's Skaftafell National Park, is a glacier tongue coming out of Iceland's biggest ice cap – Vatnajökull. The ice cap currently covers around 8 per cent of Iceland's surface area. Unfortunately, over the last couple of decades, Skaftafellsjökull has been in rapid retreat due to global warming.

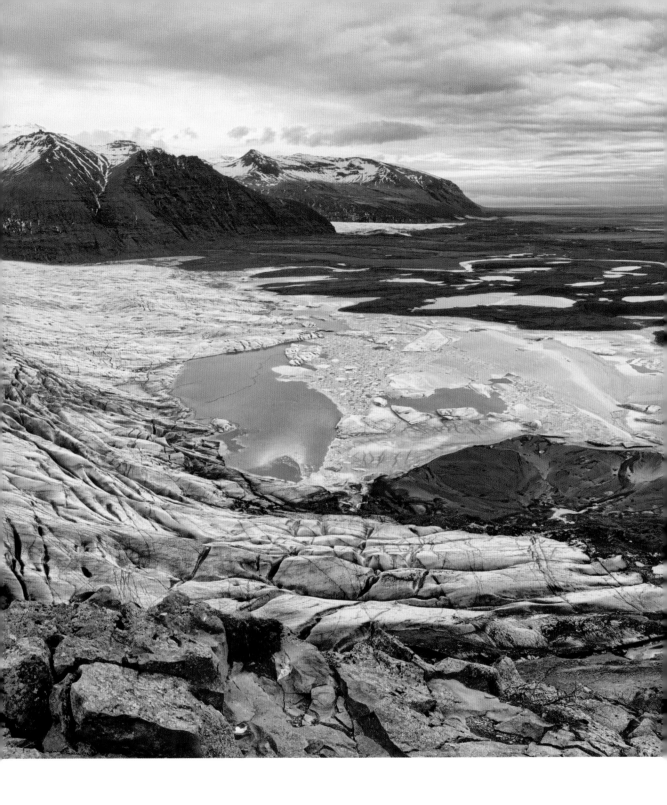

Between 1995 and 2019 the glacier retreated around 850 m (2790 ft), and at this rate the glacier can be expected to shrink by 50 to 100 m (165 to 330 ft) each year. In order to help slow its retreat, trees have been planted in the area to absorb some of the carbon dioxide surrounding it, but scientists don't think it will be enough to save the glacier.

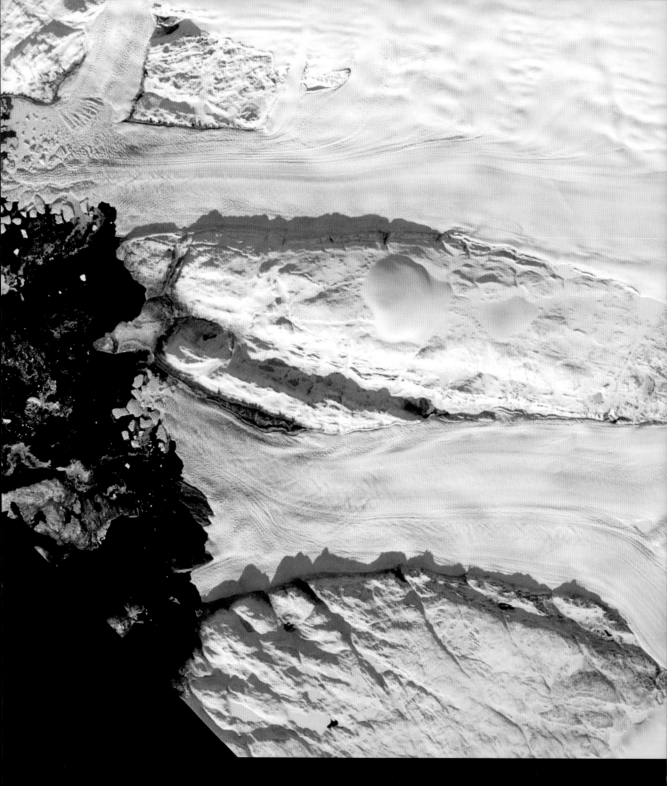

TRACY & HEILPRIN GLACIERS, GREENLAND 1987

There are two glaciers in the above images
– Tracy (the upper glacier) and Heilprin
(the lower glacier) and they both flow into
Inglefield Bredning, one of Greenland's

fjords on the northwest coast. During the
1980s and 1990s, the two glaciers retreated
at a similar rate – an average of 37 m (121 ft)
each year.

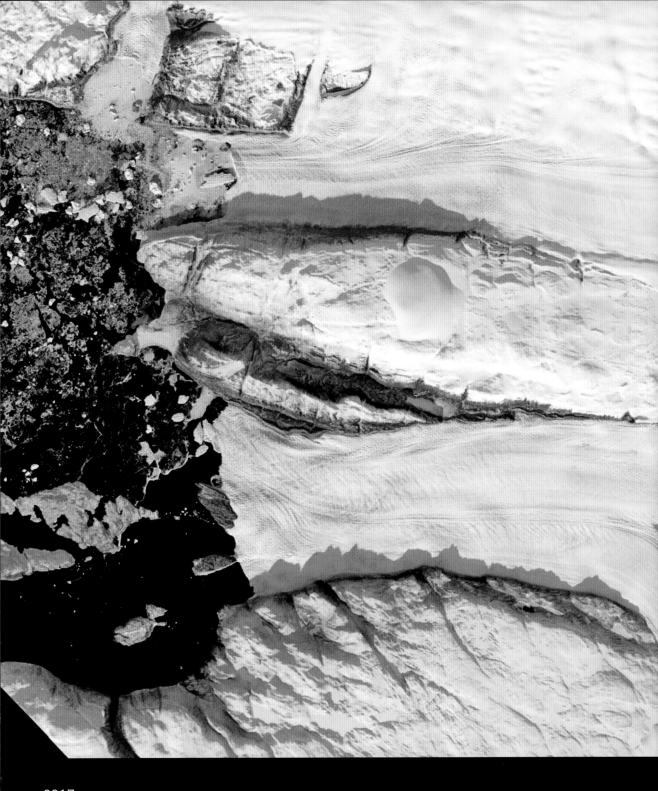

2017

Between 2000 and 2014, however, Tracy's rate of retreat accelerated to 364 m (1194 ft) a year – over three times faster than Heilprin's yearly retreat of 109 m (358 ft). Scientists think that this is due to the fact that Tracy flows into a deeper channel, which makes it more vulnerable to the rising temperature of the ocean, melting the glacier's underside.

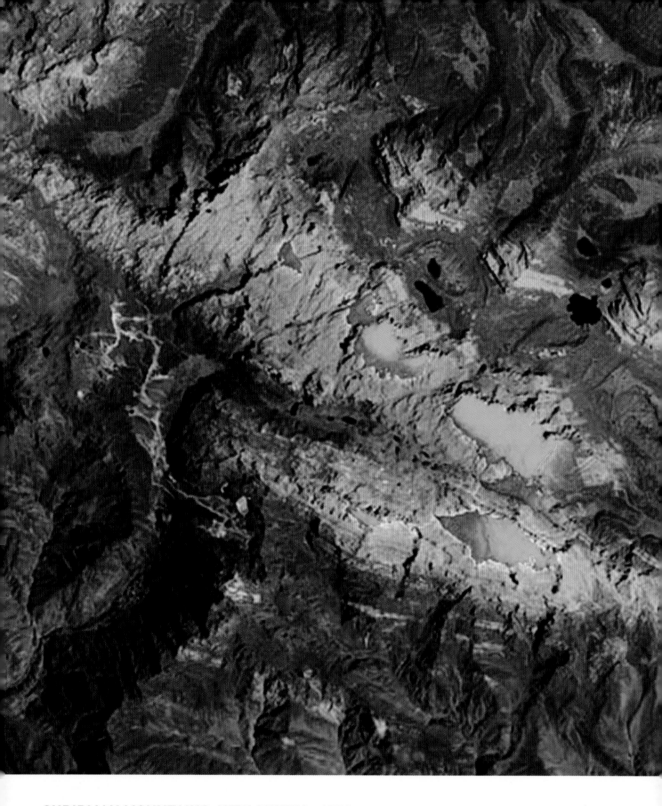

SUDIRMAN MOUNTAINS, NEW GUINEA 1988

The Sudirman mountain range in New
Guinea sits just south of the equator.
Despite this, its highest peaks have
historically been cold enough to sustain
glaciers. This, however, is a changing
situation.

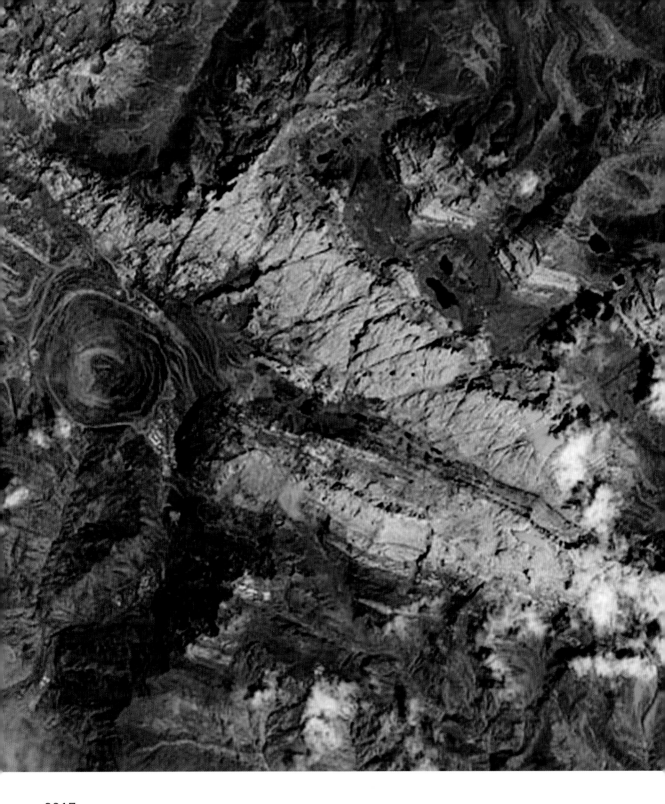

2017

The amount of ice (shown as a false-colour blue in both images above) is in rapid decline – and between 1988 and 2017, a large amount of the ice in the Sudirman Mountains disappeared.

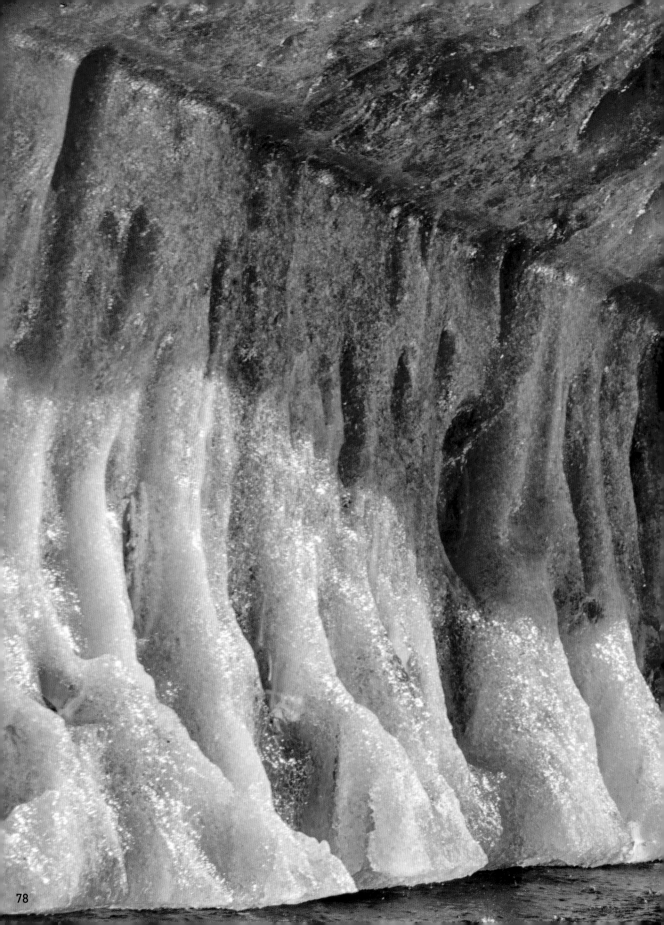

MELTING ICE

historical patches of snow and ice thawing as
temperatures rise

Qoroq ice fjord melting, Greenland

KOTZEBUE SOUND, ALASKA, US 2010

Permafrost – frozen ground that stays
completely frozen for a minimum of two

northern hemisphere, including Alaska.
In this image, former permafrost has thawed

ARCTIC NATIONAL WILDLIFE REFUGE, ALASKA, US 2007

Here, a chunk of permafrost that has already fallen into the sea along the Arctic coast of Alaska can be seen. Coastal erosion in this area is a common consequence of the combined forces of melting permafrost, rising sea levels and rough seas.

DAWSON CITY, YUKON, CANADA 2008

Many villages in the northern hemisphere are built on beds of permafrost. When permafrost starts to melt, houses, other buildings and roads that were built upon it can start to collapse, ending eventually in their destruction.

SPITSBERGEN, SVALBARD, NORWAY 2013

The buildings here have fallen victim to thawing permafrost: the image on the left of homes in Dawson City, Canada, and the image on the right of an old house sliding down a thawing slope of permafrost in Spitsbergen, Norway.

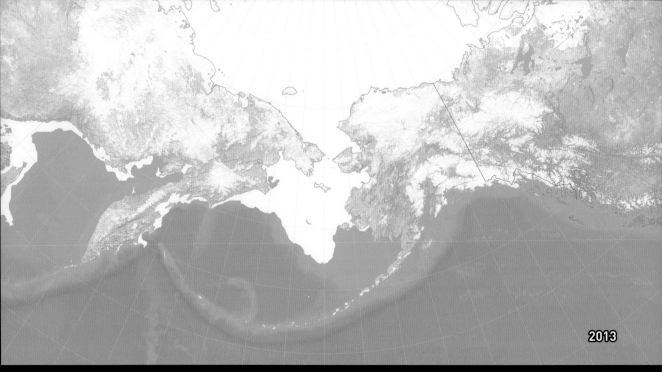

2013

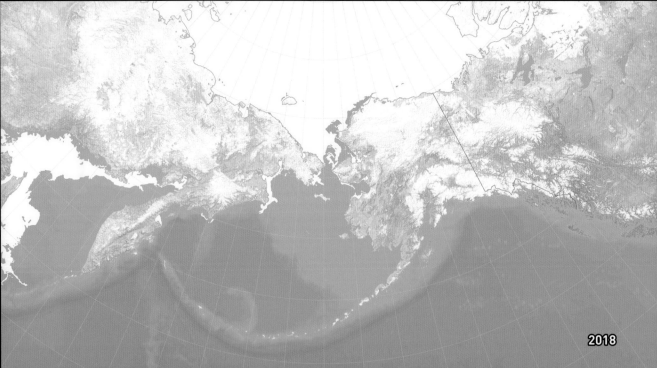

2018

BERING SEA 2013, 2018

In late April, the Bering Sea is normally covered in 679 606 km² (262 397 mi²) of ice – this is approximately the size of France. However, the winter of 2017–2018 was a concern as the lowest volume of ice ever recorded was formed. Written records began in 1850, and for the first time since then, the sea ice in 2018 was about 10 per cent of the normal amount.

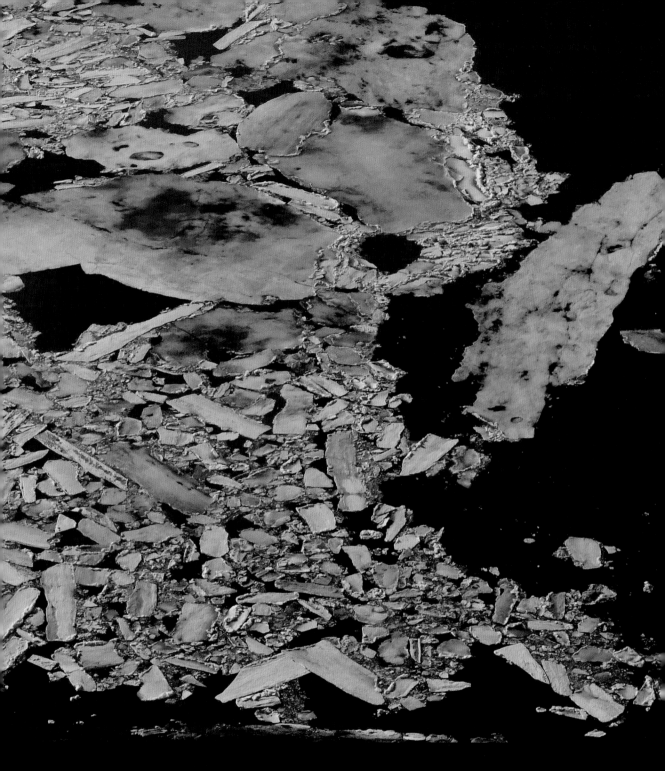

2019

Ice is shown breaking up unusually early here in Quinhagak, Alaska, US. The small village is situated where the Kanektok River flows into the Bering Sea. Temperatures here have been increasing, and as a result, flooding and erosion of the permafrost are becoming serious threats for remote communities like Quinhagak, making the likelihood of remaining here long-term extremely unlikely.

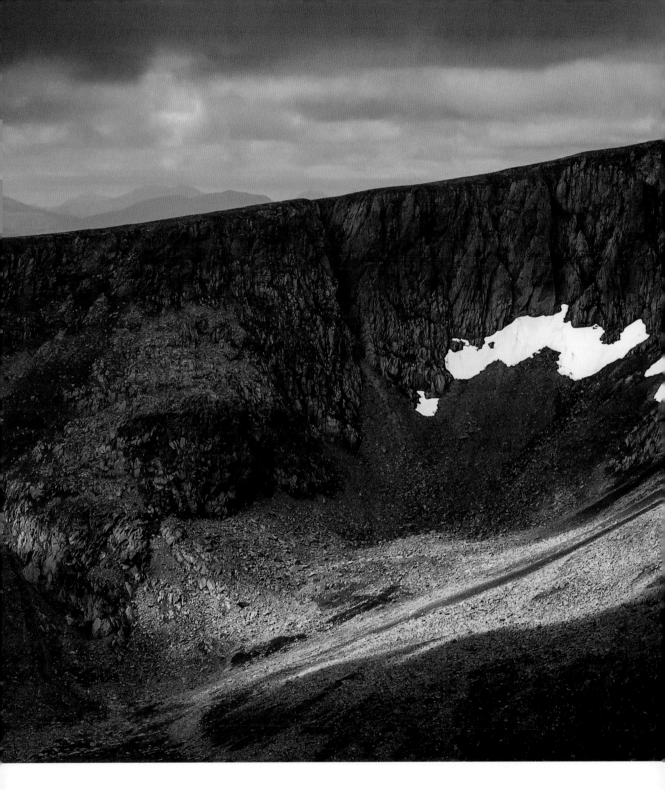

THE SPHINX, CAIRNGORMS, UK 2007

The Sphinx, the UK's most enduring and oldest snow patch, is a pocket of ice in a corrie on the third highest mountain in the UK – Braeriach. Nestled deep in the Scottish Cairngorms, the ice is thought to have melted only eight times over the last three centuries. This image of the famous snow patch was taken in 2007.

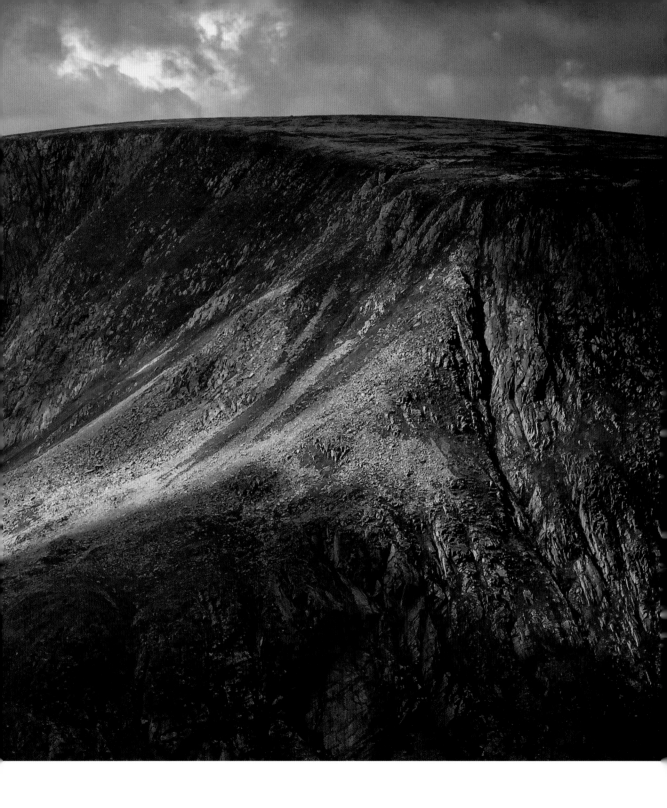

It first melted in 1933 but, latterly, its melting appears to be more frequent, having melted in both 2017 and 2018. Vulnerability to global warming, however, is of course not isolated to the Sphinx. Studies show that despite the Sphinx's survival in 2019, no other snow patches survived beyond the end of May in England and Wales the same year.

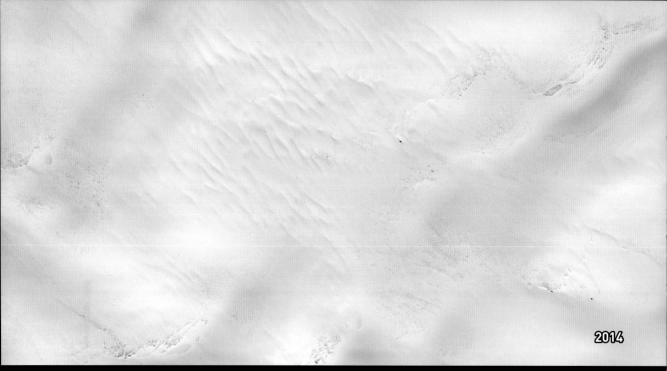

2014

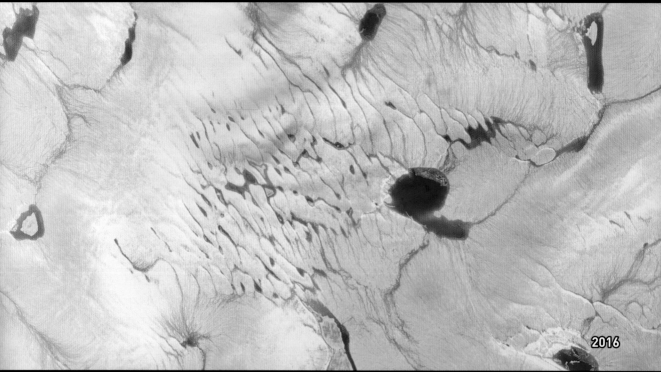

2016

GREENLAND 2014, 2016

Every year, lakes, rivers and meltwater streams are created on the Greenland ice sheet when it begins melting in spring or early summer. However, in 2016 melting began extremely early. Both of these images were taken in the middle of June, but the lower one from 2016 shows that the ice had begun melting much earlier – a sign that the planet is getting warmer.

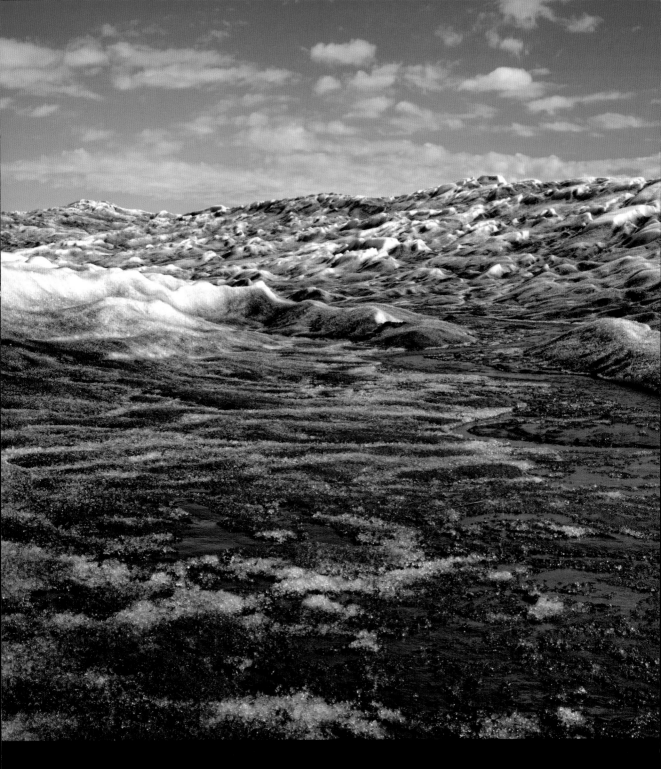

2011

When the ice sheet starts melting, the speed at which the ice continues to melt gets faster. This is because pools of meltwater make the surface of the ice sheet darker, meaning more sunlight is absorbed than by the usual white ice. All of this meltwater then contributes to the rising sea levels.

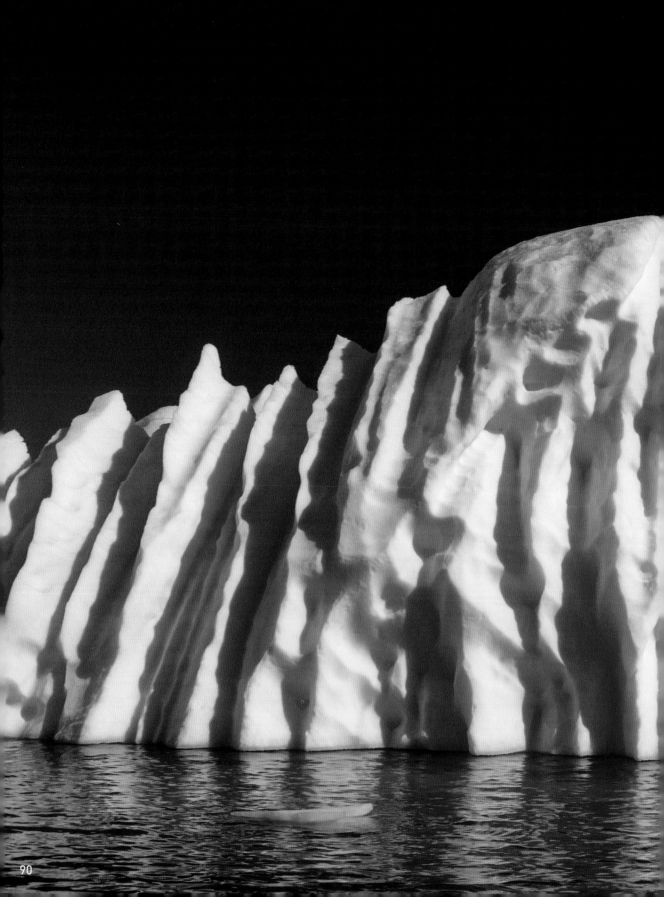

POLAR ICE

permanent and seasonal ice sheets, ice caps and sea ice
in the polar regions of the Arctic and Antarctica

Icebergs in Antarctica

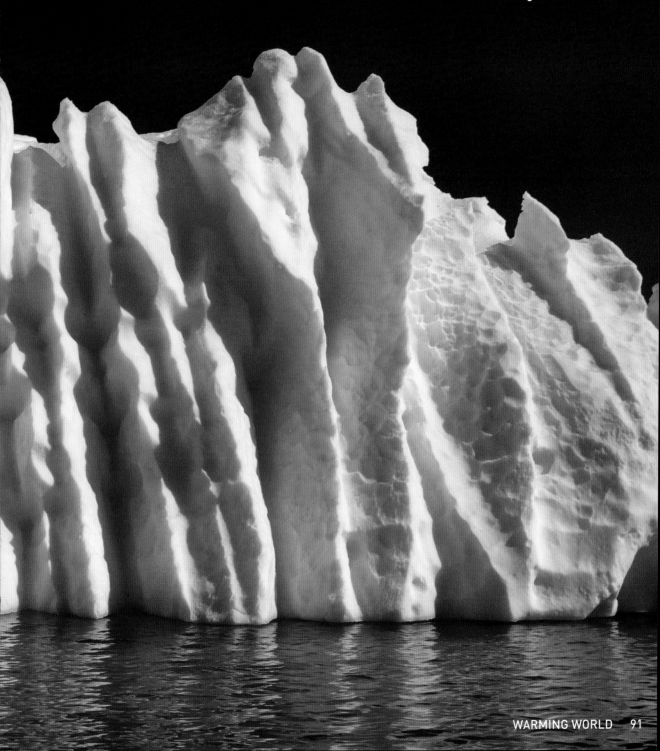

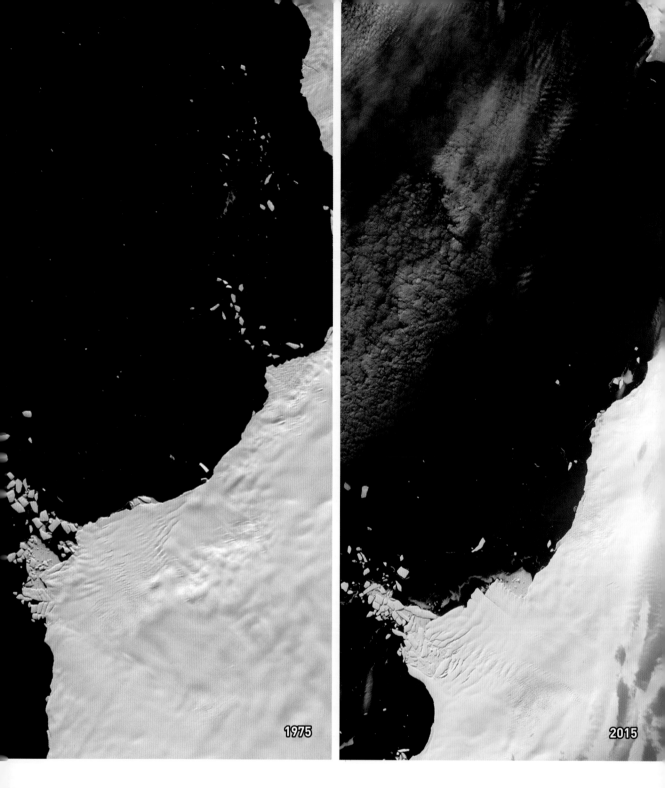

1975

2015

WESTERN ANTARCTICA 1975, 2015

The images above capture the same stretch of coast four decades apart. They show glaciers along the Bellingshausen Sea on the western Antarctic coast have been shrinking for around 40 years because of the warming oceans that lap at the underside of the floating ice.

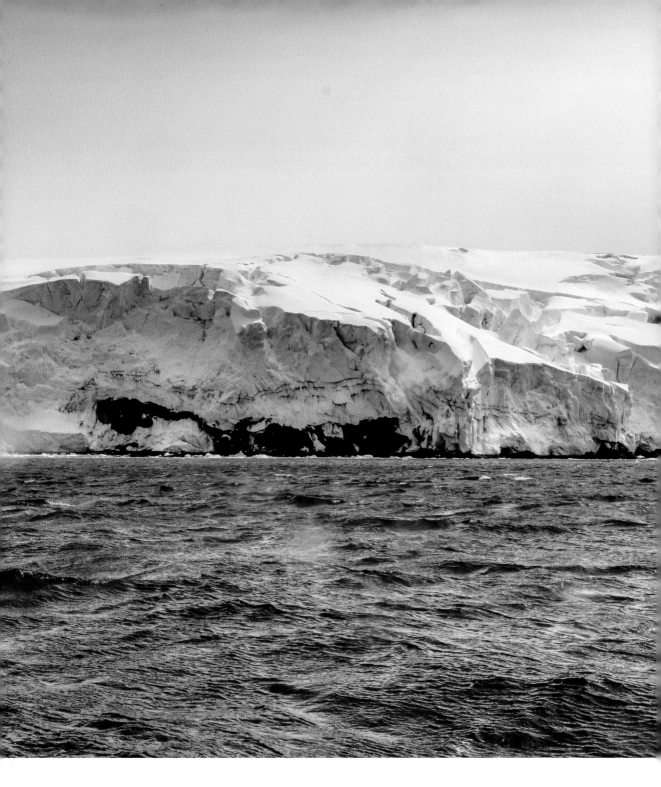

COLLINS GLACIER, KING GEORGE ISLAND, ANTARCTICA 2016

Collins Glacier sits on the coast of King George Island in the Bellingshausen Sea. As a result of rising temperatures, the glacier calves icebergs into the sea on a regular basis (as can be seen in this image), contributing to the rising sea levels.

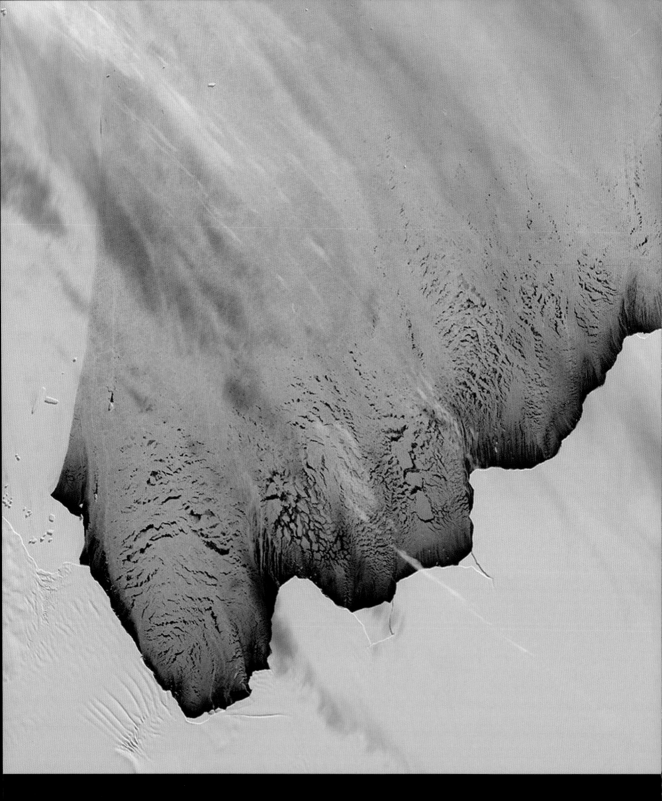

AMERY ICE SHELF, ANTARCTICA SEPTEMBER 2019

This image shows the Amery Ice Shelf before the D28 iceberg broke off and floated into the Southern Ocean. This iceberg was the biggest to calve from the Amery Ice Shelf since the 1960s, indicating the rising temperatures of the oceans.

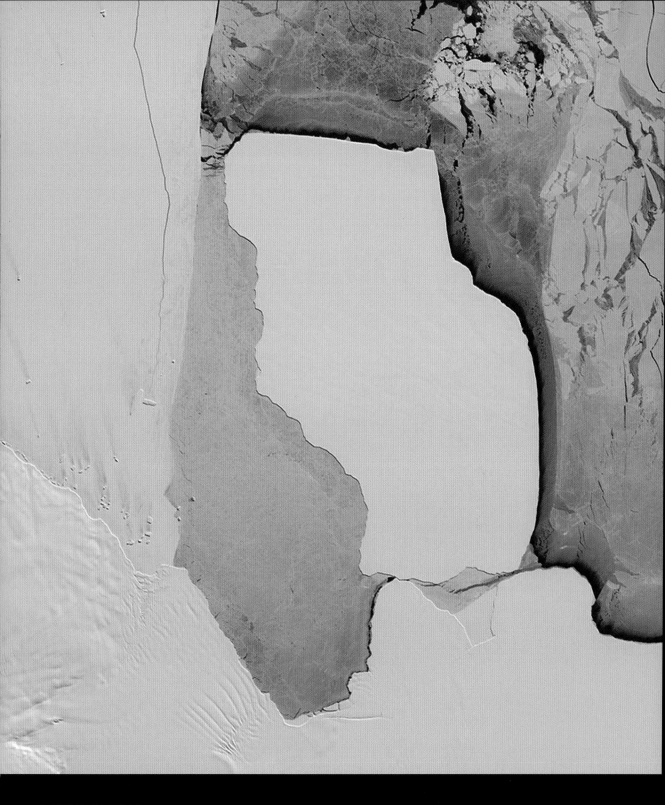

OCTOBER 2019

The Amery Ice Shelf is shown here after the iceberg was calved in late September 2019. The iceberg is thought to be around 315 billion metric tonnes (310 billion tons) and bigger than Greater London.

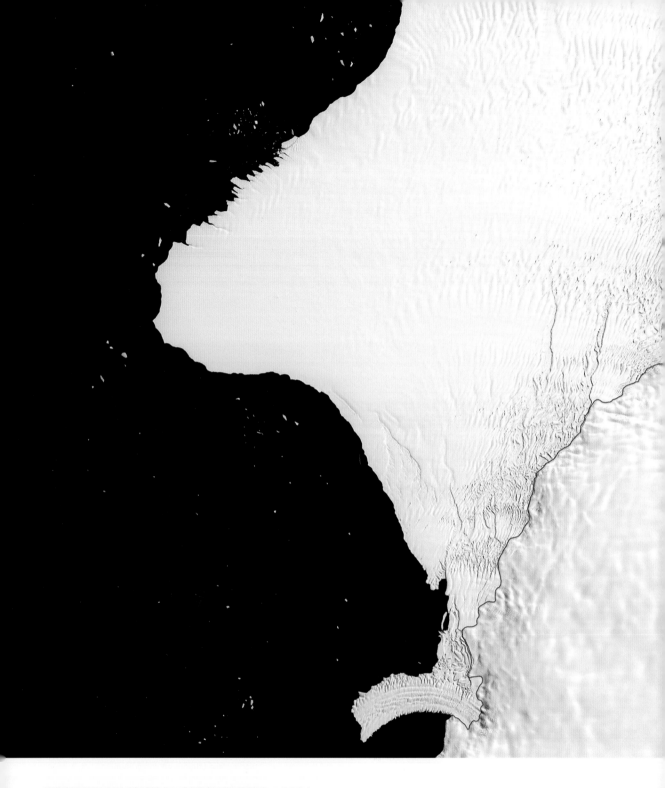

BRUNT ICE SHELF, ANTARCTICA 1986

Both of these images show Antarctica's
Brunt Ice Shelf. They were taken 33 years
apart. There is a dark blue line present in
both shots which indicates where the land

lies below the ice – anything to the left of the
line is floating in the Weddell Sea.

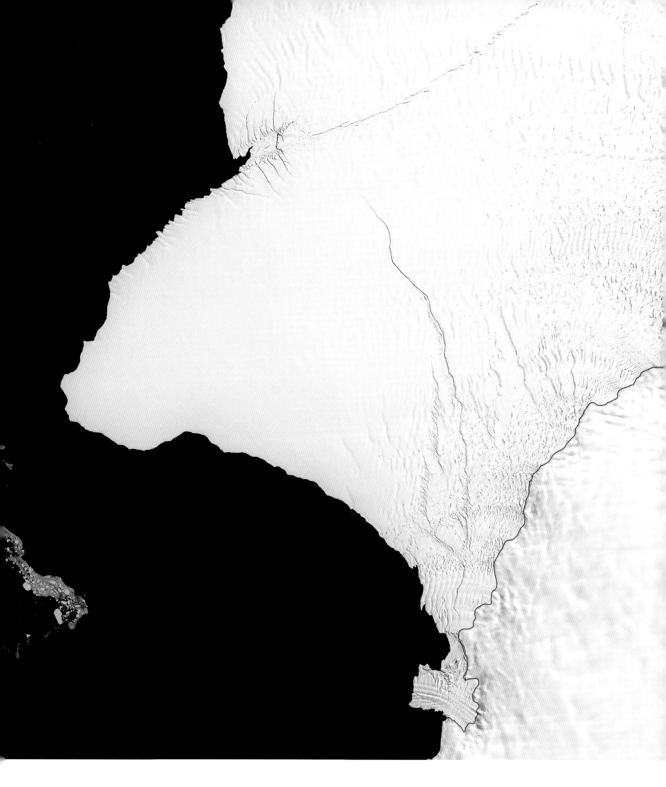

2019

The floating part of the ice shelf has grown substantially where glacial ice has flowed from the land to the sea. Two major cracks are also visible in the 2019 image, and when they meet, the Brunt Ice Shelf will calve an iceberg, which will be roughly twice the size of New York City.

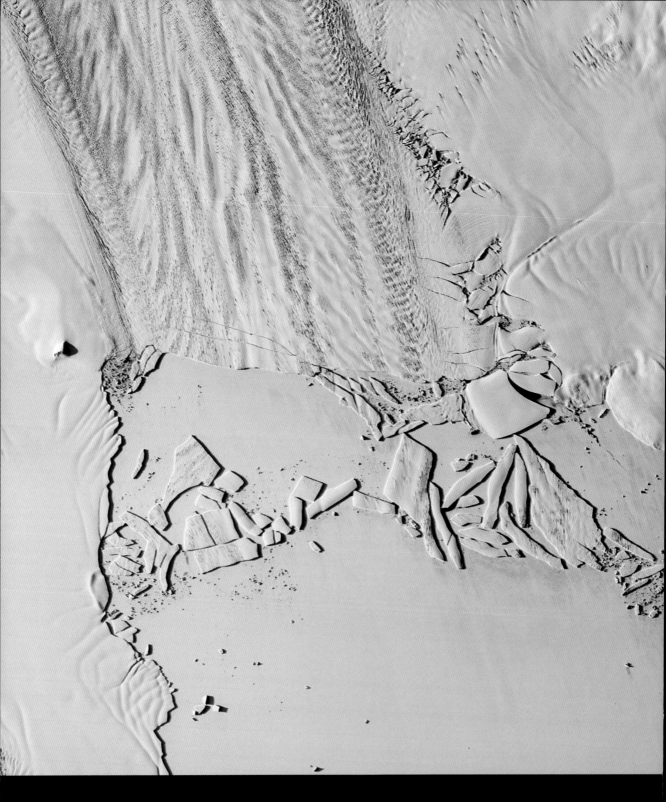

PINE ISLAND GLACIER, ANTARCTICA SEPTEMBER 2018

This is the Pine Island Glacier in Antarctica just weeks before it calved a huge iceberg. In comparison, the image on the right shows the Pine Island Glacier once Iceberg B-46 broke off in late October 2018.

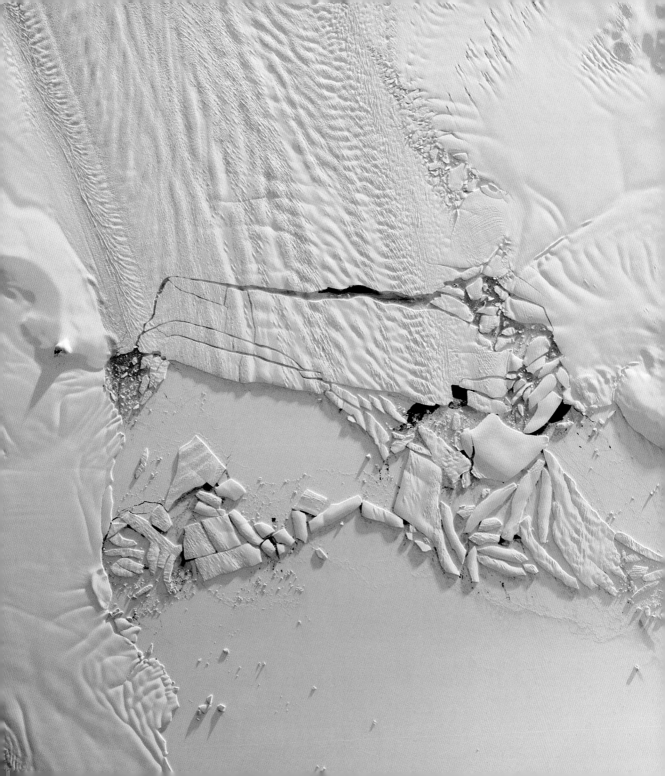

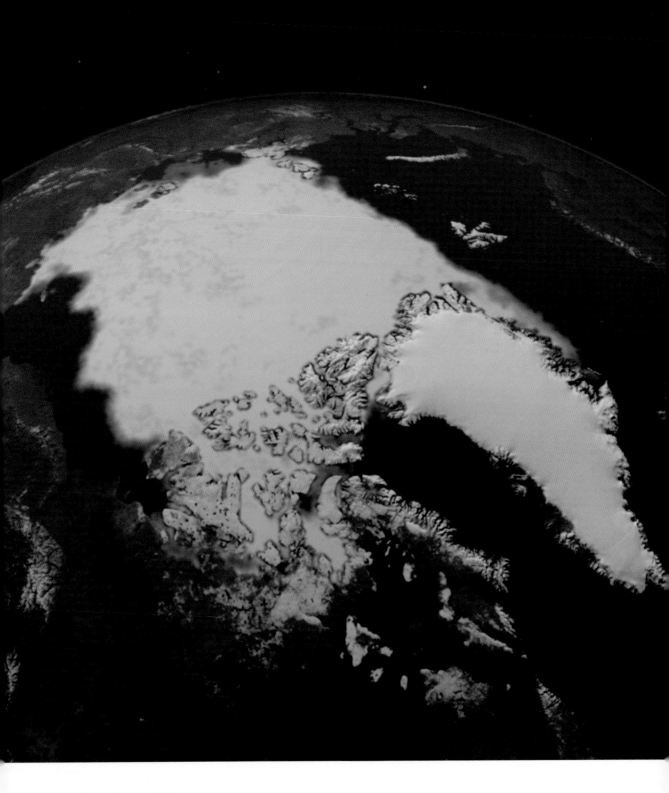

ARCTIC SEA 1984

In the Arctic Ocean, there is an area that is covered in ice during the winter months, which then shrinks over the summer months. In 2012 the minimum coverage hit an all-time low since reliable records began in 1979. The image above shows the minimum ice coverage in the summer of 1984.

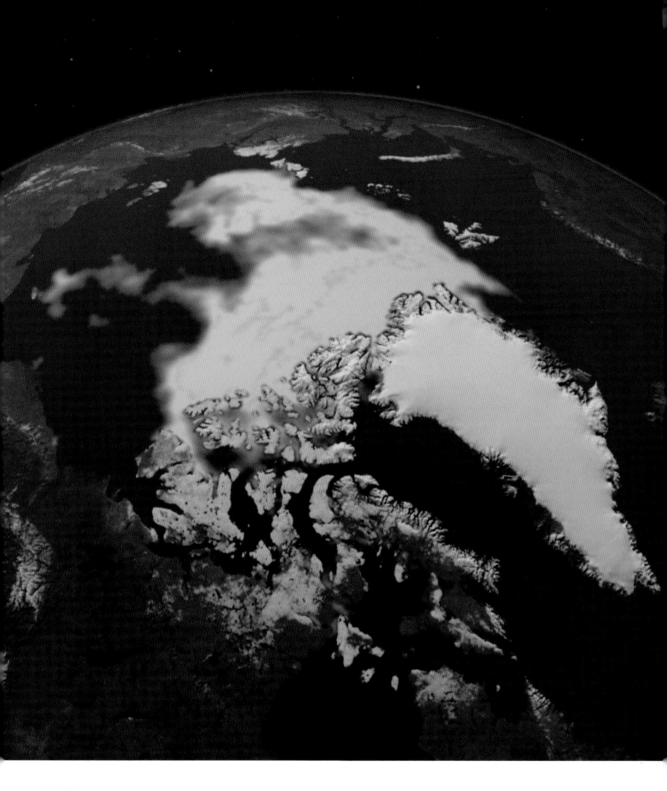

2012

Taken 28 years later, around the same time of year, this image shows the minimum ice coverage as roughly half that of 1984. Scientists believe that it is extremely likely that if the summer sea ice in the Arctic continues to disappear at the current rate, it will have completely disappeared by the middle of the twenty-first century.

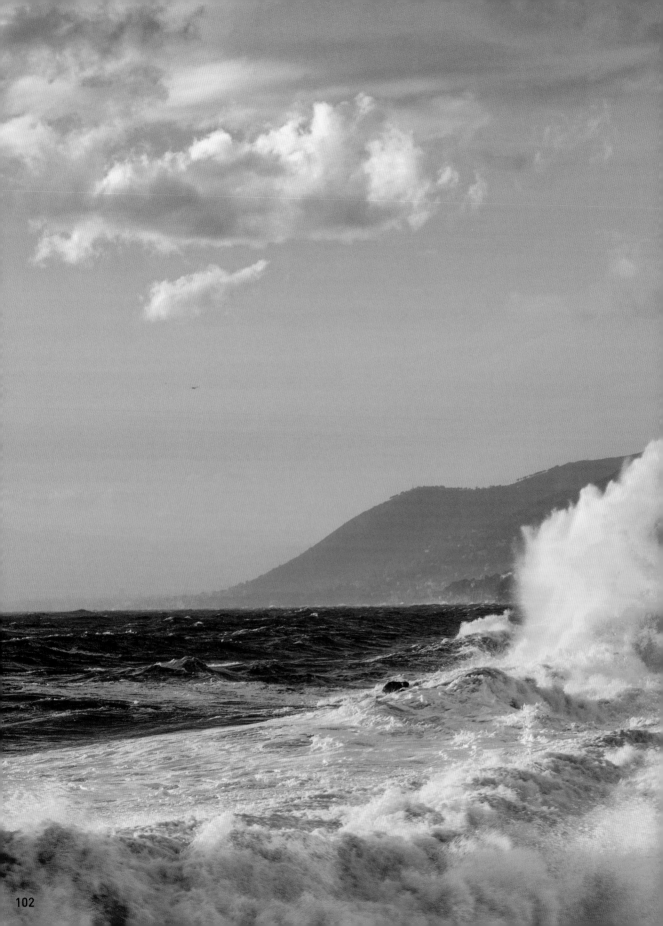

RISING SEA LEVELS

the average height of the level of the surface of the world's oceans
and seas is likely to rise as a result of global warming

Camogli, Italy

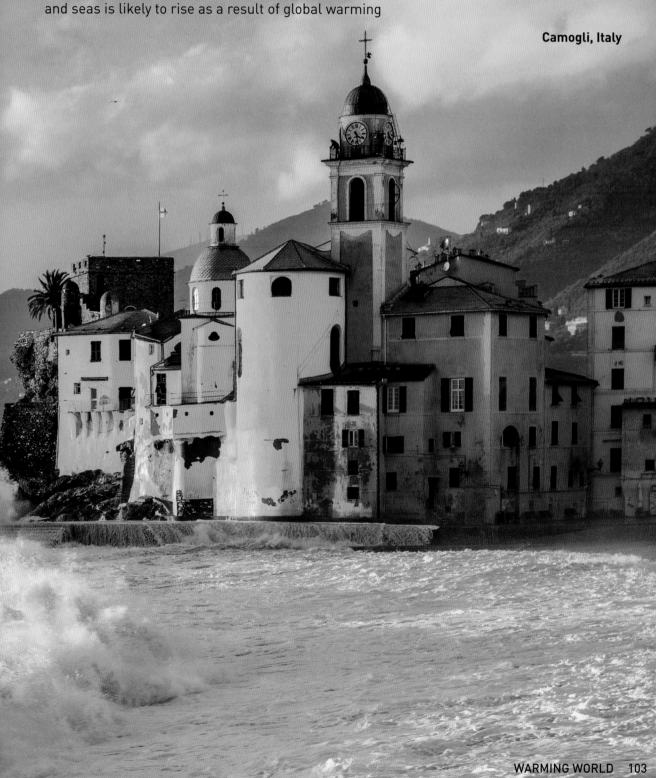

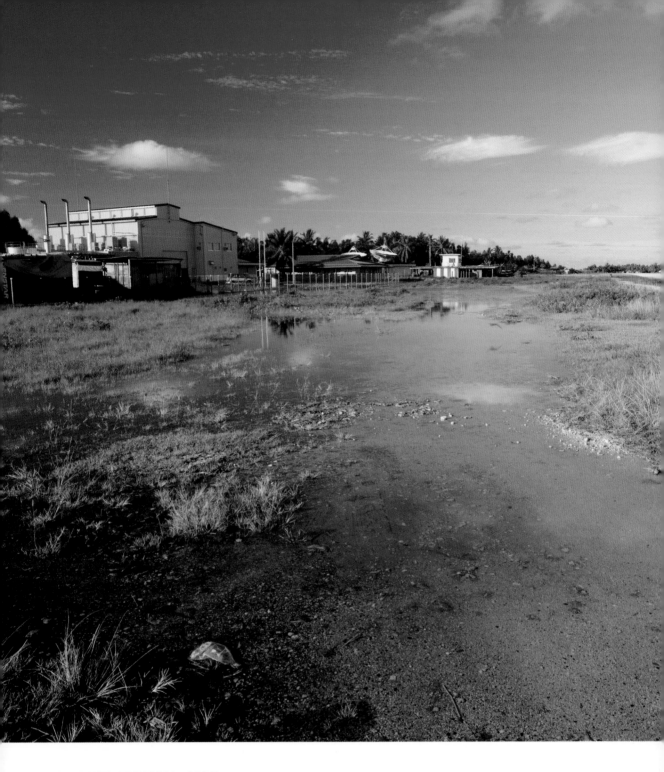

FUNAFUTI, TUVALU 2007

Tuvalu is an island nation in the Pacific Ocean. Its inhabitants live mainly on coral atolls which are very low-lying. Many of its islands are only a few metres above sea level at their highest point. Over recent years the islanders have seen many changes in their fortunes, but the most important issue now to most is that, as the tide comes in, their property is at risk of flooding.

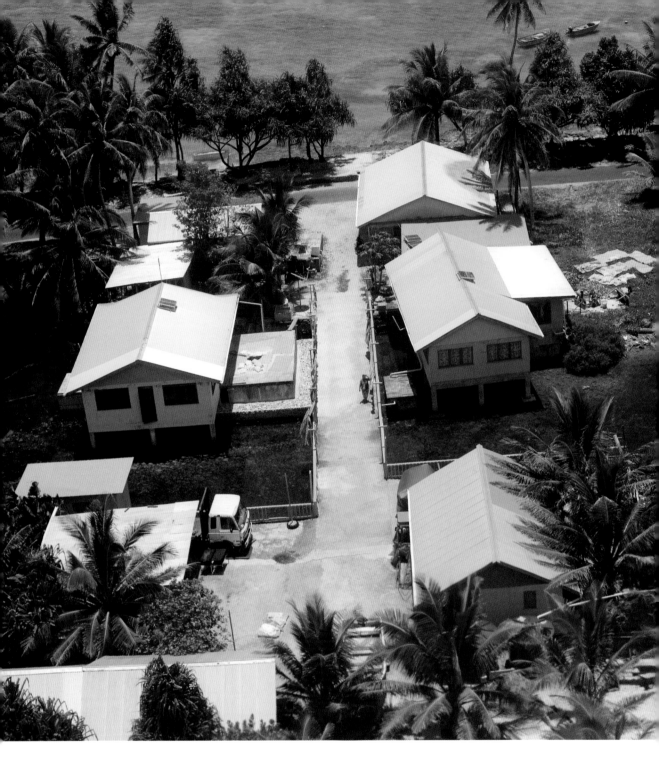

Warming of the oceans has raised sea levels in parts of the Pacific, and certain low-lying island groups such as Tuvalu are now very vulnerable. They face the prospect of losing their national identity as more and more inhabitants are forced to relocate to other countries.

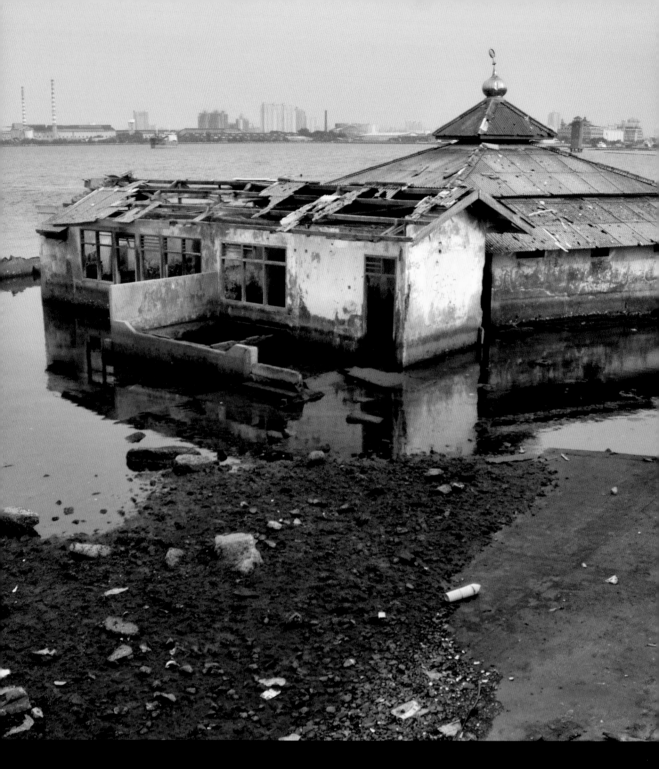

JAKARTA, INDONESIA 2018

Jakarta, Indonesia's capital city, is situated on the northwest coast of the island of Java, in the Java Sea, and it is home to around ten million people. This city, however, is in grave danger. It sits on top of swampy land is constantly battling the rising level of the Java Sea, and it has no fewer than 13 rivers. The threat of submersion means that the government's plans to move the capital away from Jakarta are no surprise.

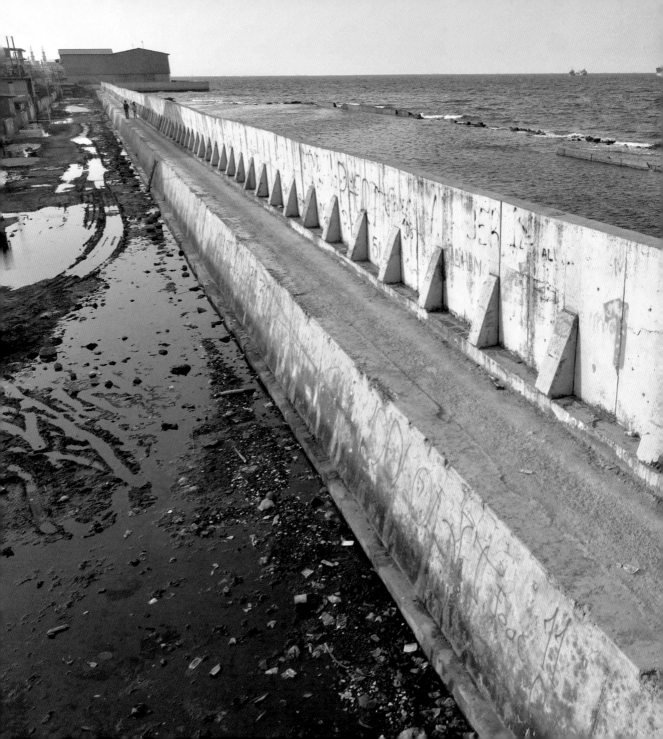

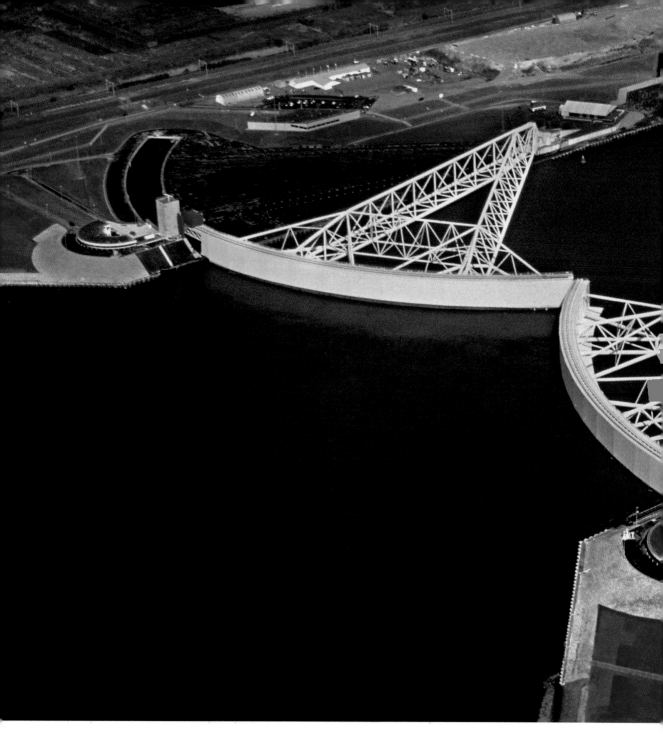

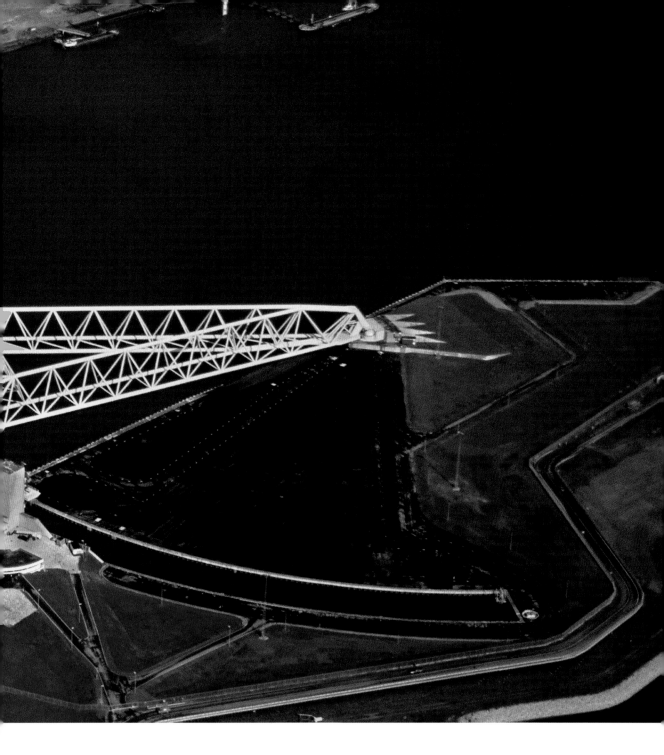

This barrier was not initially included in the Delta Works flood protection programme as the port of Rotterdam needed to be kept accessible. But it was later discovered that the dykes that were proposed were not sufficient to protect the area from flooding, so the Maeslant barrier was built – a moveable storm surge barrier whose doors are floating pontoons that fill with water in the event of a storm surge. The weight of the water causes the doors to sink, turning them into a barrier to defend against floods.

LIKIEP ATOLL, MARSHALL ISLANDS 2001

Likiep Atoll is a coral atoll in the Pacific Ocean's Marshall Islands. It occupies about 10 km^2 (3.9 mi^2) and is home to around 400 people. It is also the site of the highest point on the Marshall Islands – a knoll that stands

surprise, therefore, that this atoll, and the Marshall Islands as a whole, are extremely vulnerable to rising sea levels as a result of global warming. The homes behind the line of trees above are about to be inundated by

MAJURO AIRPORT, MARSHALL ISLANDS 2007

Majuro is the capital city of the Marshall
Islands and is located on the Ratak chain of
islands. Majuro has an international airport,
a port, shopping area and hotels, but despite
being significantly more developed than
other areas of the Marshall Islands, it still
has some incredibly narrow land masses,
and its highest point sits less than 3 m (10 ft)
above sea level. The sea is getting close to
the airport's runway despite being separated
by a sea wall, and it has, on occasion, had to
temporarily close on account of flooding.

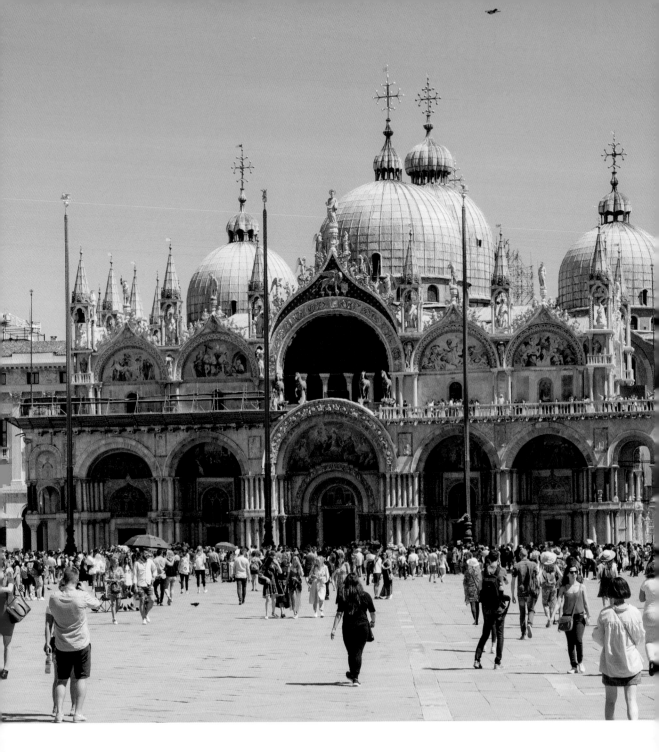

VENICE, ITALY 2018

The city of Venice covers 117 islands in the saltwater Venetian Lagoon. The buildings are constructed on closely spaced wooden piles with the foundations of the brick or stone buildings on top. Today the city is one of the top tourist destinations in the world.

Among its main sights is St Mark's Basilica, one of the best known examples of Byzantine architecture, which was built in 1071 and is now the cathedral church of the Roman Catholic Archdiocese of Venice.

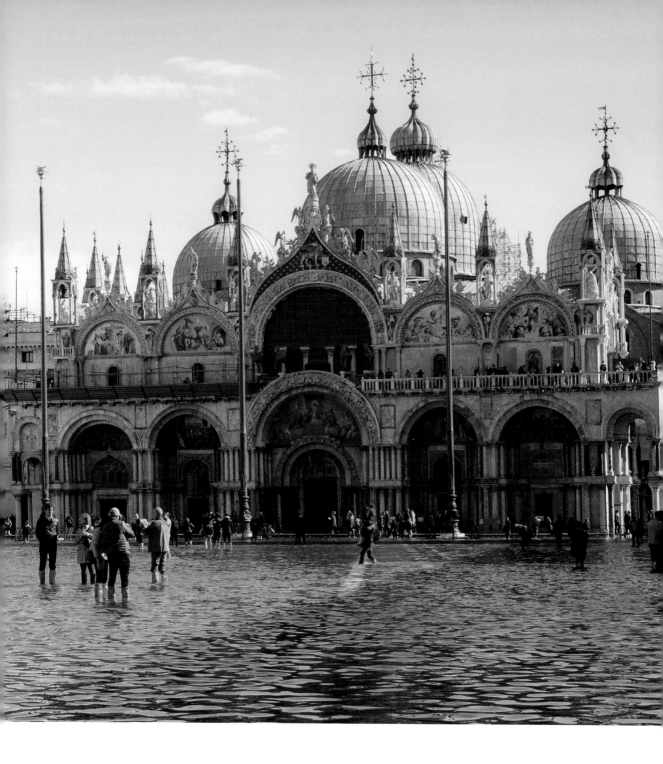

In winter Venice experiences a few exceptional tides, the 'acqua alta'. This is due to a combination of factors such as astronomical tide, strong south winds, some subsidence of the city over time and the Adriatic 'seiche' wave movement.

Lower-lying parts of the city such as St Mark's Square are most often affected, but only for a few hours until the tide ebbs. Visitors make use of the 'passarelle' walkway to visit the basilica when this happens.

ADVANCING DESERTS

the encroachment of desert conditions into settlements or agricultural
areas as a result of climate change or bad farming practices

Namib Desert, Namibia

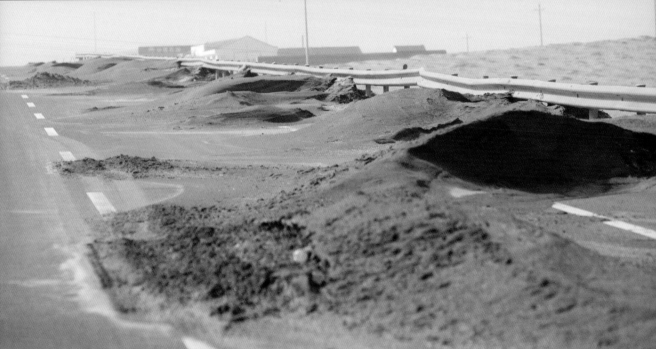

INNER MONGOLIA, CHINA 2009

Inner Mongolia is China's third largest province, and much of this autonomous region sits in the Gobi Desert. The Gobi Desert is growing at rapid rate through desertification, and every year around 3600 km² (1390 mi²) of grassland falls prey to the desert sands. The rise of global temperatures is only serving to exacerbate the situation and more and more land is becoming dry and infertile.

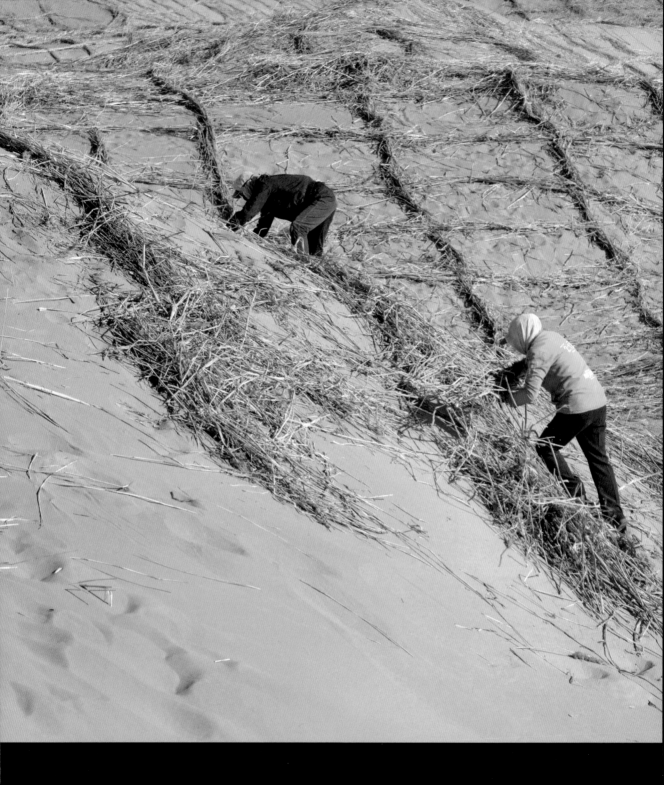

Initiatives to reduce the encroachment of the desert have been set up in areas of Inner Mongolia that are threatened by the advancing Gobi Desert. Paving sand barriers like in the photo above prepares the land for the establishment of plants that thrive in sandy soils. In turn, in the future, these plants will act as a protective barrier against the sands blown in from the desert.

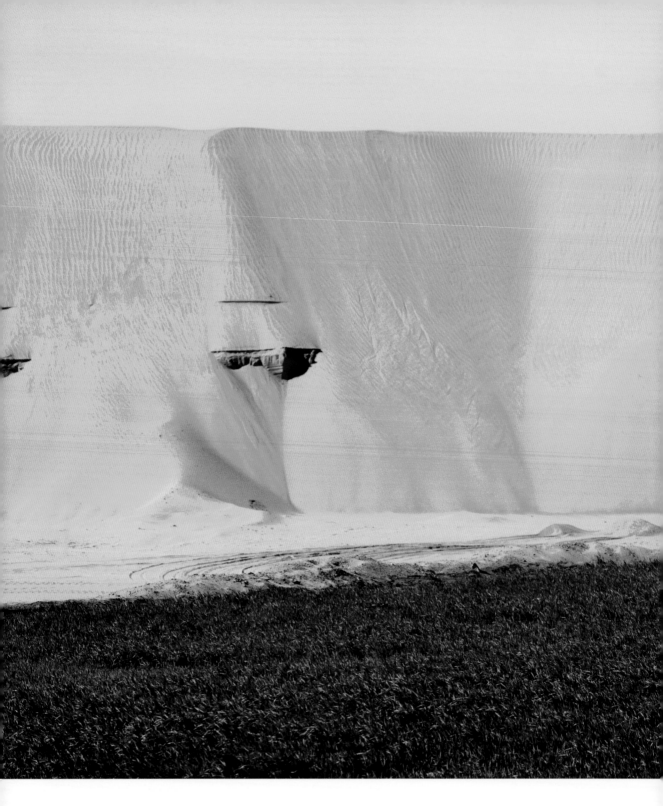

DAKHLA OASIS, EGYPT 2010

Many parts of the world, on the delicate fringes between fertile and arid regions, are at risk from advancing deserts. The Dakhla Oasis, in central Egypt, is home to around 14 fertile hamlets fed by springs.

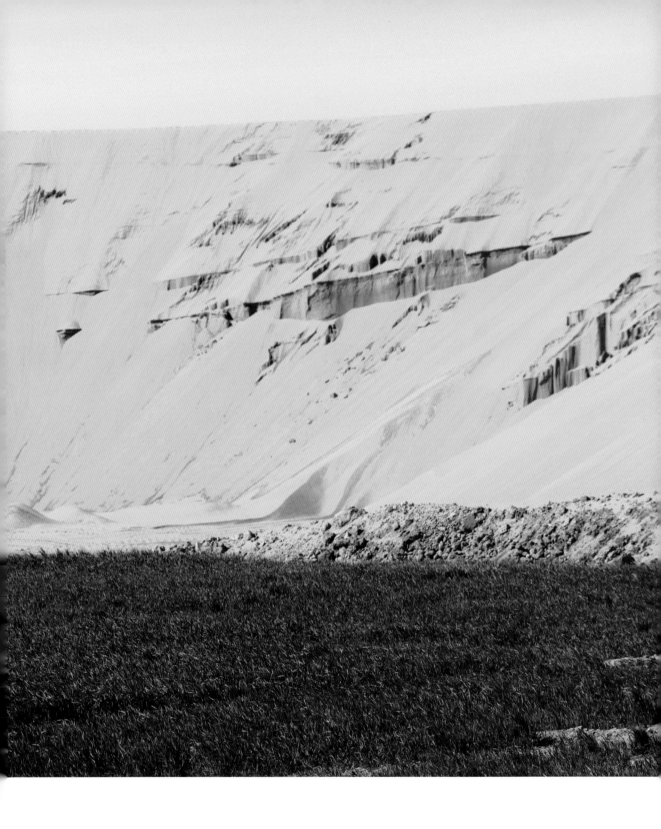

Outside the oasis, the land is scorched, rocky and arid, making it unable to support conventional farming methods. Fertile cropland is shown here, but with the threat of the ever-nearing dunes of the Sahara Desert in the background.

MOROCCO

Sand blown in from the desert can lead to the advancement of the Sahara in surrounding areas. The photos here show communities working together to prevent the ongoing threat of desertification.

On the left, palm leaf squares are being used to help stop the Saharan sands creeping into a nearby oasis. On the right, plants that can survive the arid conditions on the edge of the desert are planted to hold back the encroaching desert.

BASRA, IRAQ

Basra, in Iraq, used to have a similar climate to southern Europe. Its Shatt al-Arab River helped maintain vast areas of marshland and sustained millions of palm trees, which provided an income for many from the cultivation and sale of dates.

But now, as a result of climate change, years of war, oil exploration forcing farmers off their land, and salty water making its way back inland because of an increased number of dams, most of Iraq's marshland and fertile land has turned to desert.

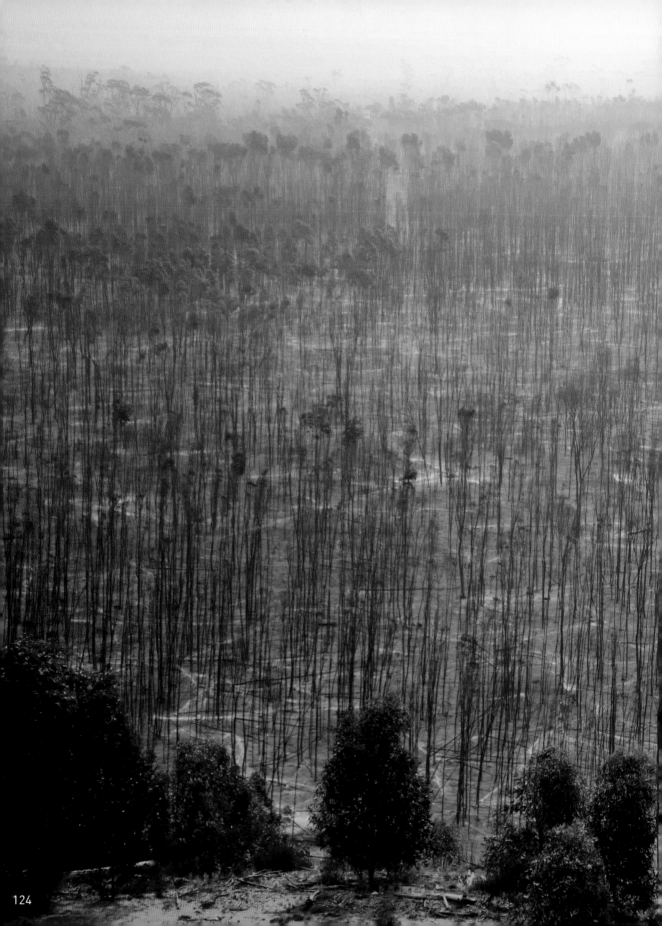

WILDFIRE

destructive fire that spreads rapidly across a range of habitats,
usually as a result of prolonged periods of dry weather

Bushfire devastation, Australia

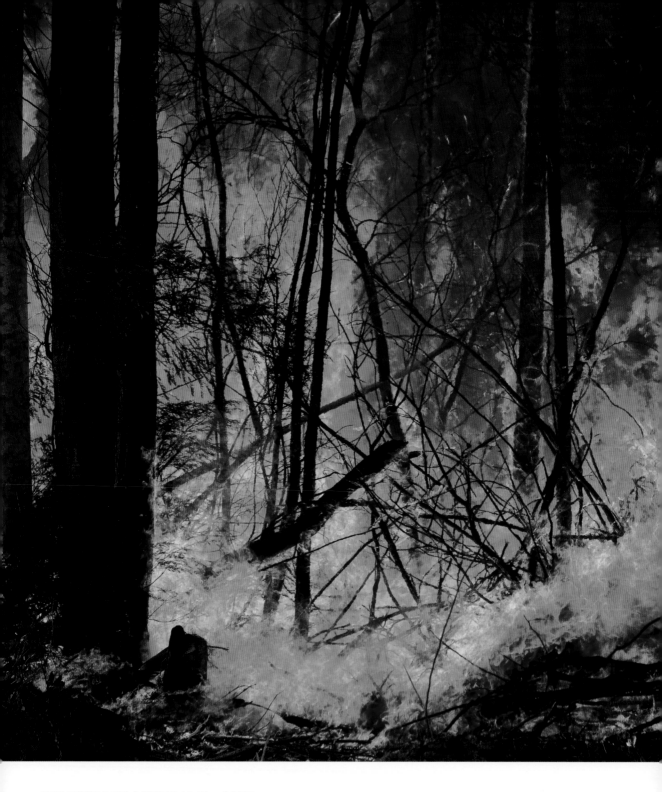

SOUTHEAST AUSTRALIA 2020

Record-breaking temperatures and a long period of severe drought caused huge bushfires across much of Australia in 2019 and 2020. As a result, more than 126 000 km² (48 649 mi²) of land – bush, forest and park – have been burnt and destroyed.

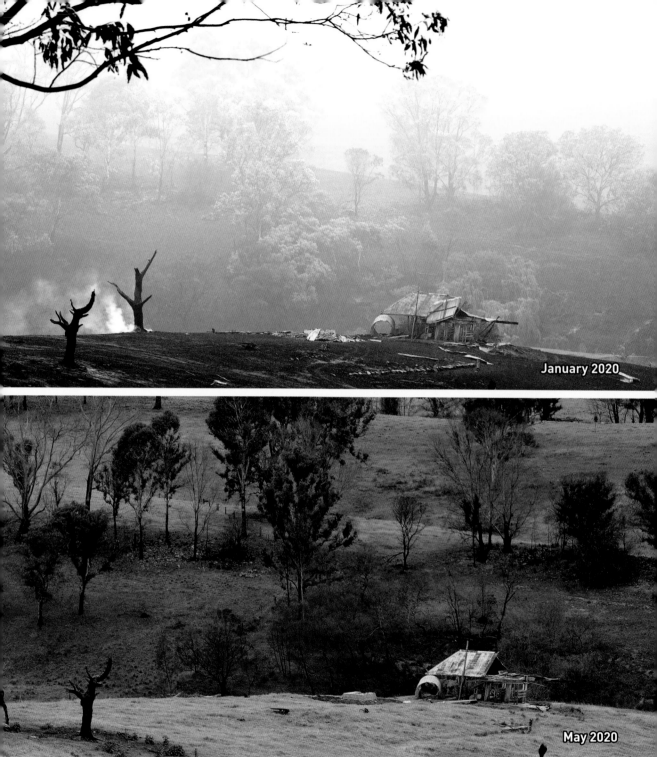

January 2020

May 2020

The first photo above was taken on 6 January 2020 in Quaama, New South Wales, while the bushfire was still smouldering. Smoke can be seen rising near the charred trees and the fire has destroyed the building on the right. The bottom photo was taken four months later at the same location and shows the landscape on the slow road to recovery.

WOLLEMI NATIONAL PARK, AUSTRALIA 24 JULY 2019

A protected area in the Blue Mountains and
Lower Hunter regions of New South Wales
in eastern Australia, Wollemi National Park

is home to a huge variety of plants and
animals, including red-necked wallabies,
broad-headed snakes and Wollemi pines.

31 DECEMBER 2019

The park lost more than 5000 km^2 (1931 mi^2) of land to the fires (above). Special teams of firefighters, however, managed to save the only known natural stand of Wollemi pines – fossilised remains show that these trees existed up to 200 million years ago.

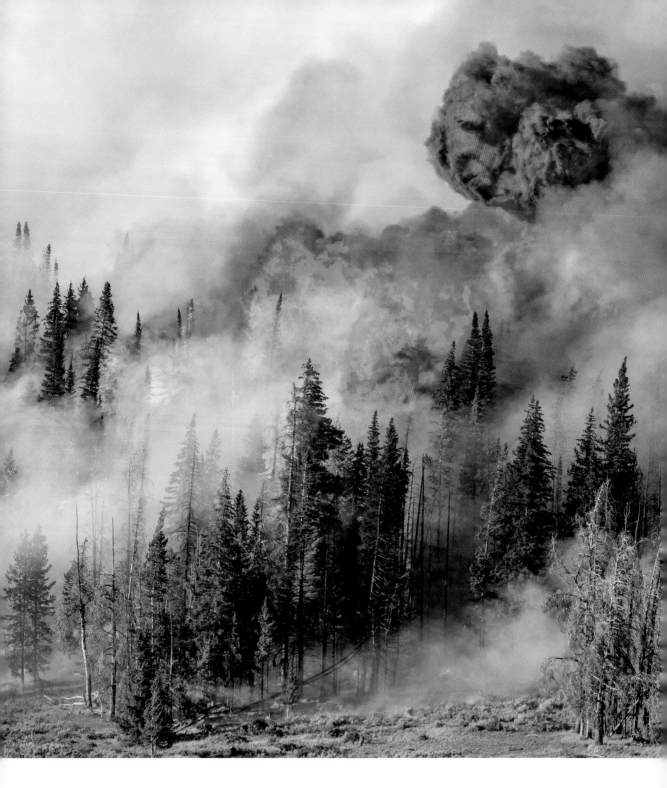

SHOSHONE NATIONAL FOREST, WYOMING, US 31 JULY 2016

In mid-July 2016, 50 km² (19 mi²) of land were lost to the Lava Mountain fire in Wyoming's Shoshone National Forest in the US. The fire started from a lightning strike and grew steadily, but not at an alarming rate, for the first two weeks, but when the temperatures and winds increased, the fire's rate of spread picked up considerably.

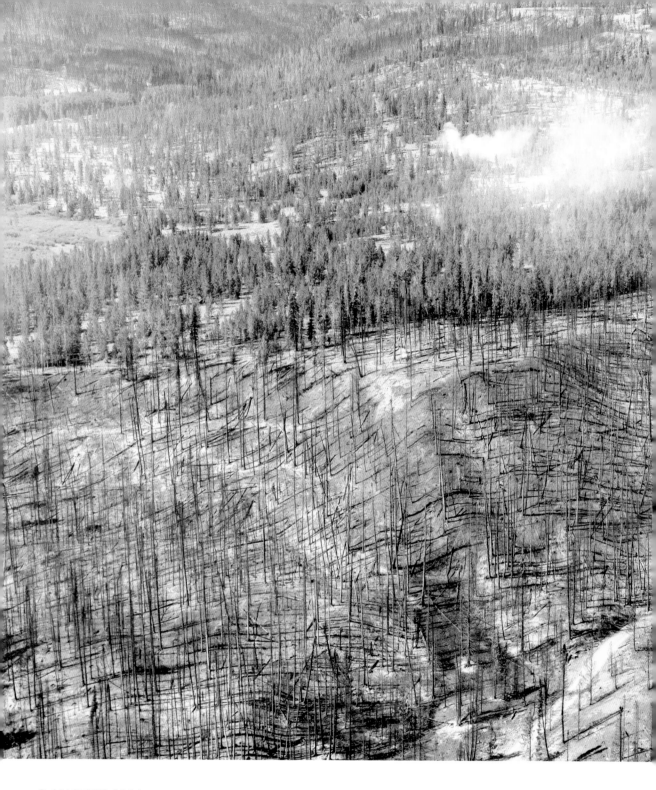

2 AUGUST 2016

As a result of a change in weather only serving to fuel the fire, nearby areas were instructed to evacuate. While residents were hoping for rain and thunderstorms to arrive to help extinguish the fires, lightning strikes in the already extremely dry area were feared likely to ignite new fires.

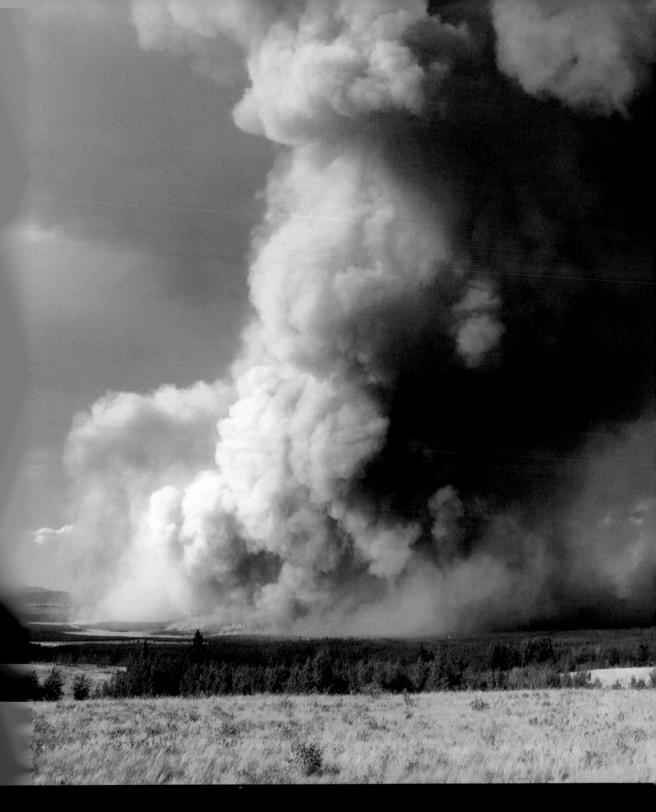

YELLOWSTONE NATIONAL PARK, WYOMING, US 2016

Yellowstone National Park spans three western US states: Wyoming, Montana (3475 mi²). In 2016, 22 fires were ignited by humans and by lightning strikes.

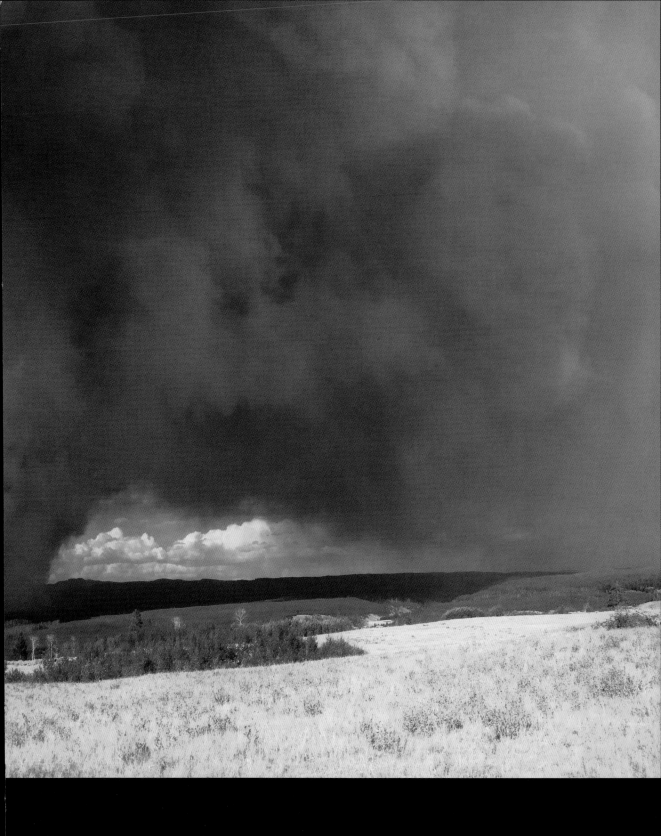

They ravaged the forests of the national park, destroying more than 250 km² (97 mi²) of land. This was the second biggest area of fire damage in the park's history. In 1988, over 3230 km² (1250 mi²) of forest were burned to the ground.

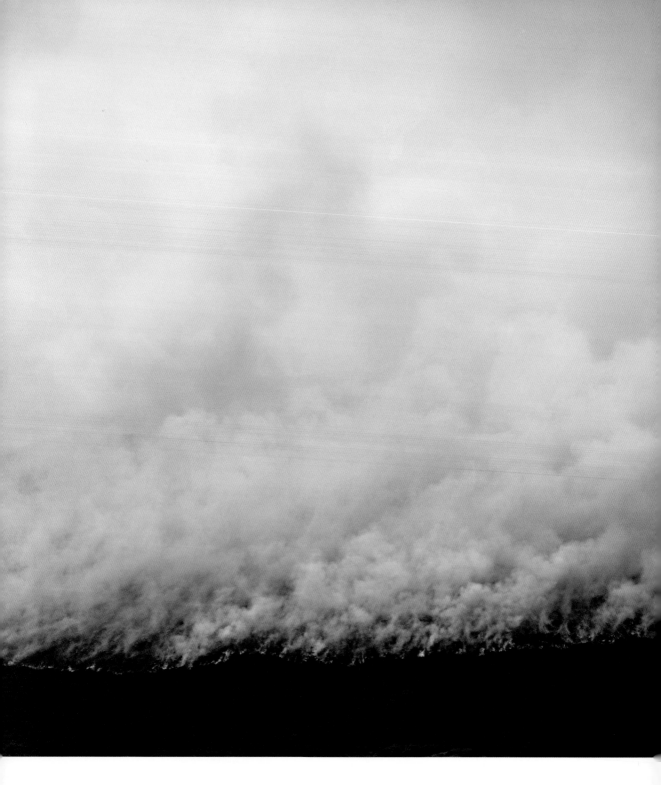

LLANTYSILIO MOUNTAIN, WALES 2018

For 40 days in July and August 2018,
the Welsh Llantysilio Mountain fire, in
Denbighshire, ravaged the area's gorse and
moorland. At one point, fire officers thought
that it had been extinguished, but it started
again after continuing to burn underground.
It is thought that sustained periods of dry
and hot weather were to blame for the fire.

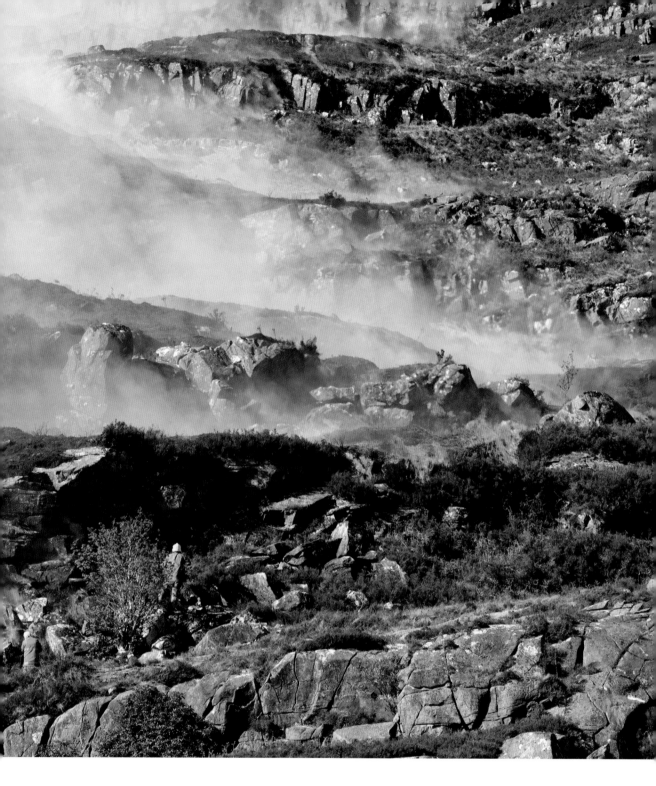

TORRIDON HILL, SCOTLAND 2011

Dry, warm weather also caused the Torridon Hill fire that devastated around 23 km² (9 mi²) of land before it was brought under control by 150 officers. In the Scottish Highlands in 2018, there were four times as many wildfires as in 2017 after more prolonged periods without rainfall, and unusually hot weather.

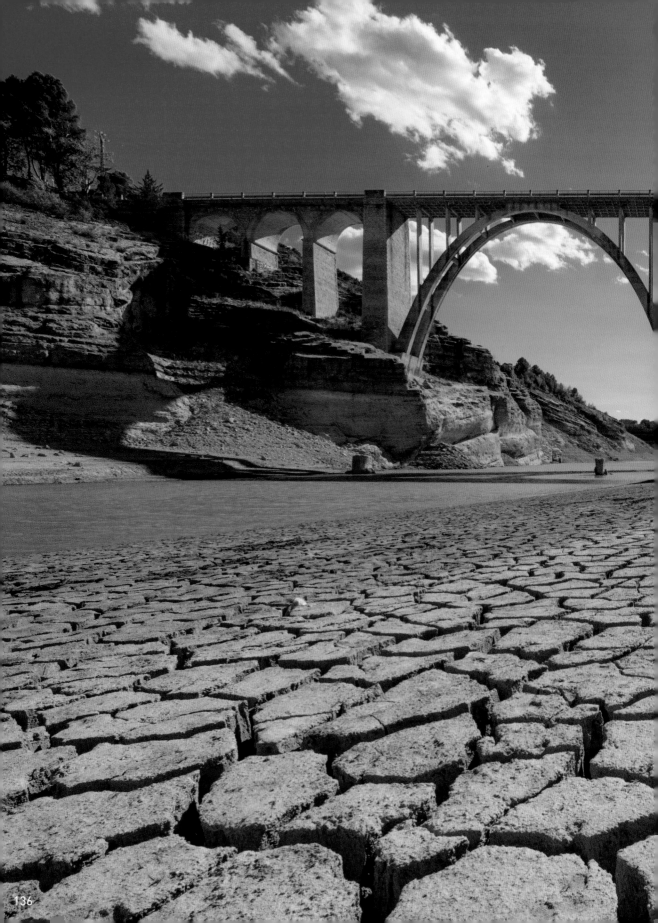

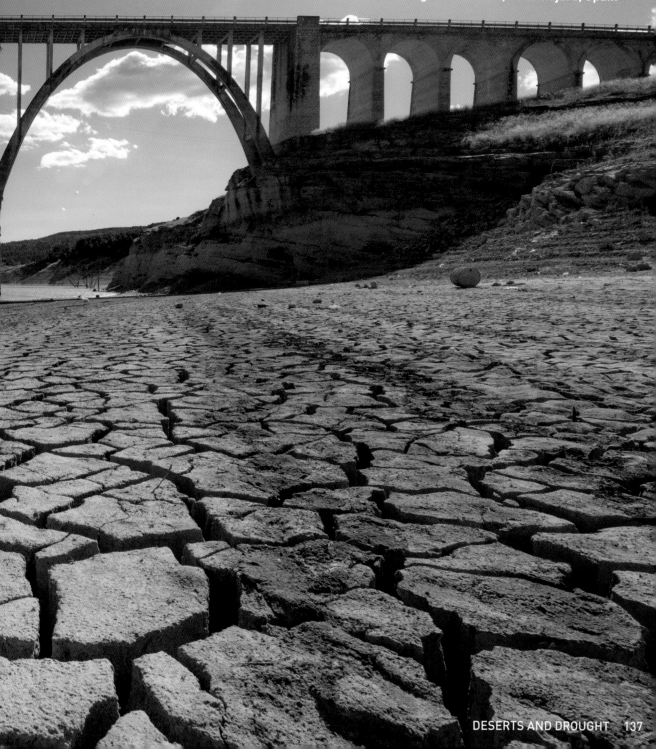

DROUGHT

prolonged period of dry weather leading to water shortages,
loss of crops and an increased risk of fire

Drought conditions, Guadalajara, Spain

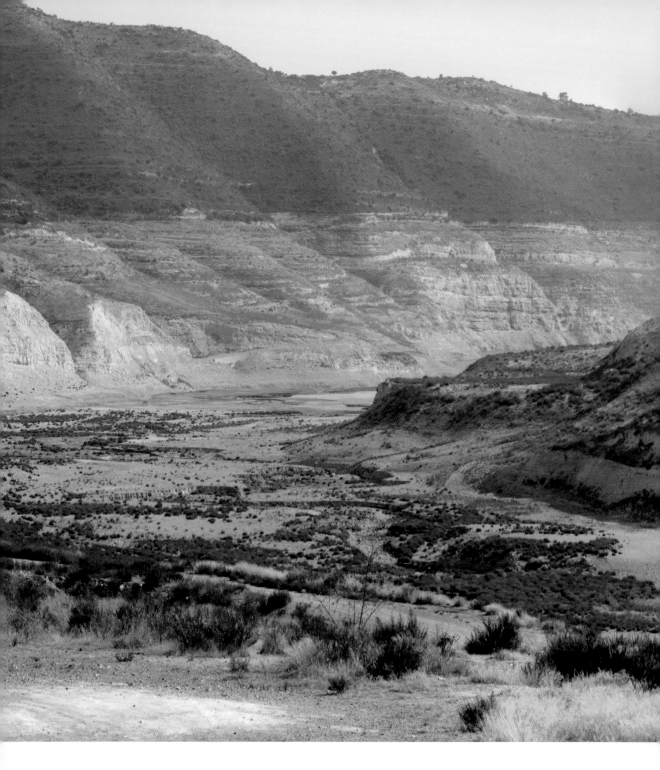

ALASSA, CYPRUS 2008

In recent years, the Mediterranean region has witnessed extreme drought. In particular, the Levant region in the eastern Mediterranean has suffered to the extreme. The drought period from 1998 to 2012 was the worst in over 900 years. Drought and heatwaves threaten farmers' crops and herds all over the region, and create serious concern for water supplies.

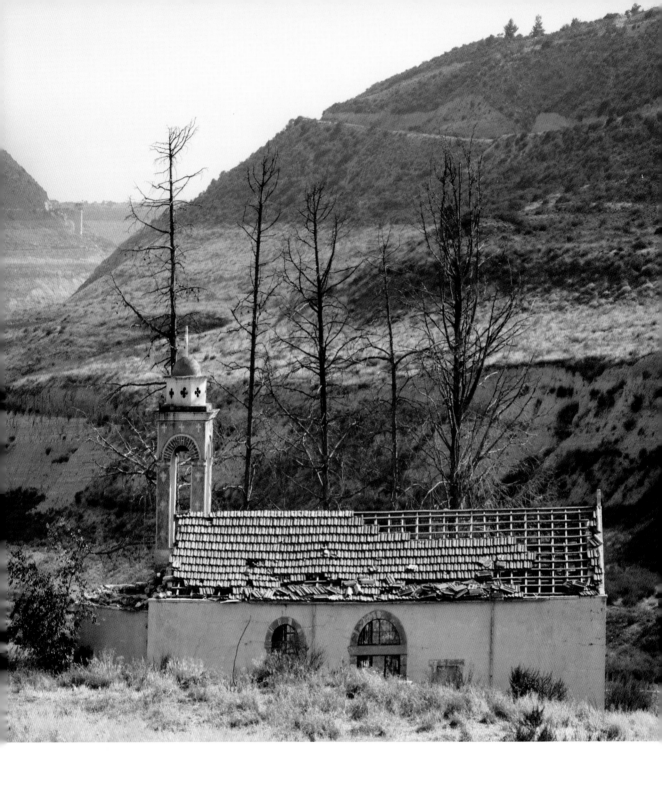

The Alassa church above had to be relocated when the Kouris Dam and reservoir were created in 1989. Normally, when the reservoir is full, only the spire of the church is visible, but in times of persistent drought, like in the case above in 2008, the old church can be seen above water in its entirety.

SOUTHERN ALPS, NEW ZEALAND 2014

In this first image, taken in December 2014, the snow and ice in New Zealand's Southern Alps can be clearly seen across the glacier tops. This is a typical view of the area at this time of year.

2019

In November 2019, shown above, the snow and ice can still be seen, but coloured with a brown tinge. This is probably dust and ash blown in from Australia and, while this is not uncommon, it began exceptionally early in 2019 due to the extreme heat and dryness.

NORTHWESTERN EUROPE 2017

During July 2018 countries in northwestern Europe – in particular Denmark and Germany – turned barren and brown, in comparison to their usual lush green landscapes, due to record-breaking high temperatures and very low levels of precipitation. Experts estimated that the affected areas took only a month to turn brown.

2018

It came in a year in which Germany experienced drought conditions for much of summer, beginning in May, and the UK witnessed its driest June and early July on record. Researchers say that global temperatures have shown a steep and constant warming trend over the years, and extreme heatwaves are becoming more and more regular.

AUSTRALIA 2019

Drought affects both humans and animals. Australian droughts result in waterholes

drying up, with wild animals forced to seek out any available water

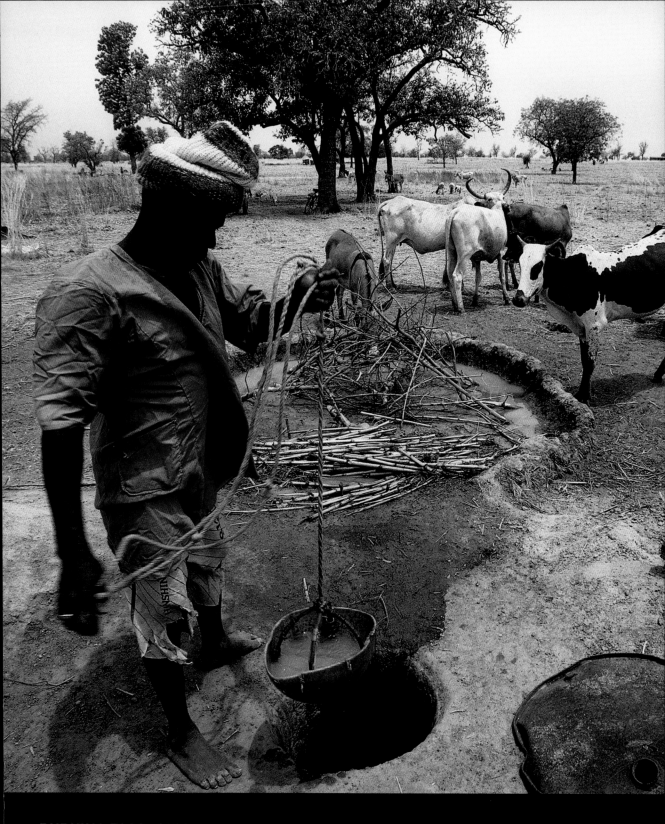

BURKINA FASO 2016

In Burkina Faso, the lowering of the water table due to drought necessitates the deepening of wells to collect enough water to sustain communities.

DRYING LAKES AND RIVERS

reduction in the size of lakes and river flow rates due to climate change or the extraction of water for agriculture or industry

Dry riverbed in New Mexico

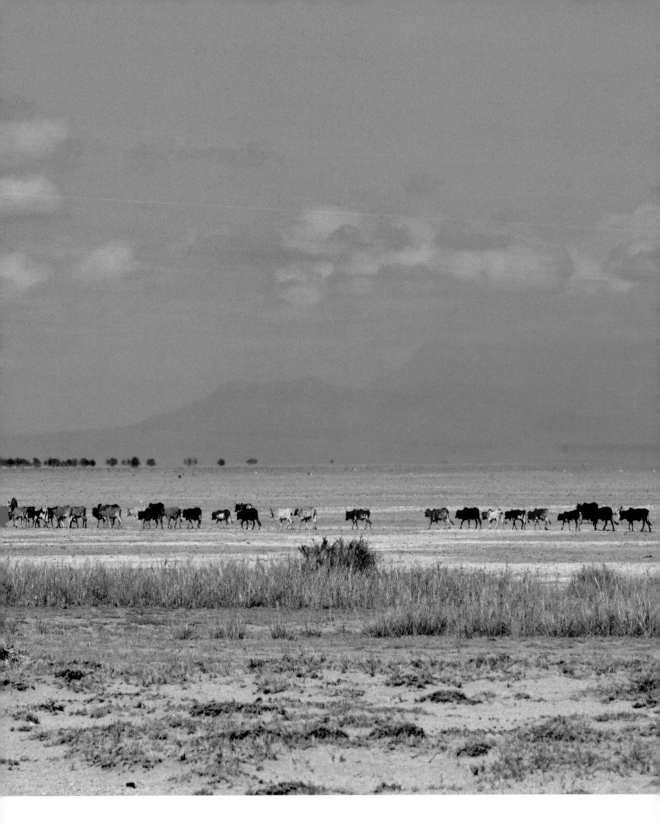

AMBOSELI LAKE, KENYA 2008

Kenya's Amboseli National Park was
named after its main lake – Amboseli Lake.

Normally, the lake takes the form of
an expanse of volcanic soil.

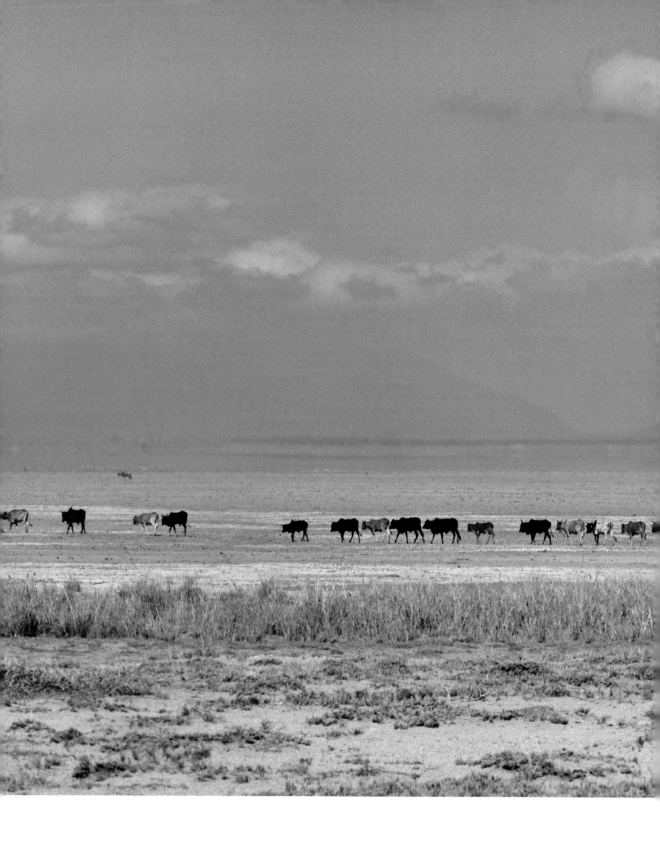

Apart from in periods of heavy rainfall, it is a dry and extremely dusty lake bed, but even when it does resemble a lake, it is rarely more than around 0.6 m (2 ft) deep.

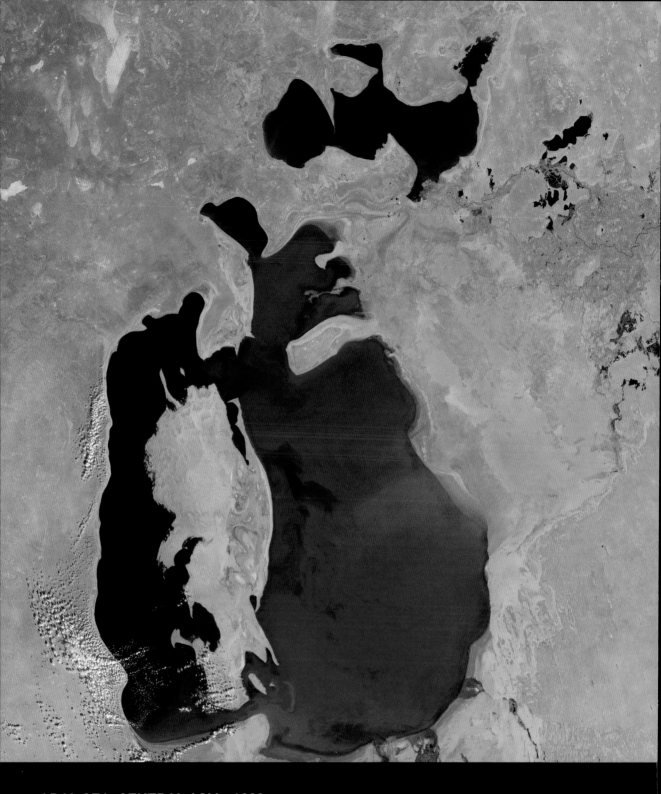

ARAL SEA, CENTRAL ASIA 1998

The Aral Sea was once the world's fourth-largest lake. Today, due to climate change and the diversion of water from its feeder rivers for irrigation, it is much smaller.

Steps have been taken to preserve the northern part by constructing a dam, but the southern part has been abandoned to its fate.

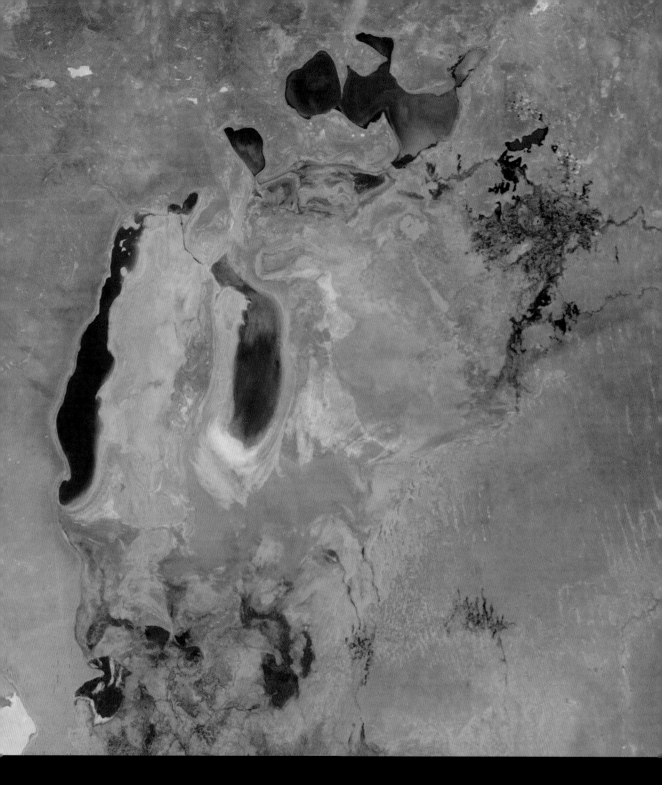

2018

The local fishing industry on the Aral Sea has been devastated by the lake's shrinkage and the local population has developed health problems due to the exposure of chemicals on the dry seabed. Abandoned ships litter the former lake bed and as it dries out, vast salt plains are forming and duststorms are becoming more frequent.

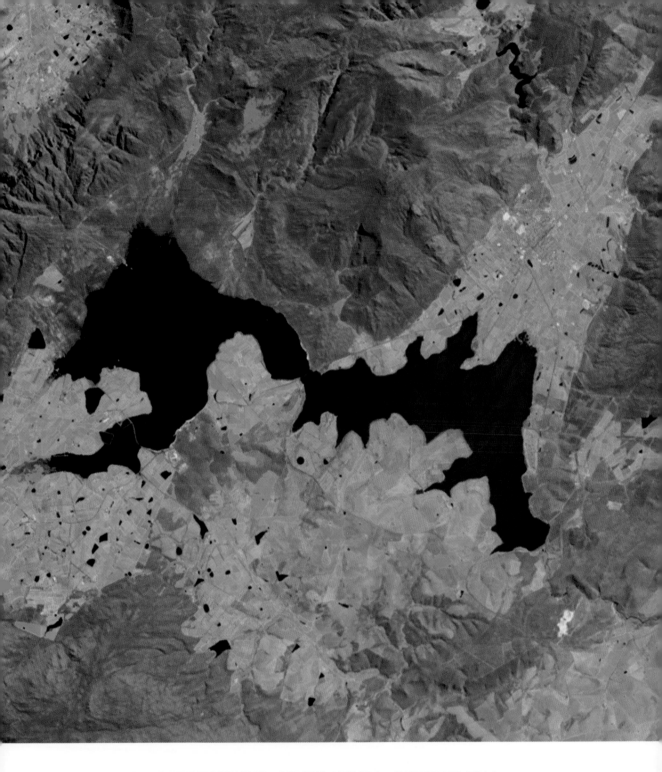

THEEWATERSKLOOF RESERVOIR, SOUTH AFRICA OCTOBER 2014

Beginning in 2015, South Africa's Western Cape entered a period of drought that saw many of its reservoirs shrinking to critical levels. In 2015, only 28 cm (11 in) of rain had fallen by November (compared with a normal amount of 45 cm (18 in)). In 2016, 20.6 cm (8 in) rain fell, and in 2017, only 13.5 cm (5 in) was recorded. Authorities in Cape Town restricted water usage, and non-essential use of drinking water was banned.

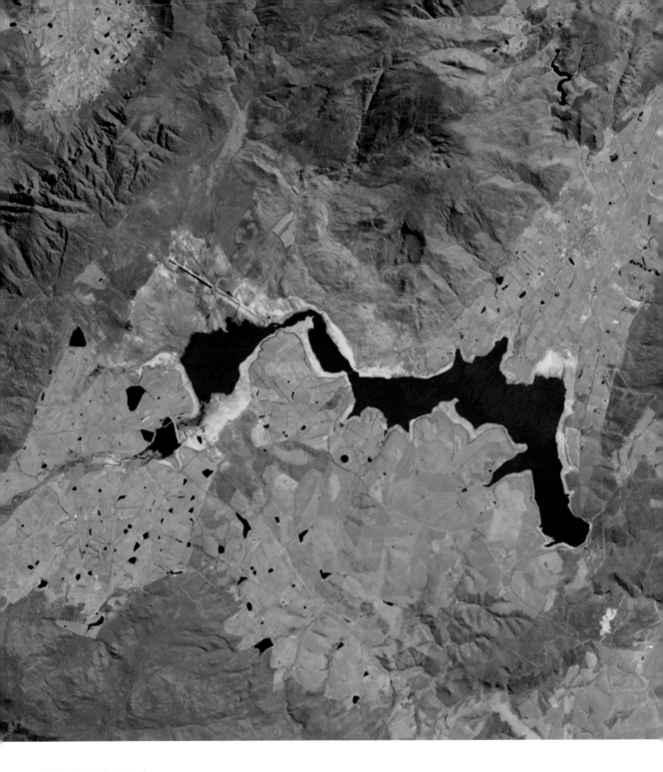

OCTOBER 2017

Theewaterskloof Reservoir dropped to 27 per cent capacity in 2017. This can be seen from the reduced water levels in the reservoir in the image on the right (compared with the 2014 image of when the reservoir was at full capacity), but also from the beige-coloured 'bathtub ring', which is because of the exposed sediment around the edge of the reservoir's basin, showing lowered water levels.

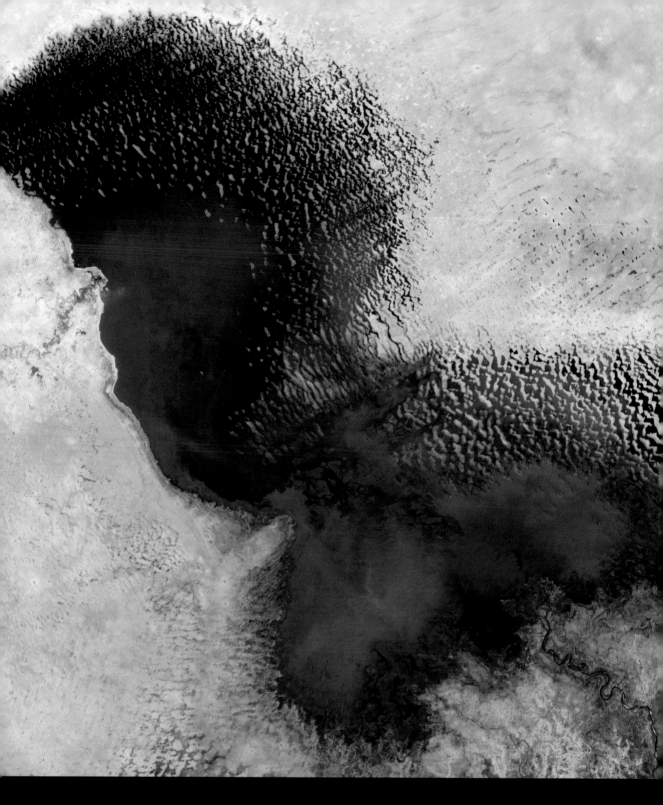

LAKE CHAD, WEST-CENTRAL AFRICA 1973

Lake Chad was once one of the largest lakes in Africa, but as a result of extensive irrigation projects, the encroaching desert and an increasingly dry climate, it now covers less than a tenth of the area it covered in the 1960s.

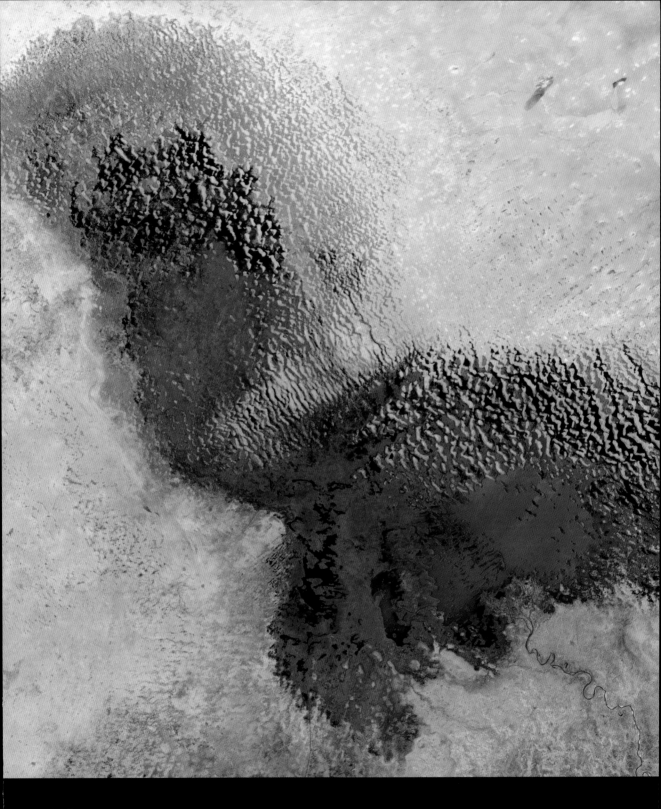

2017

As the lake floor is flat and shallow, the water level fluctuates seasonally with the rainfall. With a drying climate, the desert is taking over, as is shown by the ripples of wind-formed sand dunes where the northern half of the lake used to be.

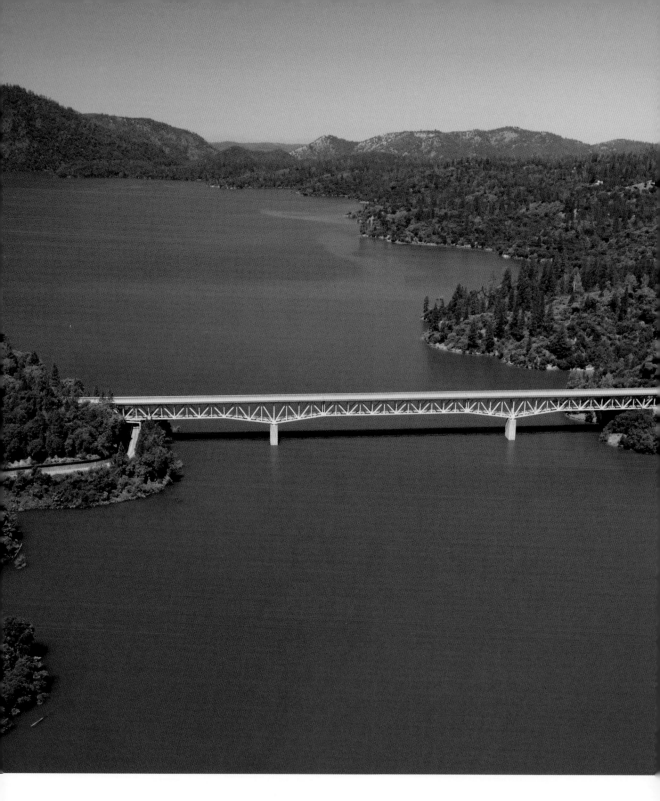

LAKE OROVILLE, CALIFORNIA, US 2011

In 2014, California, US, was declared to be in a state of emergency as severe drought conditions caused the state's reservoirs and lakes to dry up. By the end of 2013 California had had its driest year on record, prompting concerns regarding future water supply.

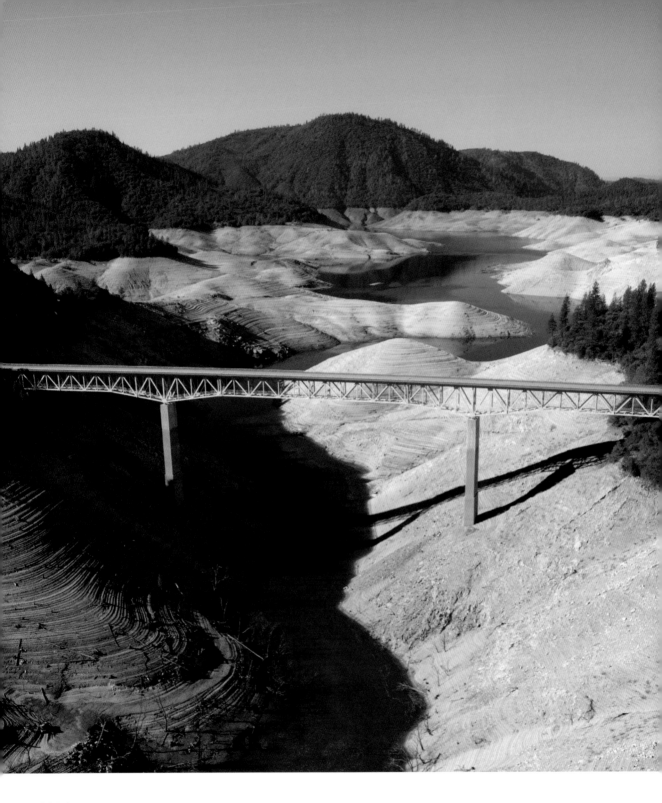

2014

By January 2014, Lake Oroville was at 36 per cent capacity. Officials suggested that the snowpack, which provides around a third of the water needed for the state's cities and farms when it melts in spring, was at a mere 20 per cent of normal.

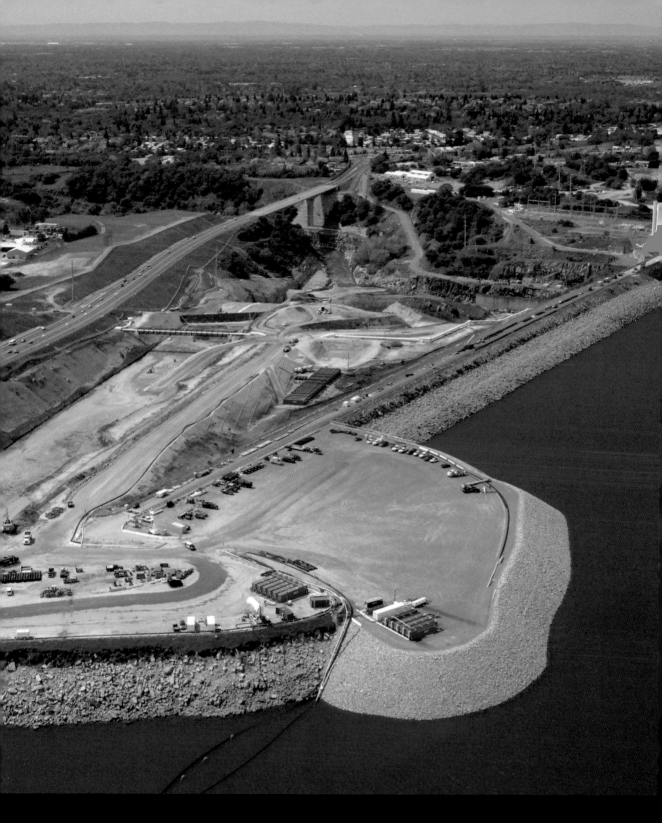

FOLSOM LAKE, CALIFORNIA, US 2011

Like on the previous page, 2014 saw water drastically reduced due to long periods of

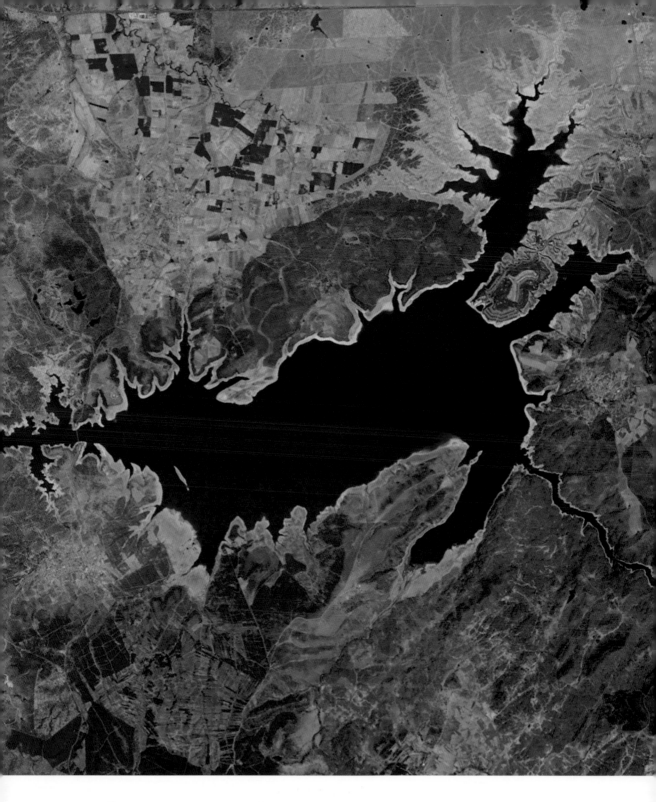

VALDECAÑAS RESERVOIR, SPAIN 2013

When the Valdecañas Reservoir was built in central Spain, in 1963, the ancient monument, 'the Dolmen of Guadalperal' – Spain's answer to Stonehenge – was submerged underwater.

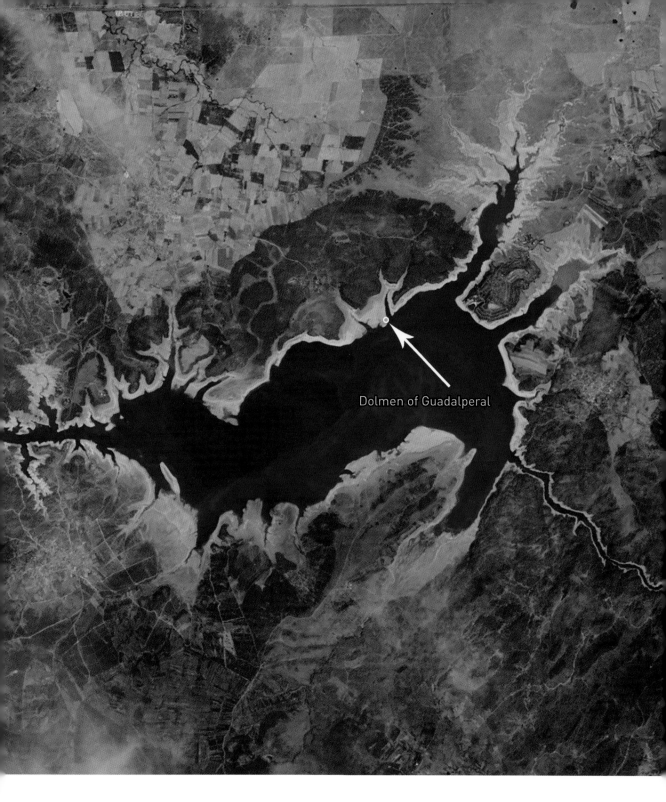

Dolmen of Guadalperal

2019

The monument consists of 144 standing stones and is thought to be in the region of 7000 years old. In 2019, Spain saw very hot and dry conditions and, as a result, the reservoir's water level became so low that the stones became exposed again.

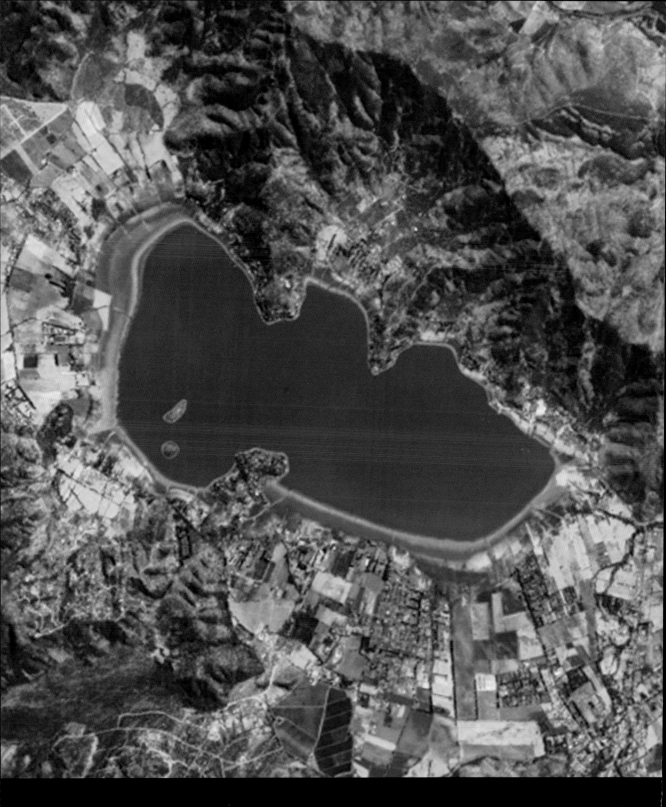

LAKE ACULEO, PAINE, CHILE 2014

Lake Aculeo, in the Maipo Province of central Chile has dried up completely. The images above show the difference between when it contained water in February 2014, and when it contained nothing more than dried mud and vegetation in March 2019.

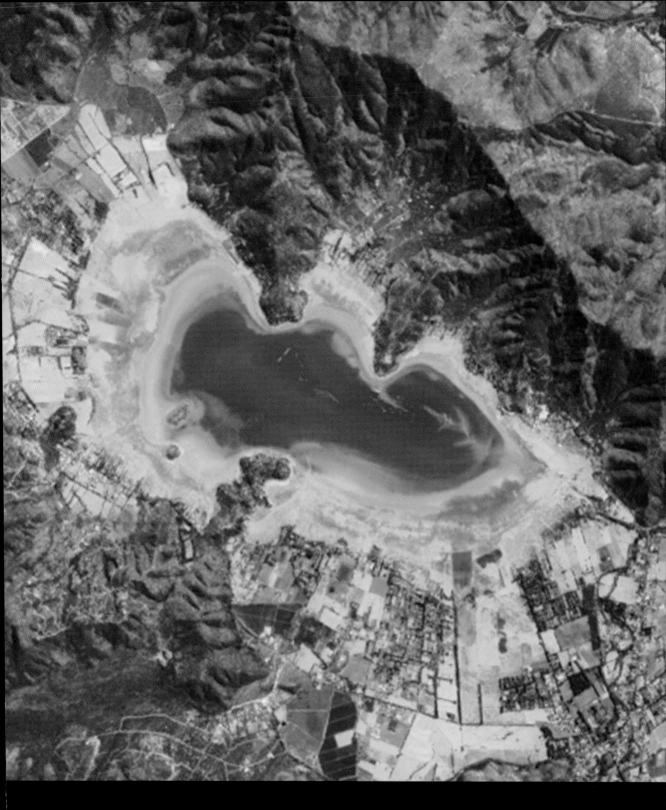

2019

Scientists put the lake's demise down to the combination of an abnormally long period of drought (spanning at least ten years), and the increased water consumption from the area's growing population.

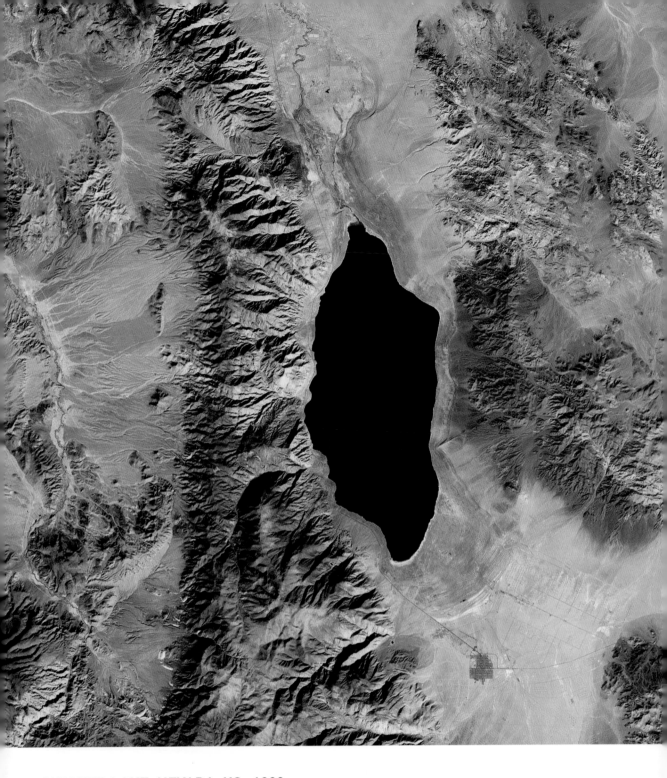

WALKER LAKE, NEVADA, US 1988

Walker Lake in Nevada has lost 90 per cent of its original capacity since around 100 years ago, when new communities of farmers and ranchers started settling in the area. When the snow in the mountains of the Sierra Nevada melts in springtime, the water feeds the lake, but over the years, more and more of this snowmelt has been diverted by the farmers to their crops and pastures.

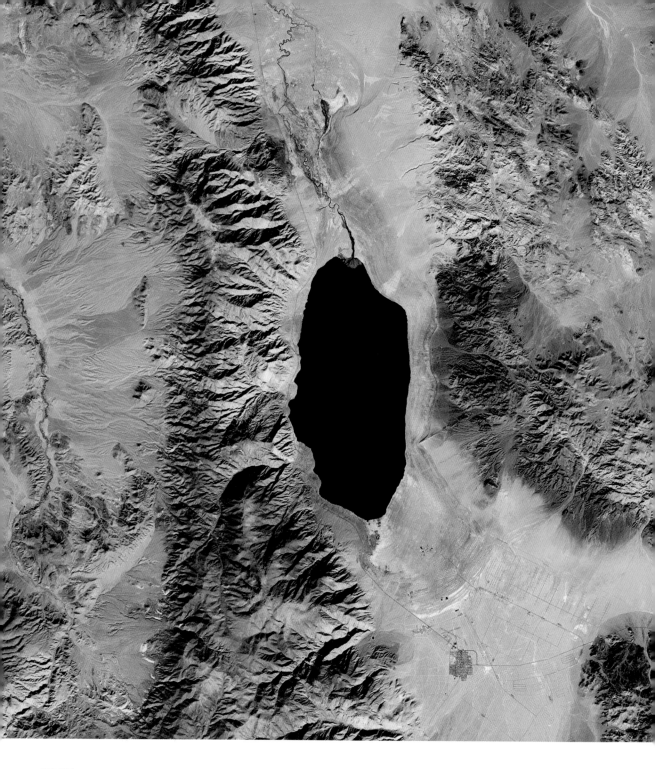

2017

This means that the amount of freshwater reaching the lake has been in decline and the water has become saltier. The lake's salt concentration level is now about half that of seawater, and it is having a severe impact on the lake's ecosystems. In 1979, there were 17 different species of fish living in the lake, but now there are only three left.

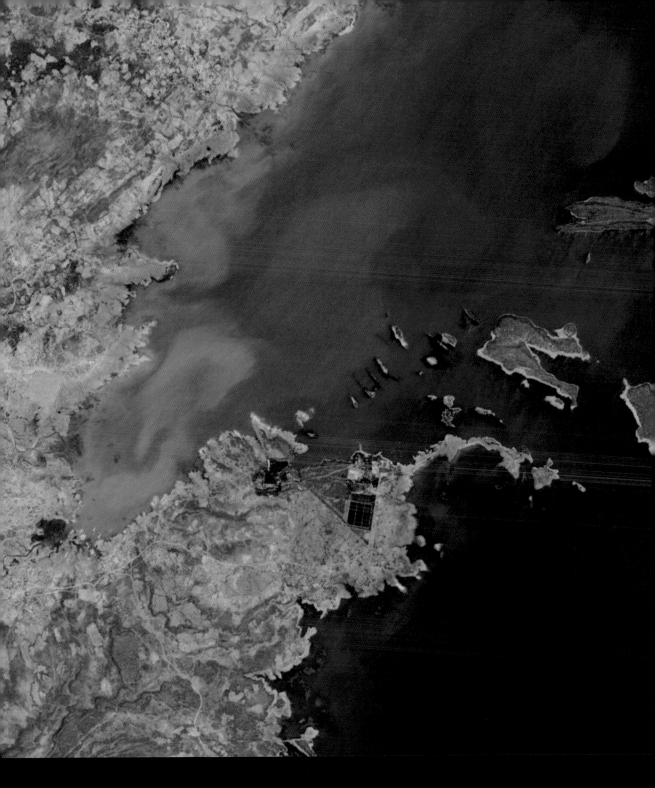

LAKE KARIBA, AFRICA 2018

Lake Kariba on the border between Zambia
and Zimbabwe is Earth's biggest reservoir
(by volume), but as a result of a severe

near full capacity in either of the images
here. In December 2019, it was at only
8.36 per cent capacity.

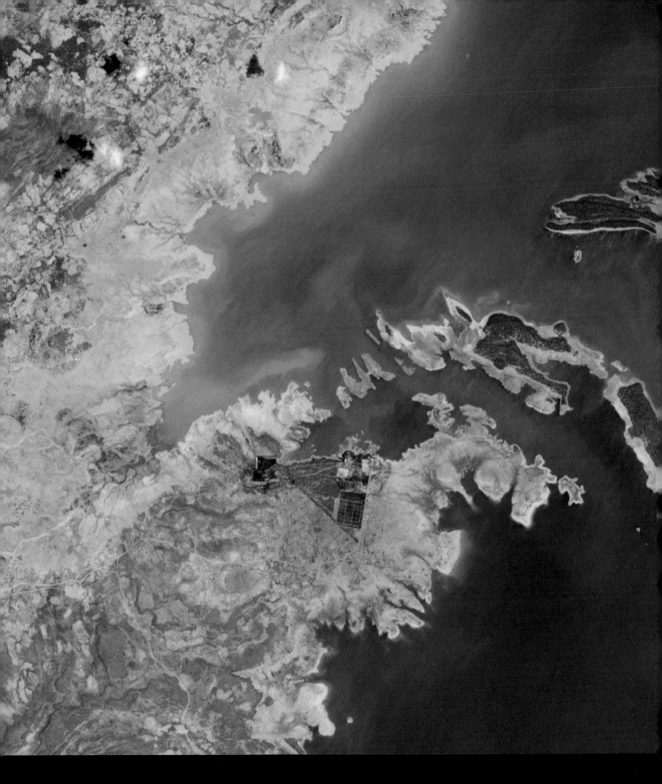

2019

The reservoir is fed by the Zambezi River and, because of the drought, in 2019 there was barely enough water in the river to generate power in the Kariba Dam hydroelectric plants (which produce half of all electricity supplied in Zambia and Zimbabwe).

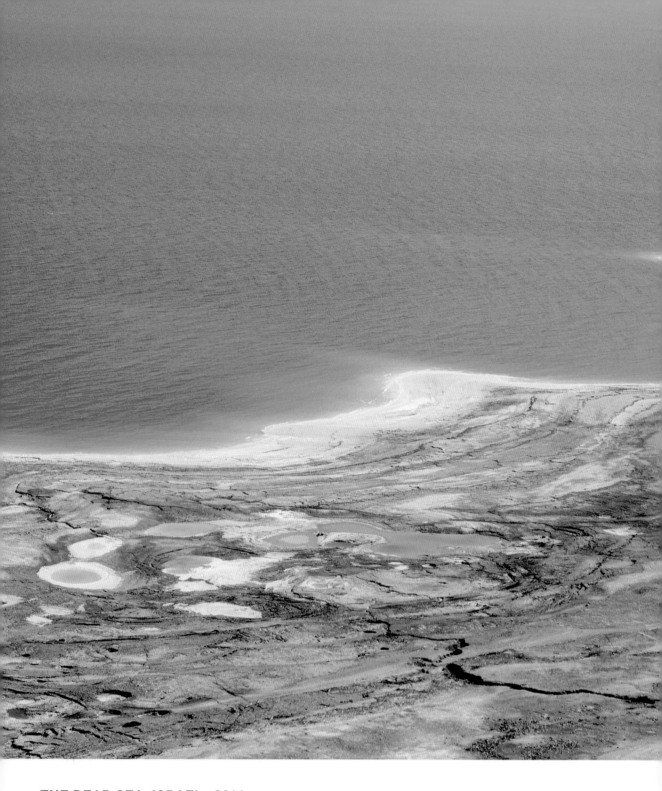

THE DEAD SEA, ISRAEL 2011

The Dead Sea is a salt lake that lies on the border between Israel and Jordan. Its shores are the planet's lowest land elevation, sitting some 430 m (1411 ft) below sea level. The level, however, is dropping by around 1.2 m (4 ft) a year. The location of the Dead Sea is very warm and dry, and as a result of rising global temperatures, it is only getting hotter.

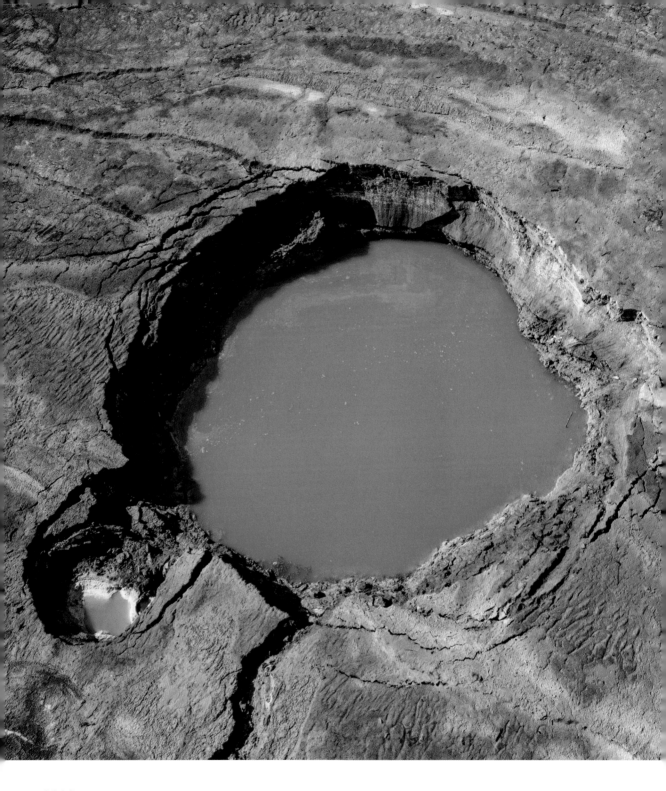

2018

The heat makes the water in the lake evaporate more, making the water even saltier. The consequence of this is that the salt deposits left behind often collapse into sinkholes, which create large craters in the ground. There are now over 5000 sinkholes on the shore of the Dead Sea, which have all appeared since the late 1970s.

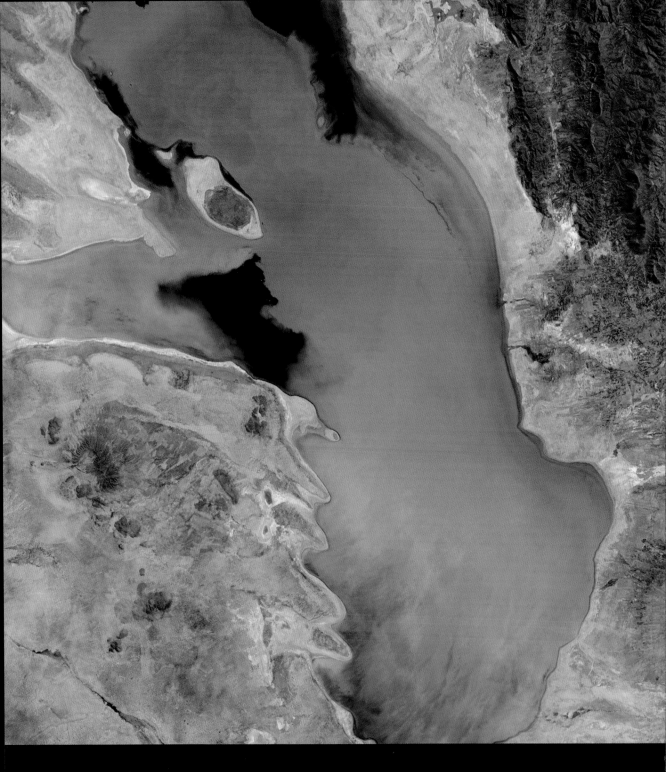

LAKE POOPÓ, BOLIVIA 2013

At times of high water, Lake Poopó in the Altiplano Mountains of west-central Bolivia is the country's second-largest lake. At its original capacity, it was about 3000 km^2 (1200 mi^2) – which is around twice the size of London, UK. The lake is a vital resource to the area local: many people fish in it to make a living.

CHANGING COASTLINES

the action of the sea and rivers in the erosion of coastal features
and the deposition of sediment along the coast

Pancake Rocks, Punakaiki, New Zealand

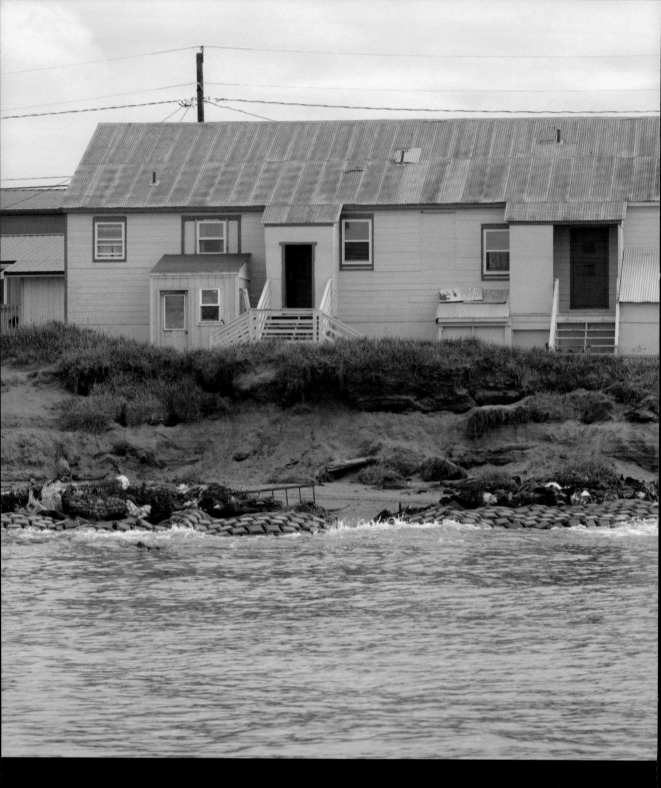

SHISHMAREF, ALASKA, US 2004

In winter, Shishmaref's shoreline is protected by sea ice. In summer months, however, there is much less ice and the coastline suffers as a result. The permafrost which the village is built on is also melting (see pages 80–83 for more on thawing permafrost). This makes the shore much more vulnerable to erosion.

Recent erosion rates average around 3.3 m (10 ft) per year, and buildings are being lost. The community is now faced with moving the village's location or building sea walls, like the one shown above, to give themselves some of the protection once afforded by the sea ice.

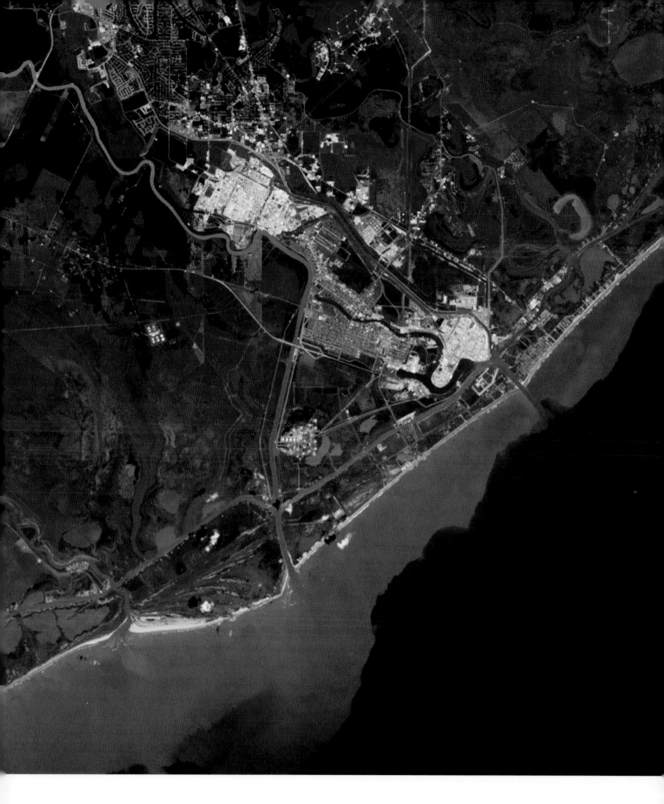

FREEPORT, TEXAS, US 1987

Twenty-four per cent of the sandy beaches around the world are eroding at a rate of more than 0.5 m (1.6 ft) a year. The images above and right show the area south of Freeport in the state of Texas, US, 28 years apart.

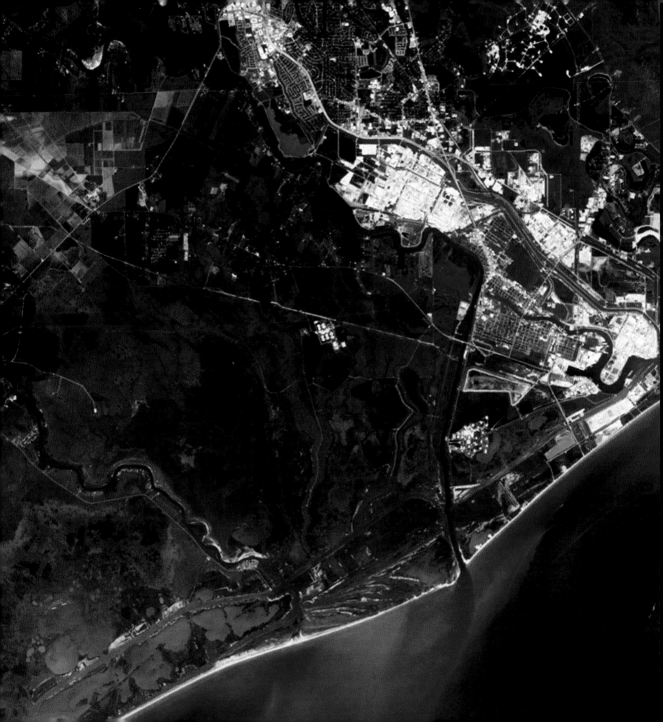

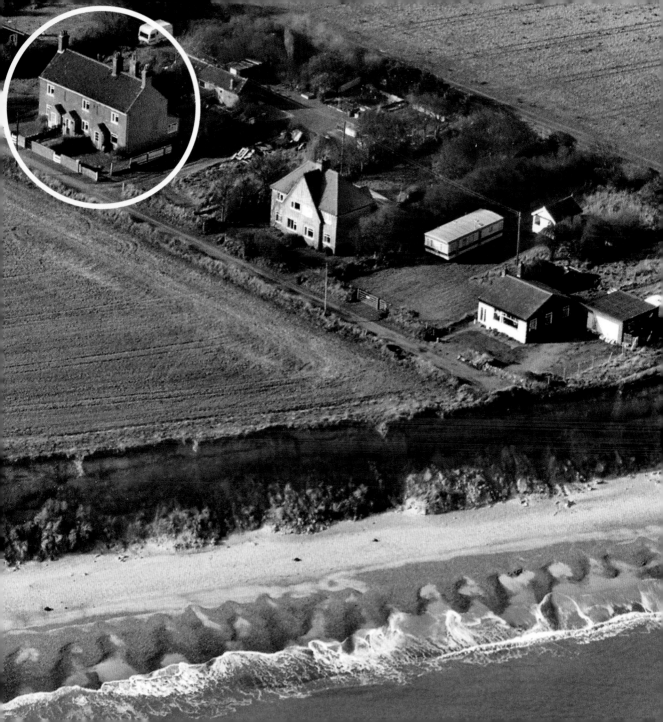

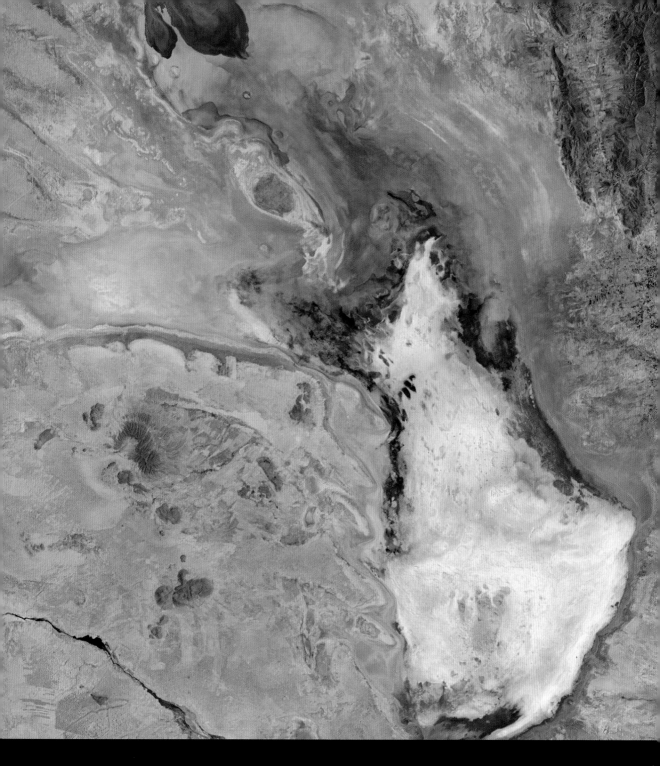

2016

Lake Poopó, however, is shallow and never deeper than 3 m (9 ft), making it especially vulnerable to drought and rising global temperatures. The lake last dried up in 1994, but gradually filled back up after a few years, although it took a long time for its ecosystems to be restored. It has now dried up again, and the image above from 2016 shows the lake in stark contrast to how it looked in 2013.

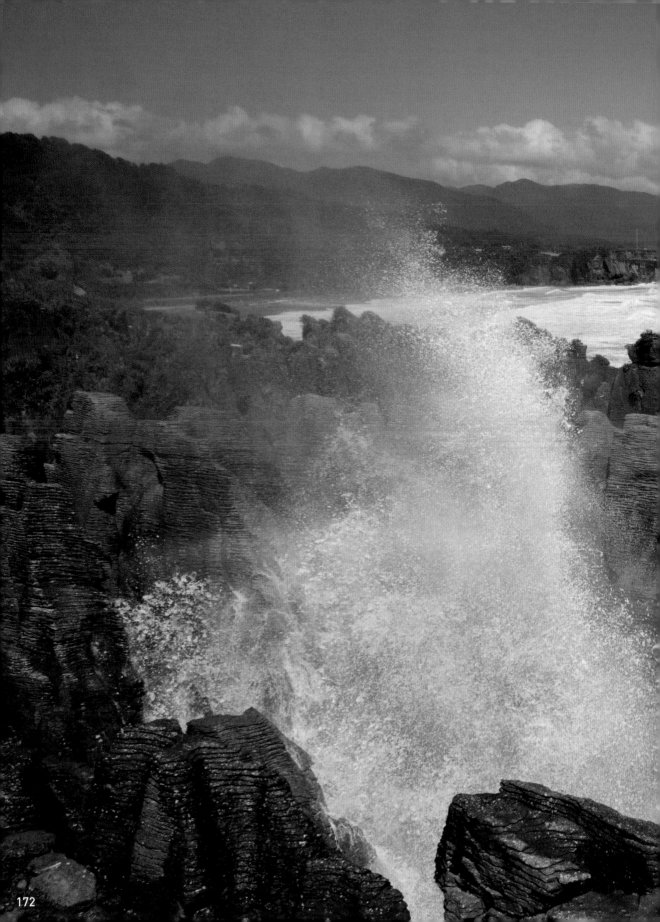

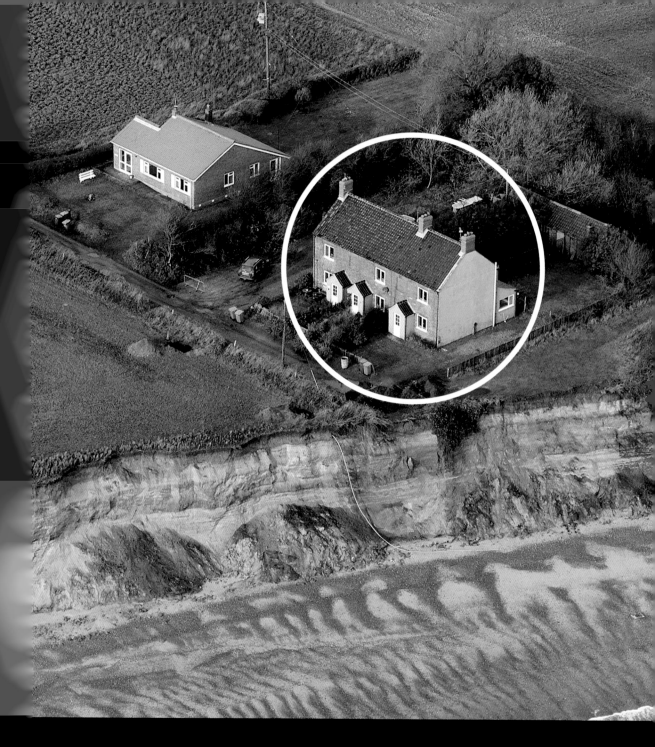

2019

The two images, taken 20 years apart but from the same location, first in 1999 and later 2019, show the same house, but note how much closer to the edge of the cliff it is in 2019. This was just a few months before the house was demolished. By the time it was destroyed, the house was teetering extremely close to the edge – a mere 6 m (20 ft) from the edge of the clifftop.

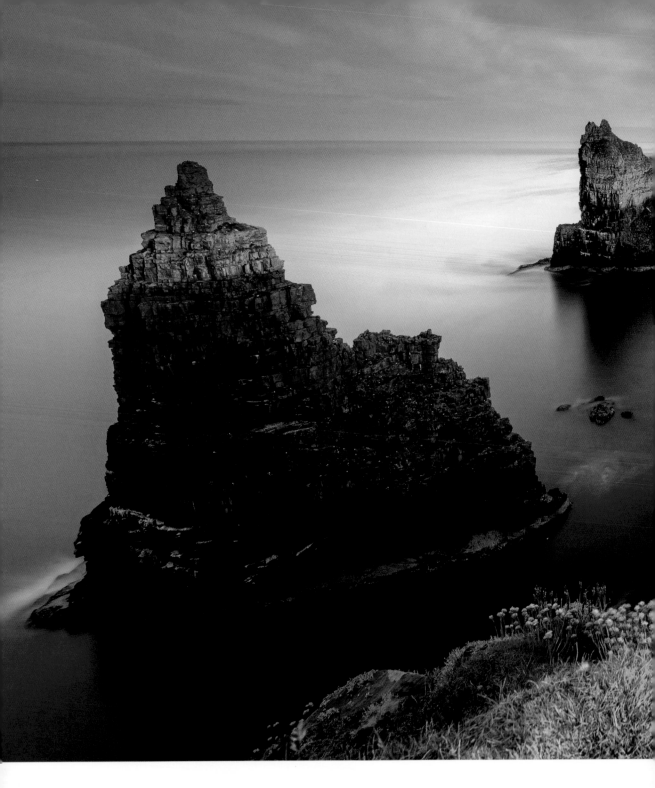

DUNCANSBY STACKS, CAITHNESS, UK 2013

The impressive Duncansby Stacks can be found off the northern tip of Scotland's coast, near John o' Groats. They are a group of sea stacks that have been eroded over many years from the mainland's red sandstone cliffs. The tallest stack – Great Stack – stands at over 60 m (197 ft).

Once, they would have formed part of the cliffs now beside them. Typically stacks are formed when cliffs erode into headlands, in which caves then form. When caves break through a headland, a sea arch is formed; then when an arch collapses a sea stack is left.

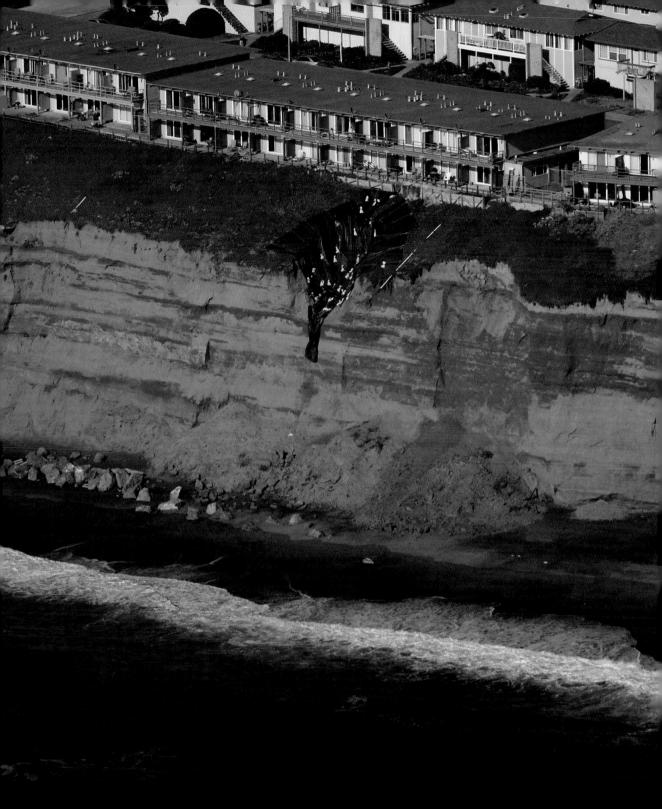

DALY CITY, CALIFORNIA, US 2008

Around 75 per cent of California's coastline
is currently being eroded. Scientists say that
rising sea levels will exacerbate cliff retreat

Cliffs in Daly City, California (above) have
been weakened by erosion and buildings on
the clifftop will soon need to be evacuated.

ENCINITAS, CALIFORNIA, US 2003

The cliffs along California's coast have been
crumbling for decades, but this will get
worse with the rising sea levels. Rain and
erosion washed away parts of the Beacon's
Beach trail in Encinitas, and new railings had
to be installed to make the trails safe again.

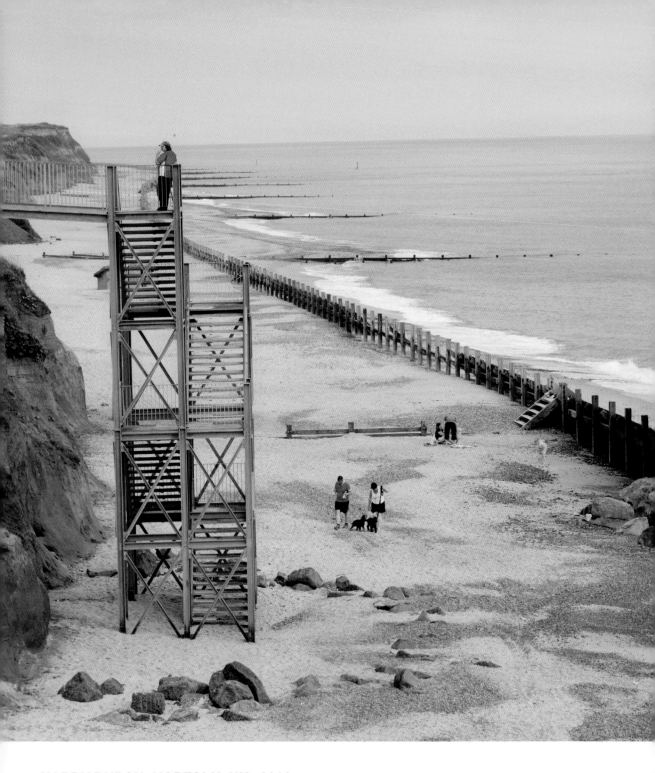

HAPPISBURGH, NORFOLK, UK 2010

This is a stretch of the Happisburgh coastline in Norfolk in eastern England. The image shows the steps leading from the clifftop down to the beach. Happisburgh was once much further away from the sea, but the parish of Whimpell, which separated it from the coast, has long disappeared because of coastal erosion. Records suggest that between 1600 and 1850, over 250 m (820 ft) of land was eroded.

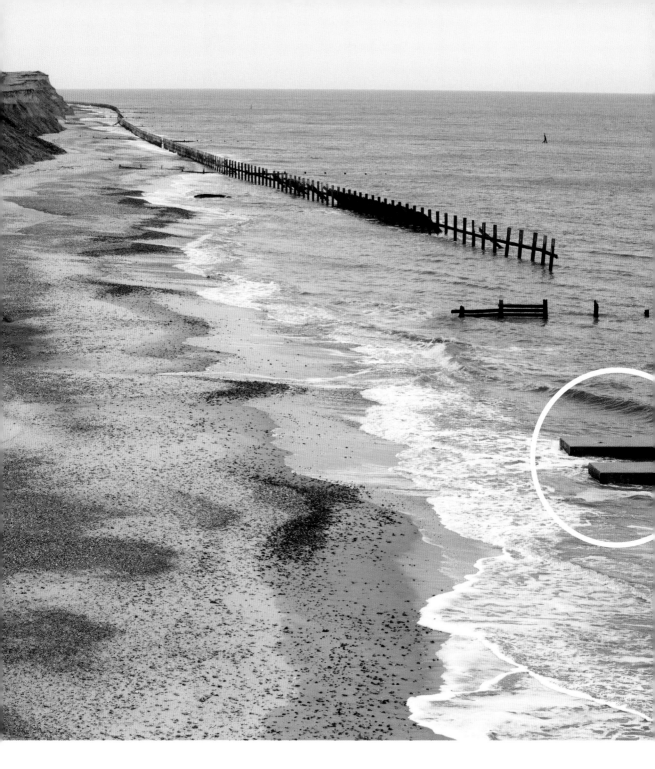

2015

This image, taken five years later, was captured in exactly the same location and shows how rapidly the sea has eroded the cliffs away, resulting in a much larger distance between the cliff base and the foundations for the original steps (right). The cliffs consist of less-resistant boulder clay, and scientists believe that the coastline is being eroded at an average rate of 2 m (7 ft) a year.

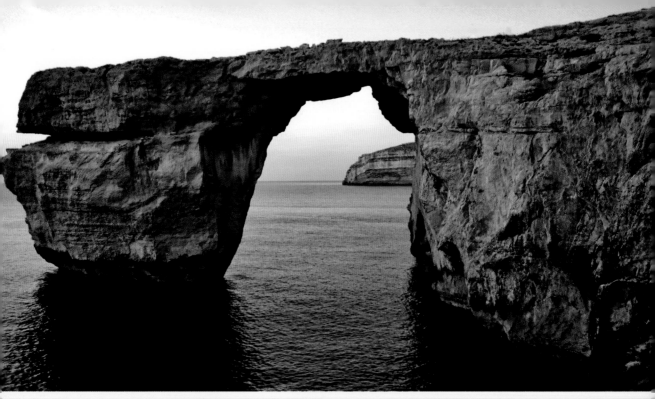

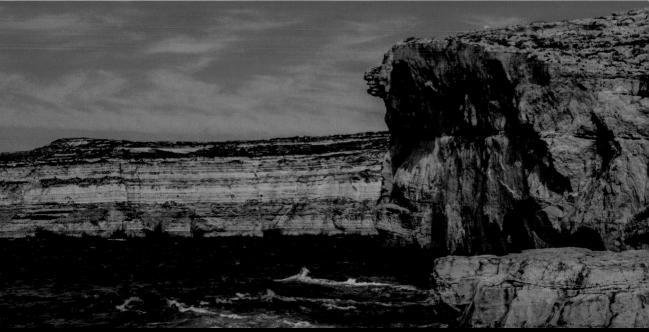

AZURE WINDOW, GOZO, MALTA 2017

The Azure Window in Gozo, Malta was world famous until March 2017 when, during a heavy storm, it collapsed into the Mediterranean Sea. The arch had been subject to erosion for its entire existence.

the slab across the top of the arch collapsed, which widened the arch. In the 2000s, right up until its collapse, it constantly shed chunks of rock, and even days before its final collapse people were walking on top of it.

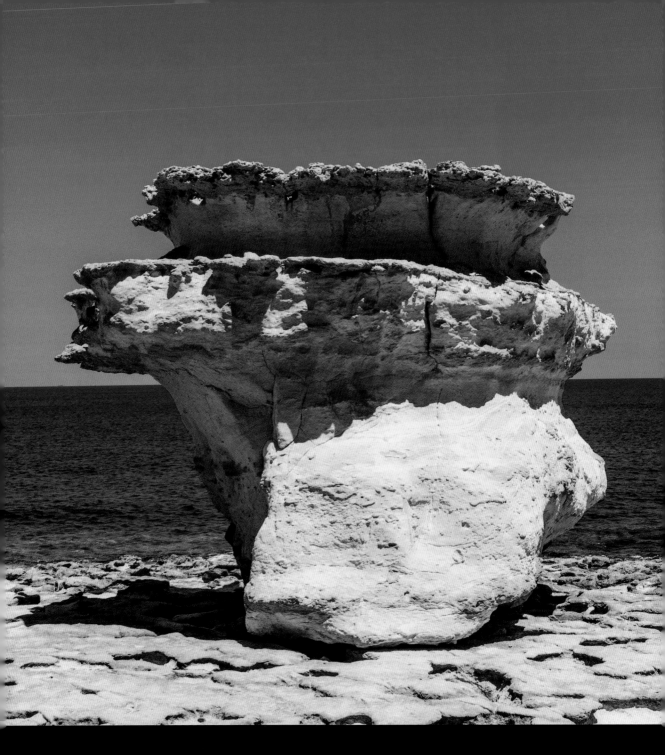

MARSAXLOKK, MALTA 2017

The sea has significant impact around any island, and the island of Malta, in the middle of the Mediterranean Sea, is no exception. Any rocks in the sea's vicinity will be eroded to some degree. Mushroom rocks, like the southeast coast of Malta, are found around the Maltese coast. These spectacular-looking rocks are formed as a result of erosion and weathering: from the wind, waves and intrusion of seawater.

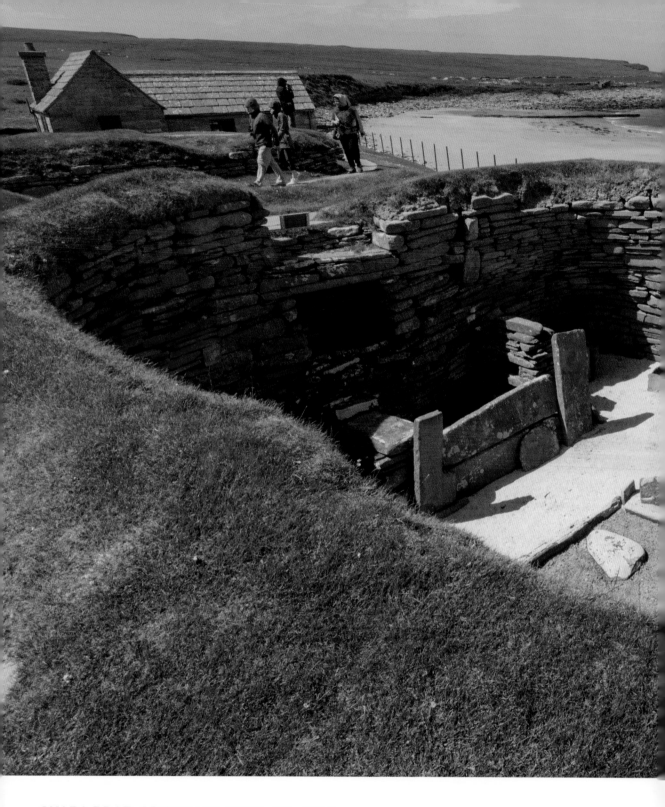

SKARA BRAE, ORKNEY ISLANDS, UK 2017

Skara Brae is a stone settlement that sits
on the Orkney Islands, just off the coast of
northern Scotland. It was first discovered in
the late 1800s when the sand dune
which was burying it was destroyed
by a heavy storm.

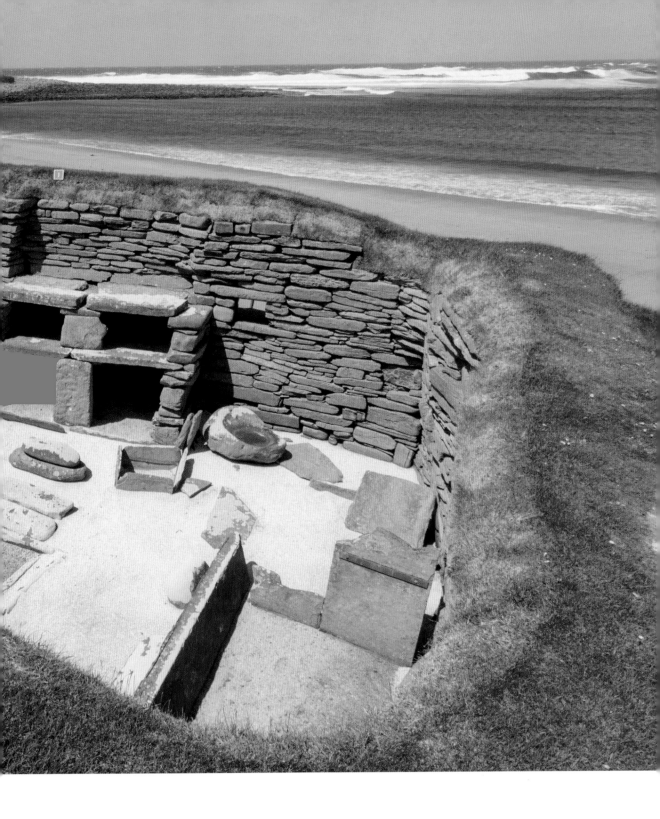

It is thought to have been built and lived in around 3000–2500 BCE, during the Neolithic era. Unfortunately, however, due to its exposed location, it is very vulnerable to coastal erosion and storms, and another storm could destroy it completely.

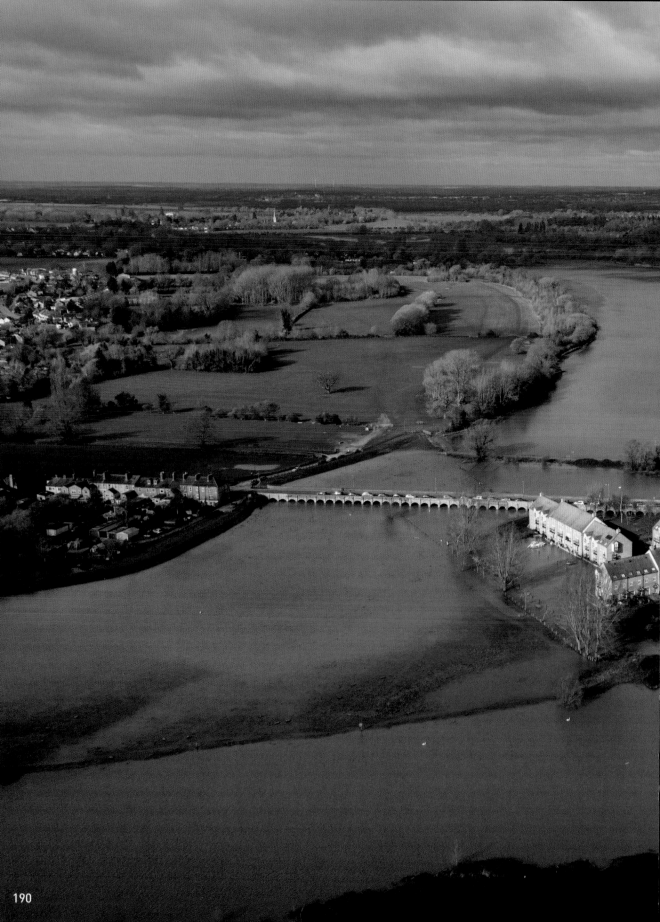

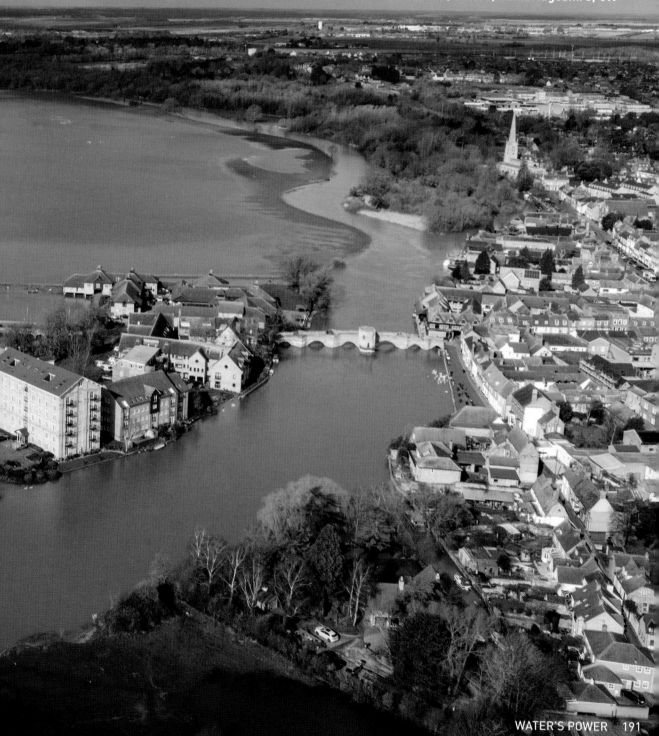

RIVERS IN FLOOD
water inundating normally dry land as river levels rise
after heavy rainfall or as a result of melting snow

River Great Ouse, St Ives, Cambridgeshire, UK

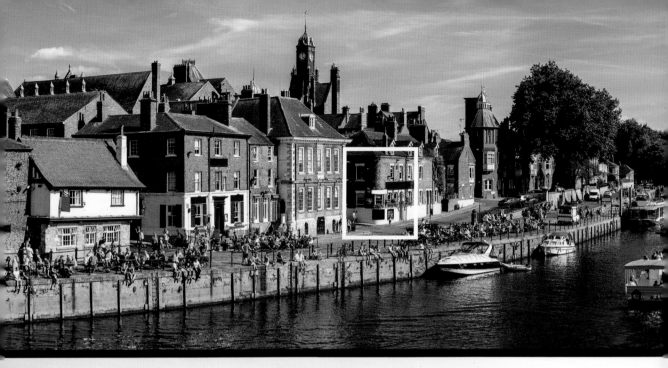

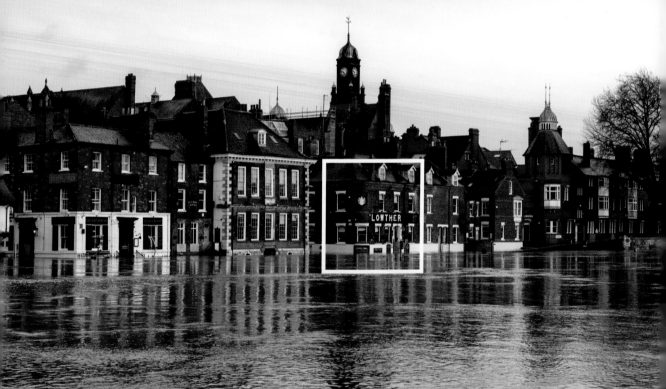

YORK, NORTH YORKSHIRE, UK 2020

The first image above shows the riverside off King's Staith in York before flooding. The second image was taken on 18 February 2020 when parts of York were flooded after the

River Ouse burst its banks. Following storms Ciara and Dennis, the river was 4.35 m (14.2 ft) above normal when it peaked – its highest level since the 2015 flood disaster

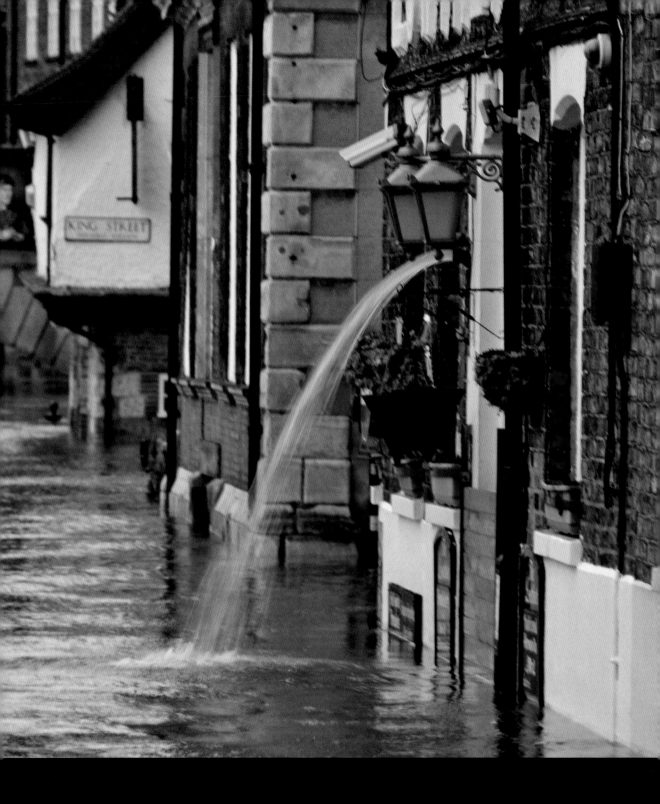

Despite the flood defences (installed after
the 2015 floods) helping to reduce the impact
of the 2020 flooding, many traders still
experienced disruption. The [...]

on the banks of the River Ouse (above, and
also highlighted in both images opposite),
had to pump floodwater out of its premises.

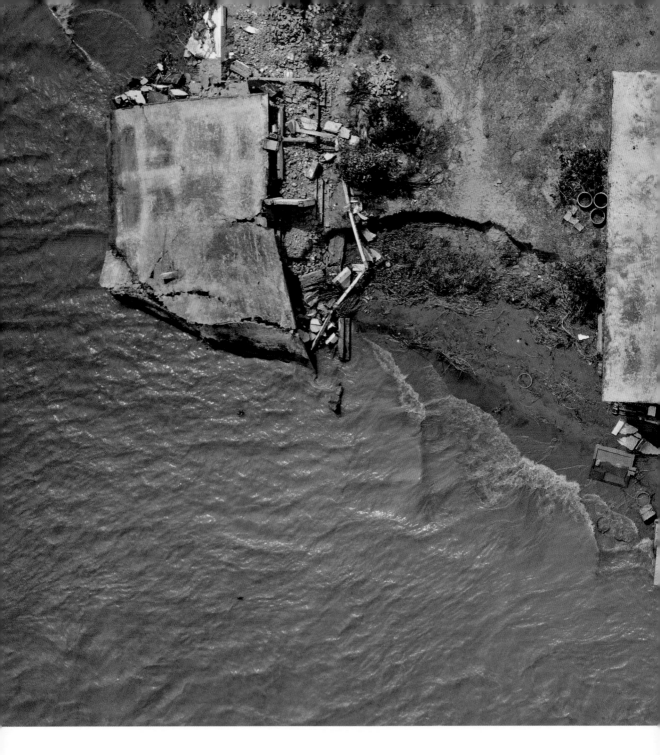

DHAKA, BANGLADESH 2019

According to scientists, Bangladesh is one of the planet's most vulnerable countries to climate change. It is constantly battered by cyclones and heavy rains to name just two of the regular threats. But homes built on Bangladesh's rivers are at constant threat of destruction from another force. Worsening heavy rains during monsoon season inundate three major rivers – the Padma, the Meghna and the Jamuna – and in turn lead to the erosion of land, wiping out homes and communities in the process.

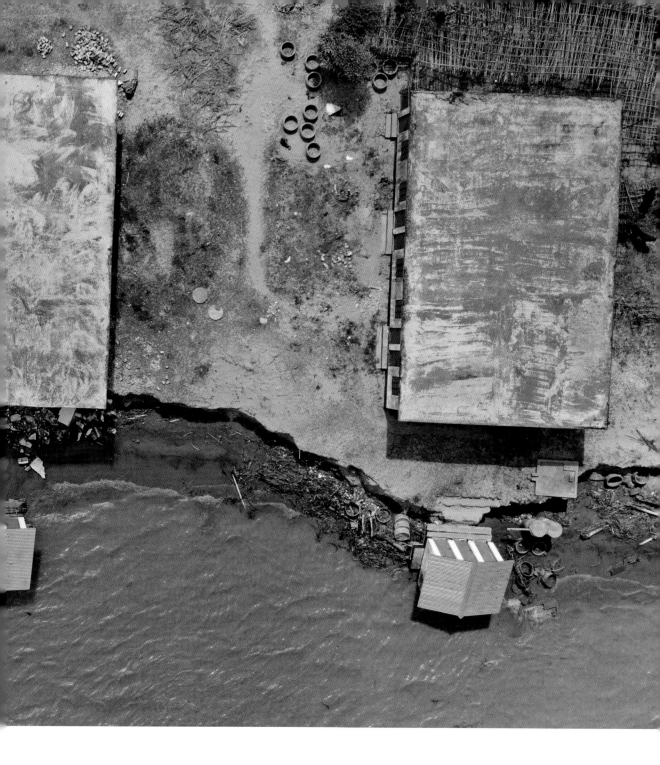

It is thought that river erosion claimed more than 1600 km² (618 mi²) of the country's land between 1973 and 2017. This image shows just three buildings and their surrounding land on their way to being eroded away by the Padma River, but the issue is much greater than this isolated view. It is predicted that another 45 km² (17 mi²) of land could disappear by the end of 2020, forcing thousands more to relocate and, if this rate continues, millions may lose their homes and towns in the future.

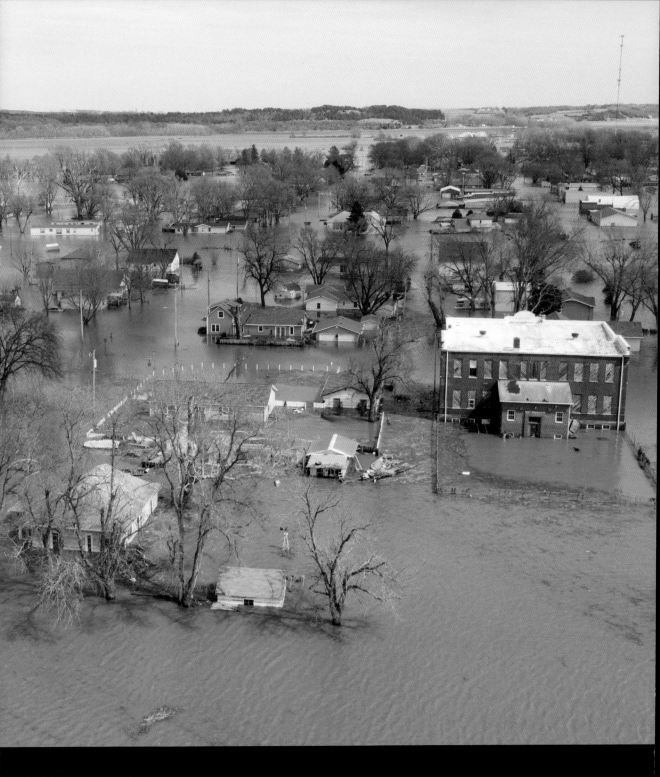

IOWA, US 2019

From March to December of 2019, Iowa and many other US states witnessed severe flooding. The inundated rivers affected around 14 million people living in the Midwestern and southern states of the

US. Rivers became swollen by heavy rain and snow that melted very quickly, and the situation was exacerbated by thick river ice clogging the rivers and preventing them from flowing normally.

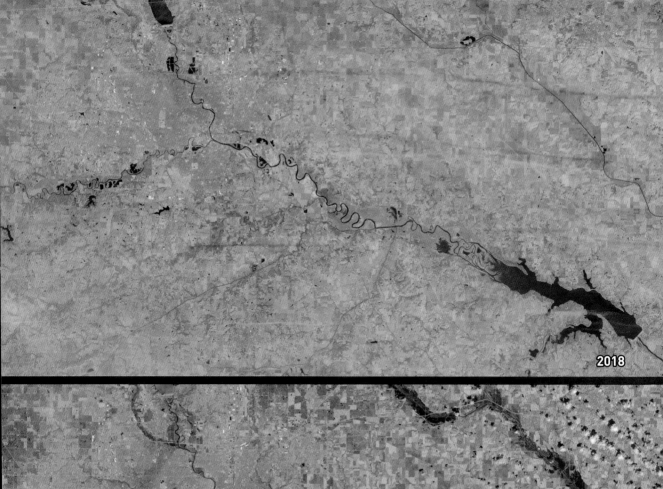

2018

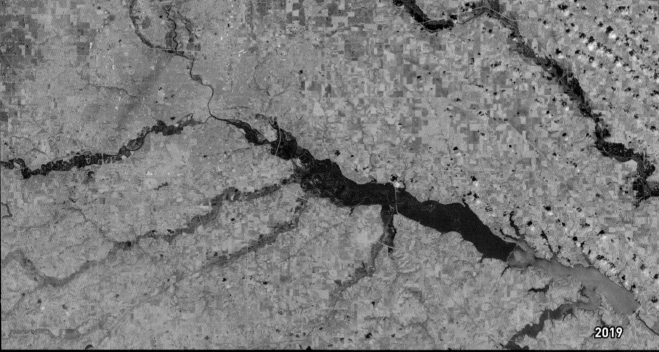

2019

2018, 2019

The image at the top was taken in March 2018, before the flooding. The image at the bottom, from March 2019, shows the flooding of the major rivers – Raccoon, Des Moines and South Skunk – in Iowa. In the bottom image, large quantities of water (shown in dark blue) and ice (in light blue) can be seen backing up behind dams on the rivers.

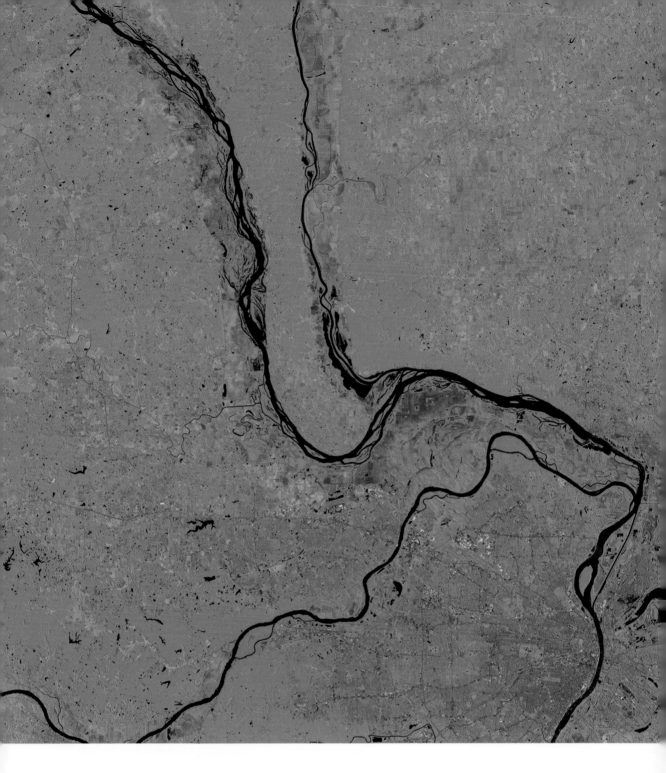

MISSISSIPPI AND ILLINOIS RIVERS, US 2018

Following the flooding of Iowa and other Midwest states in the US earlier in 2019 (see the previous pages – pages 196–197), the Mississippi and Illinois rivers also flooded. Eighteen river gauges within a 200-mile radius of St Louis, Missouri, were said to be at 'major flood stage', and a new record river depth for Rock Island, Illinois was hit when the river reached 6.9 m (22.7 ft).

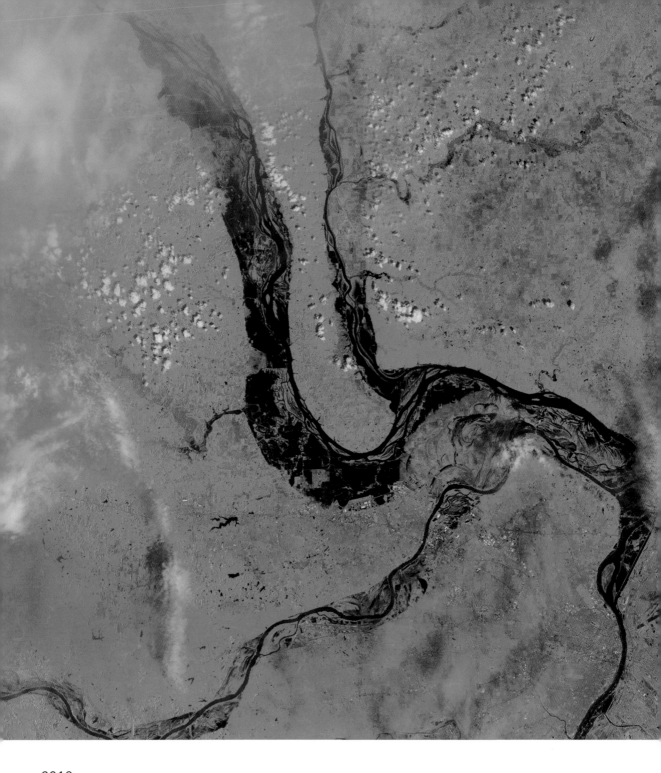

2019

Ground that was already saturated from the first round of flooding in March 2019 could not absorb any more water when multiple heavy rainstorms hit the region in late April and May, and many of the Midwest and plains states were once again flooded. The image on the left shows the Mississippi River and Illinois River in June 2018, which can be compared with the one on the right from May 2019, captured during the floods.

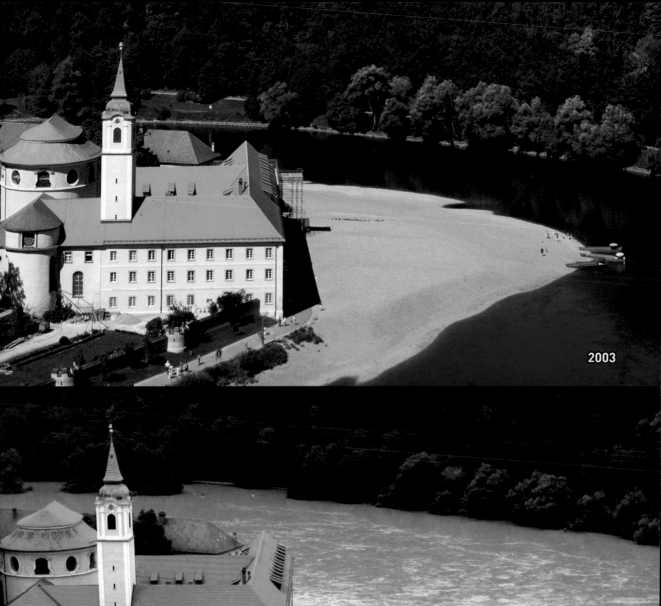

2003

2005

KLOSTER WELTENBURG, BAVARIA, GERMANY 2003, 2005

Kloster Weltenburg, a normally serene Benedictine monastery on the banks of the River Danube, dates back to around AD 600. There has been a brewery on the site since 1050 and it is a popular tourist destination. In August 2005, the river rose by 7 m (24 ft), flooding the monastery, but not the brewery.

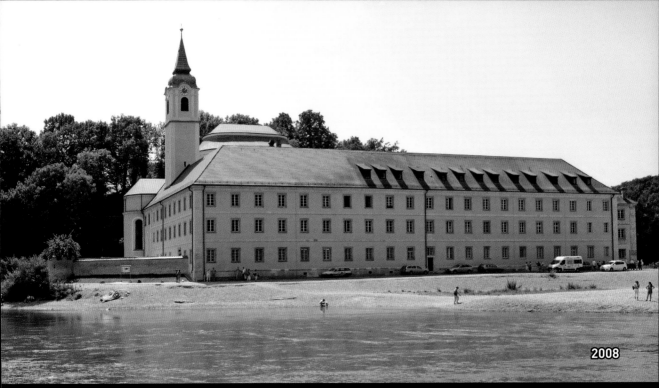

2008

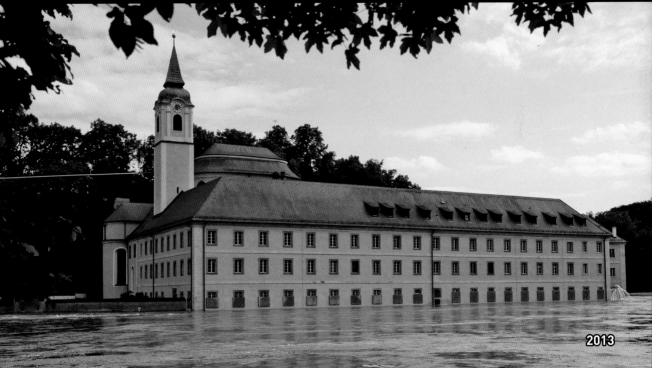

2013

2008, 2013

Areas surrounding the monastery have been flooded again and again over the years. The monastery, however, had flood protection installed in 2006 to help prevent further damage from future floods. Here, in 2013 (with 2008 low water for comparison), the floodwaters have surrounded the building again, but have not entered.

SUDAN 2018

In August and September of 2019, 16 of Sudan's 18 states were flooded by heavy rainfall. Areas south of where the White Nile and the Blue Nile rivers join were the worst hit, including the country's capital city – Khartoum.

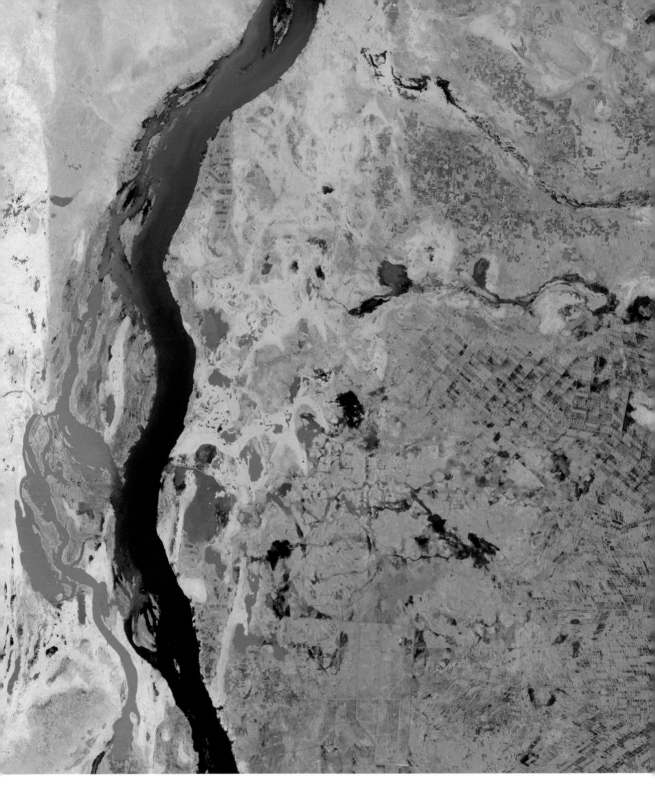

2019

Over 340 000 people were affected by the flooding. There were many deaths, and tens of thousands of homes were destroyed. The flooded areas also presented sanitation concerns as water-borne diseases such as cholera thrive in these affected areas.

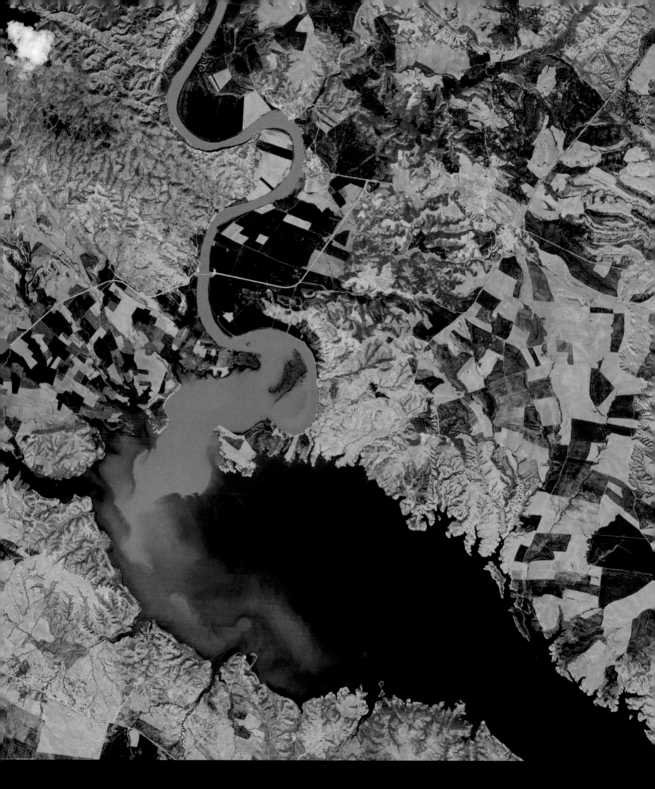

IRAQ 2015

This is the River Tigris in Iraq in its usual
state in April 2015. Iraq suffered severe
drought conditions in 2018, but the unusually
wet winter and spring of 2019 refilled the

nation's rivers. Up to two to three times the
average amount of rain fell in the early part
of 2019.

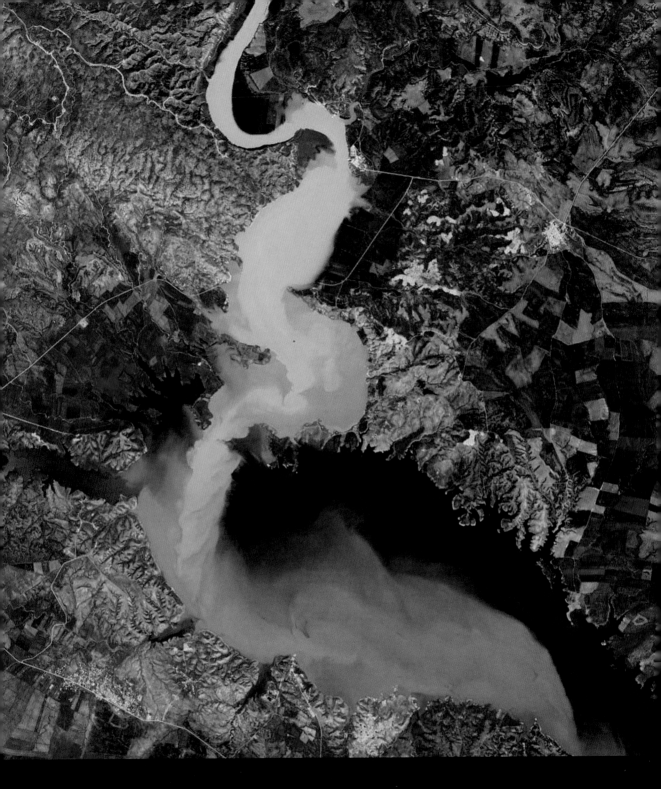

2019

In April 2019, however, the river was much fuller, and turned a murky brown colour – it was filled with suspended sediment as a result of its increased size and flow. The land around the swollen river also appears much greener than in the 2015 image showing that the land became more fertile as a result of the increased rainfall.

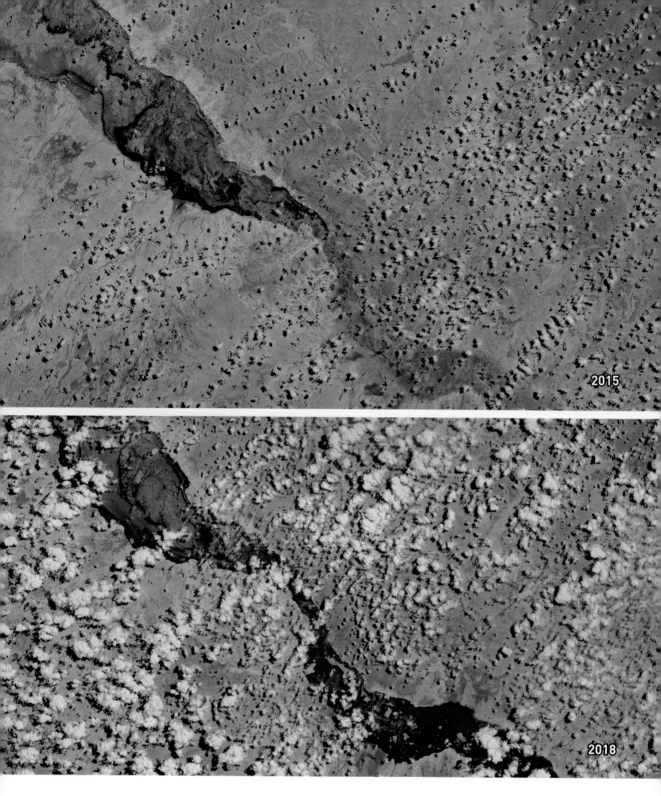

2015

2018

SOMALIA 2015, 2018

Much of Somalia in eastern Africa was affected by floods in April 2018. The floods devastated many parts of the country when the Shebelle River burst its banks. Houses and crops were destroyed in what is thought to be one of the worst floods ever recorded.

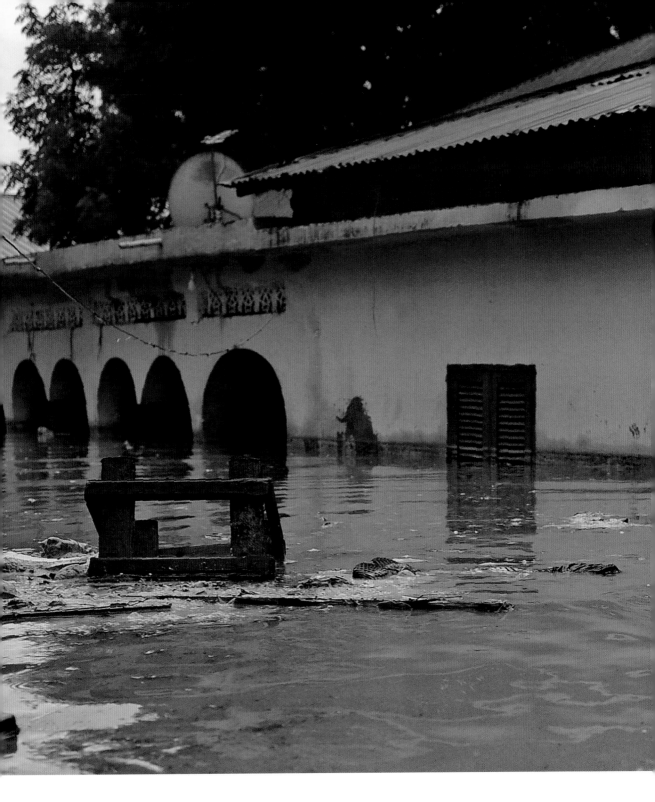

MOGADISHU, SOMALIA 2018

People all over eastern Africa were affected by the heavy rainfall and flooding and 120 000 people had to evacuate their homes by the river. The building above, in Somalia's capital, was flooded when the Shebelle River overflowed.

QUEENSLAND, AUSTRALIA JANUARY 2019

Relentless rainfall in Queensland, eastern
Australia, in early 2019 flooded most of the
state. In some areas, up to 55 cm (22 in) of
rain fell in two weeks. The two images here
compare the land on 7 January prior to heavy
rains, with afterwards, on 10 February.

FEBRUARY 2019

Farmers in rural areas had battled droughts
for years and worked tirelessly to keep their
crops and herds alive, but the floods of 2019
led to crop devastation and many cattle
herds were completely wiped out.

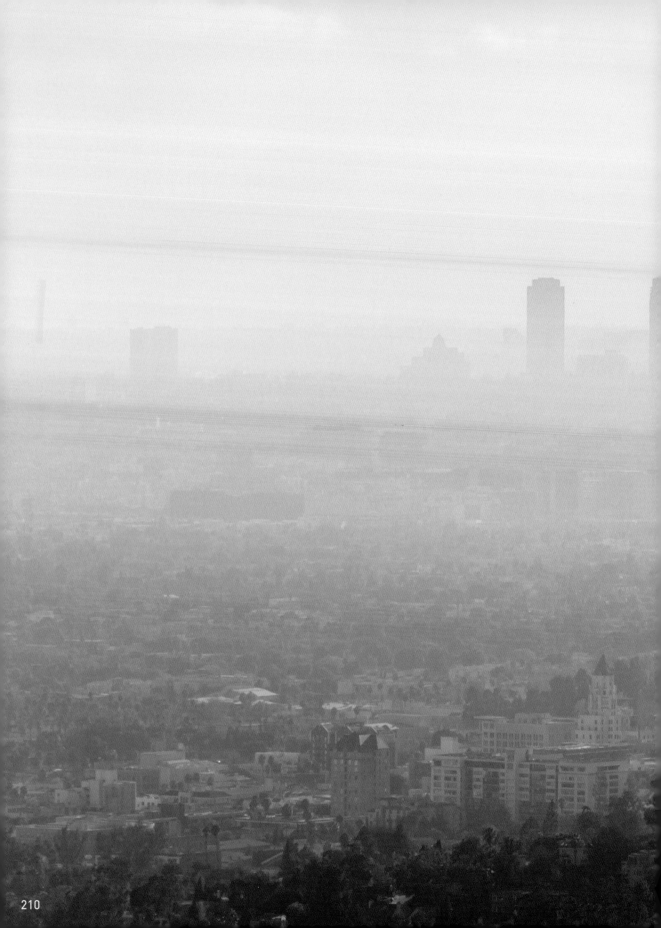

POLLUTED AIR

the presence of a substance or substances in the air
which have harmful or poisonous effects

Smog in Los Angeles, California, US

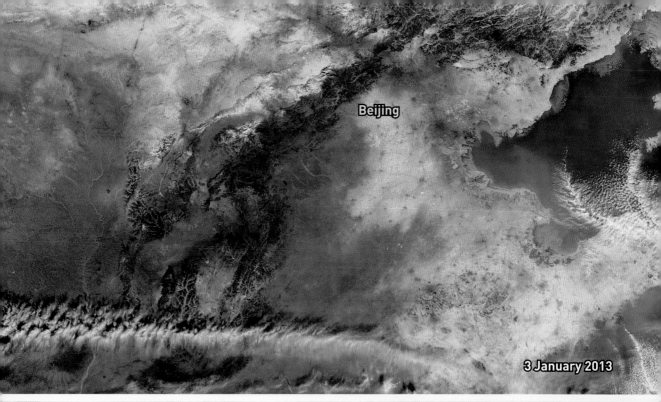

Beijing

3 January 2013

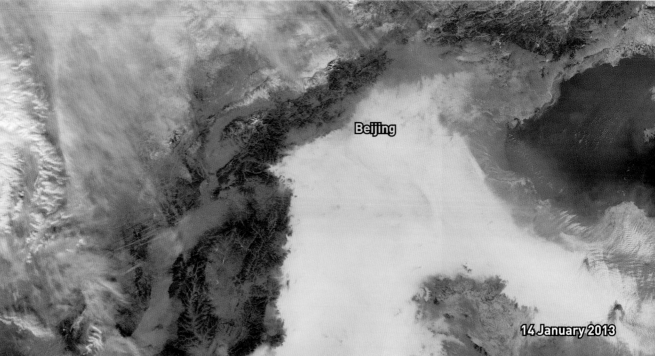

Beijing

14 January 2013

BEIJING, CHINA 2013

In January 2013, residents of Beijing and other major cities in China were advised to stay indoors after the air quality became extremely poor. In the bottom image acquired on 14 January 2013, there is extensive haze, low cloud and fog over the region. Even the areas with no cloud coverage are covered in brown smog.

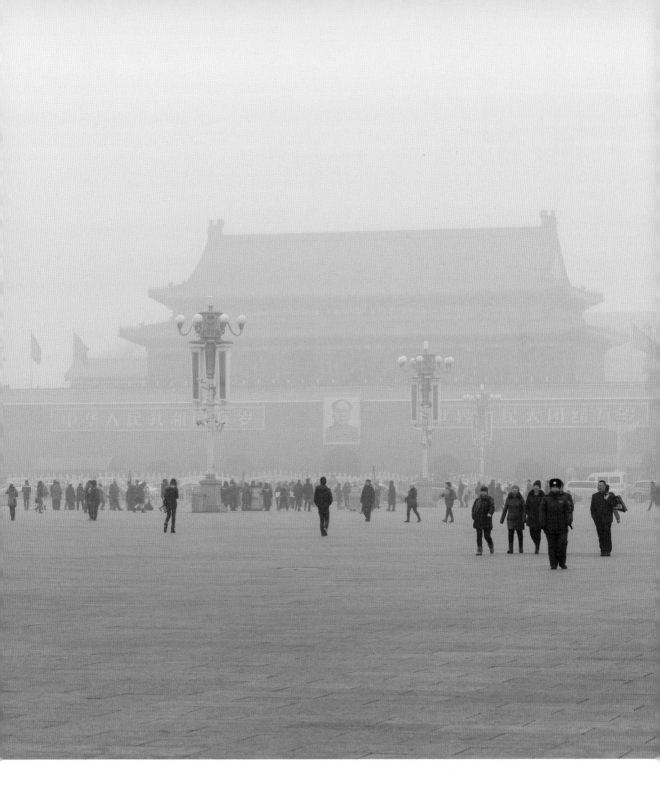

A barely visible Tiananmen Tower in January 2013 is shown here. At the time, factories were told by the Chinese government to reduce their emissions after hospitals reported a 20–30 per cent increase in patients presenting with respiratory-related illnesses.

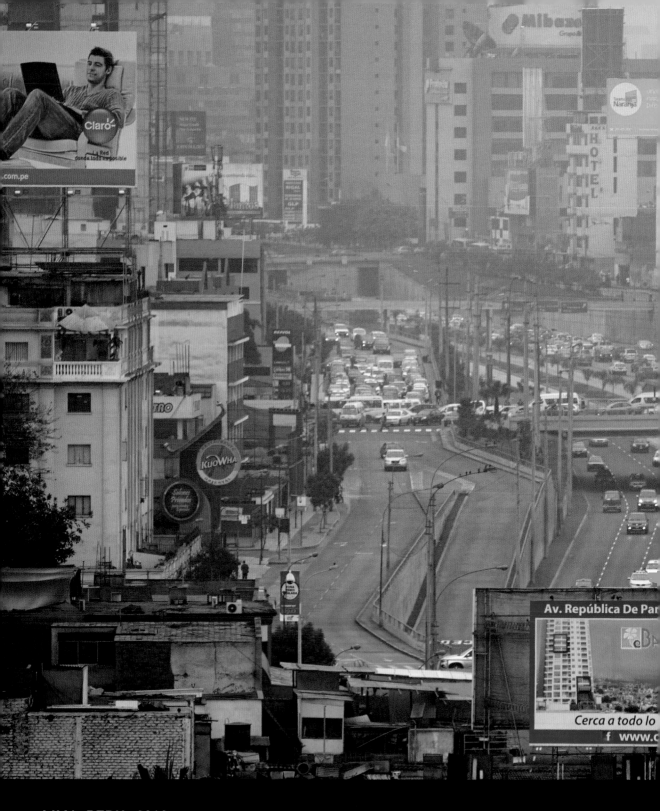

LIMA, PERU 2019

Many South American cities are amongst
the worst offenders in the world for poor

in particular, has very high levels of air
pollution.

In 2019 it was estimated that around 690 children out of every 100 000 will develop asthma – as a result of the harmful levels of nitrogen dioxide emitted from vehicles.

POLAND 2019

Poland is one of the countries in Europe with the worst air pollution. In 2019, around a quarter of the 100 European cities with the worst air pollution were in Poland. Levels of PM2.5 – particulates in the air that are breathed in and cause a variety of respiratory problems – were dangerously high in many Polish cities, leading to tens of thousands of deaths attributed to poor air quality. Around half of all air pollution in Poland is due to the use of old-fashioned domestic fuel burners.

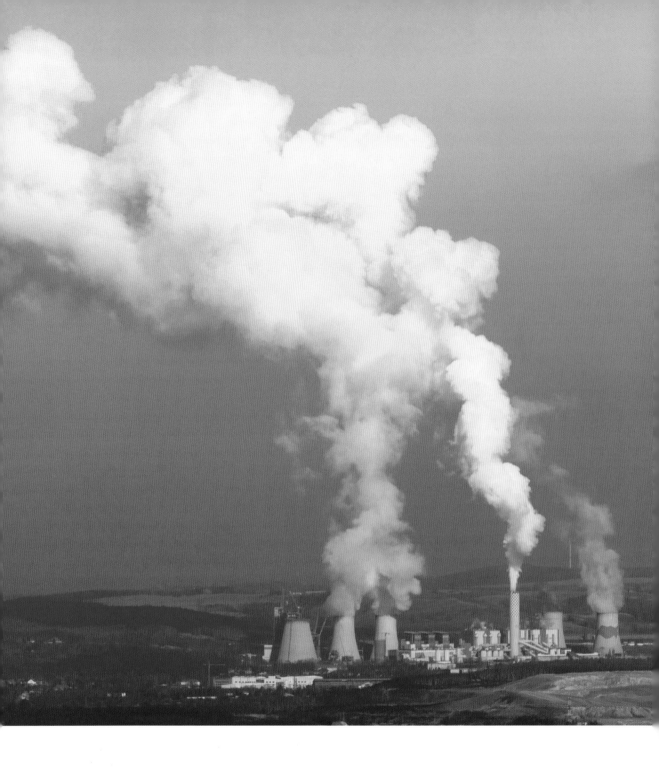

Four million households rely on coal and wood burners to heat their homes, churning out harmful emissions into the atmosphere (image above left). The Polish government is devoting billions towards finding alternative, cleaner heat sources to traditional coal heating. Coal, however, is not just a domestic issue – many power plants across Poland rely on coal to generate power. The image on the right shows a coal-fired power plant in Turów that generates around 8 per cent of Poland's electricity.

BANGLADESH 2019

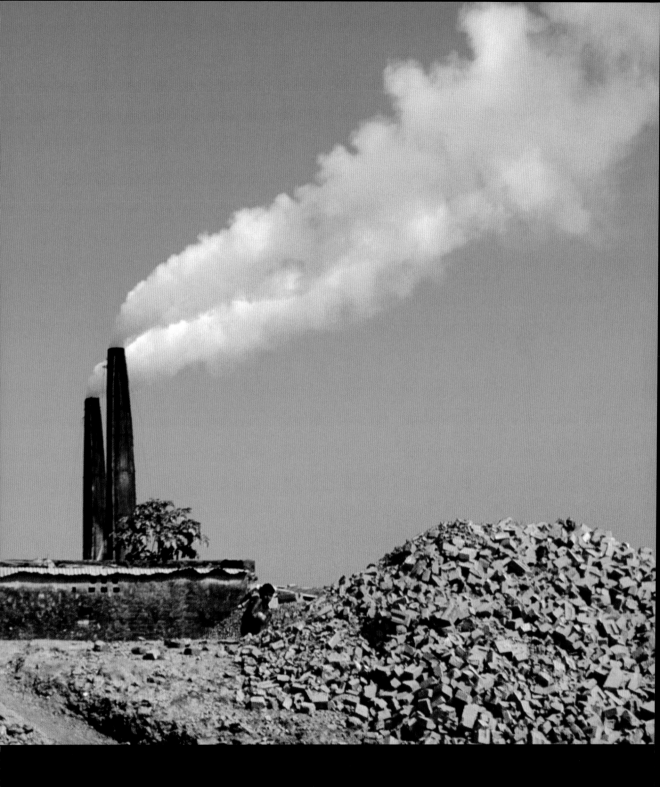

Dust and smoke particles from the wood- and coal-fired kilns create well over half of the country's air pollution. Dhaka, the country's capital, has particularly high pollution levels from the brick-making industry, and when this is combined with high vehicle emissions and the burning of waste, it is clear why the country has major pollution issues to resolve.

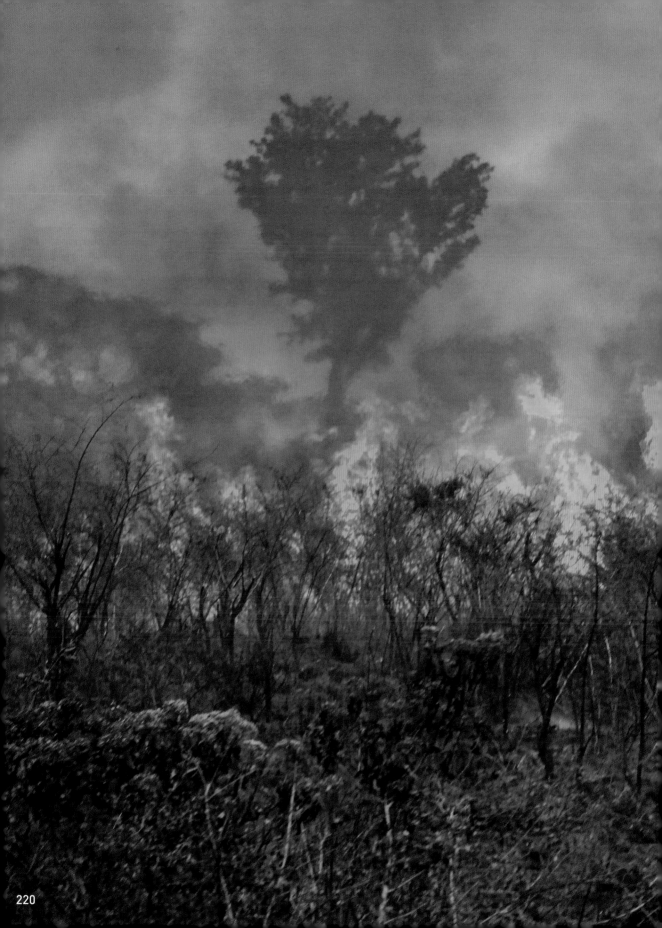

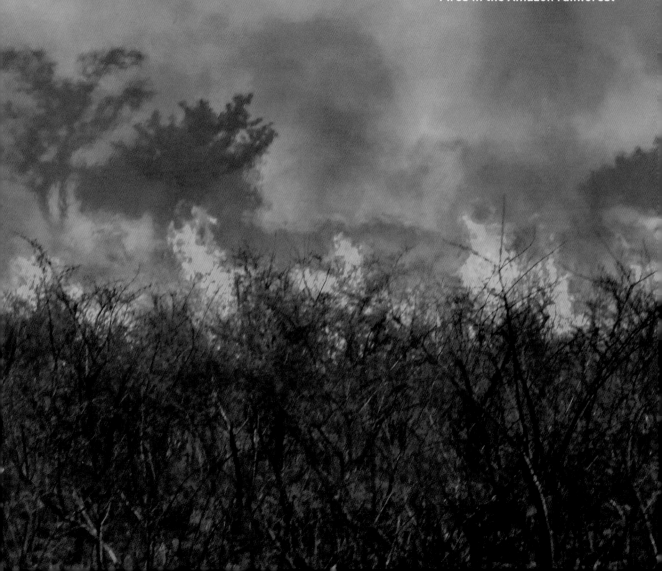

DEFORESTATION

the felling of trees, often illegally and in an unmanaged way,
commonly to provide land for agriculture or industry

Fires in the Amazon rainforest

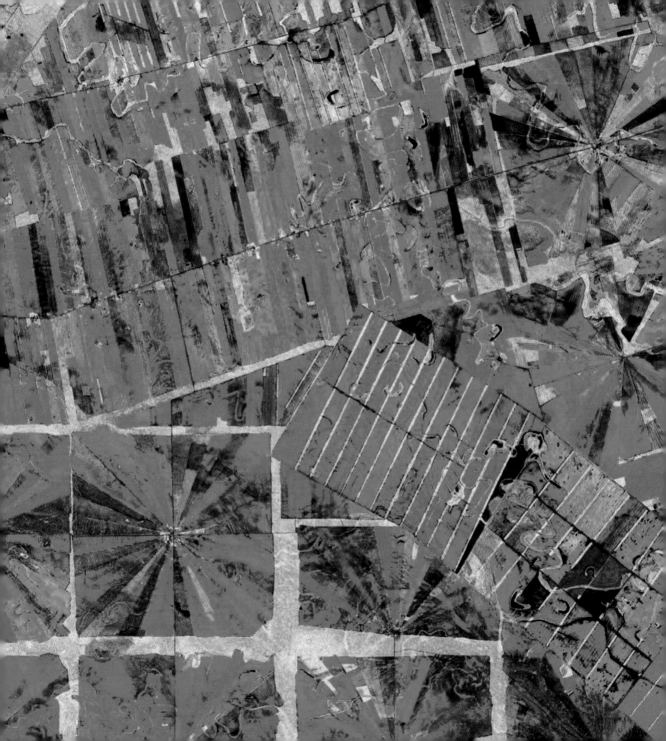

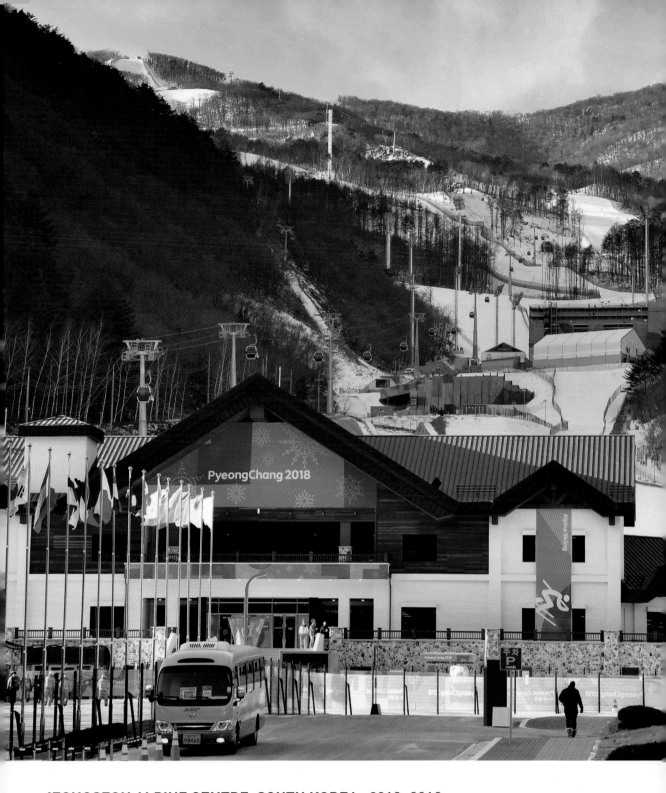

JEONGSEON ALPINE CENTRE, SOUTH KOREA 2013–2018

In 2018, South Korea hosted the Winter Olympics, and in order to do so, had to create a new alpine centre (pictured above) where it would host its events. Many South Koreans expressed their anger at the organisers for destroying the 500-year-old mountain forest on the slopes of Mount Gariwang that was sacrificed to make way for the centre.

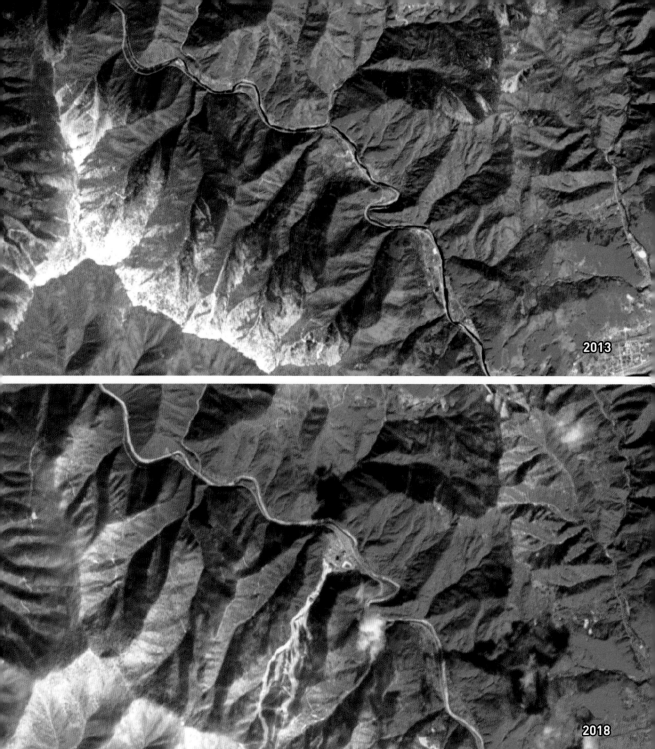

2013

2018

MOUNT GARIWANG, SOUTH KOREA 2013, 2018

The top image shows Mount Gariwang in 2013 before construction started. The bottom image from 2018 shows the same area once 58 000 trees had been cut down.

Campaigners in South Korea said that the irresponsible deforestation would create an ecological disaster that would destroy Mount Gariwang's ecosystem.

EAST RONDÔNIA, BRAZIL 1986

Rondônia, a state in western Brazil, is one of the most deforested areas in the Amazon. Rondônia once provided over 200 000 km^2 of rainforest, but by 2003, an estimated 67 769 km^2 (26 166 mi^2) had been cleared. These images of the eastern part of the state, from 1986 and 2001 – 15 years apart – show the radical change in landscape.

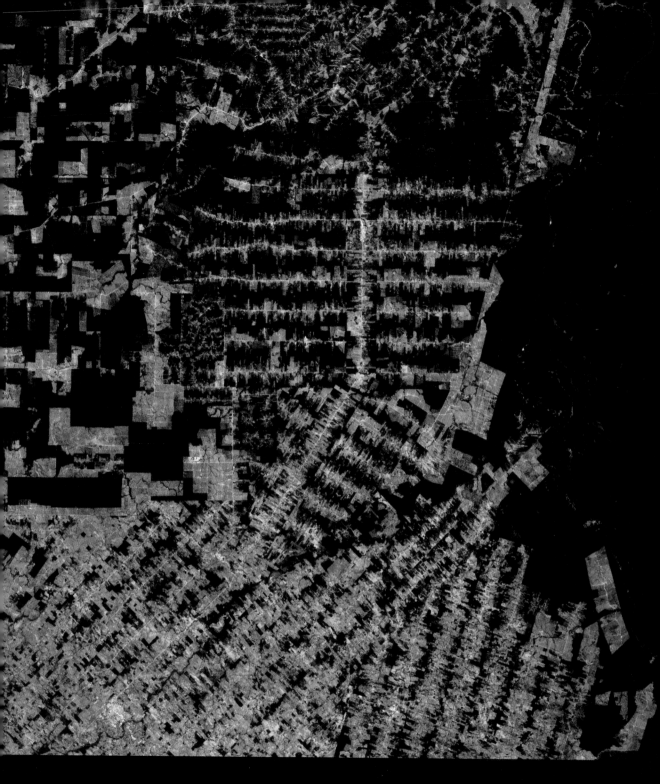

2001

All the major tropical forests of the world are disappearing rapidly to make way for livestock and crops. The Amazon rainforest is no exception. Along with the destruction of natural ecosystems, leading to the loss of plant and animal species, the drastic reduction in forested area is a significant contributor to climate change.

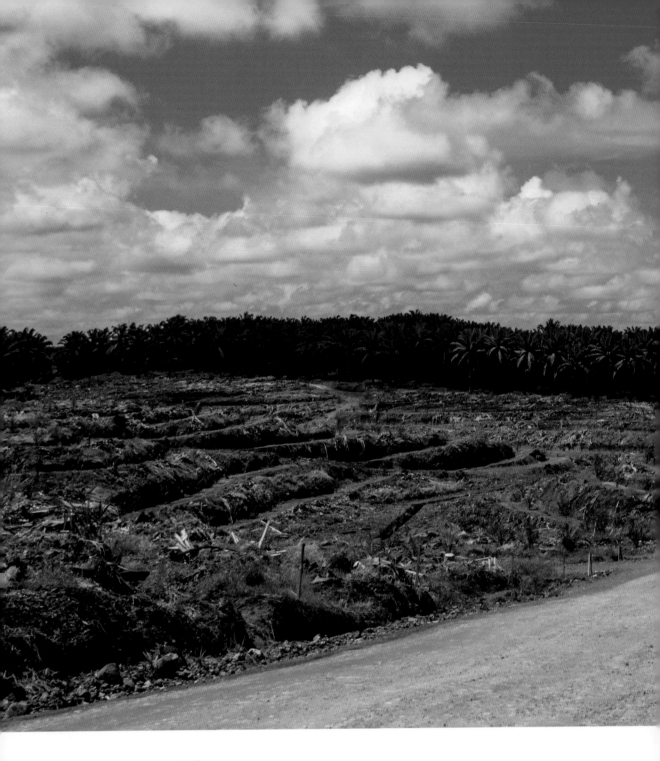

SABAH, BORNEO 2017

Around 100 years ago, the majority of Borneo's land was covered in dense forest but, today, only about half is forest. Conservationists say that around 13 000 km² (5000 mi²) of Borneo's forests are being destroyed every year, which means that the vast majority of its forests will be wiped out in a few years. The main reason for deforestation in Borneo is palm oil production – an important oil in the global oils and fats industry.

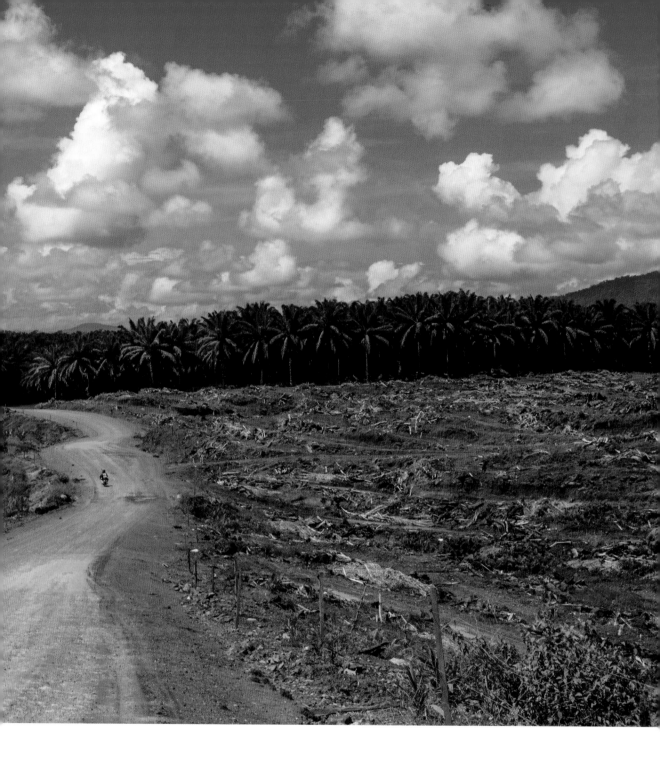

This image shows a palm oil plantation in Sabah, Borneo. By 2007, the land area cleared for the production of palm oil had increased from 6000 km^2 (2300 mi^2) in 1985 to more than 60 000 km^2 (23 000 mi^2). The devastation of tropical forest also destroys the natural habitats of plant and animal species that live there.

DISTURBED ECOSYSTEMS

a change to the normal conditions of an ecosystem, including those driven
by climate change, that affects the natural organisms in an area

Blue-green algae, Puy-de-Dôme, France

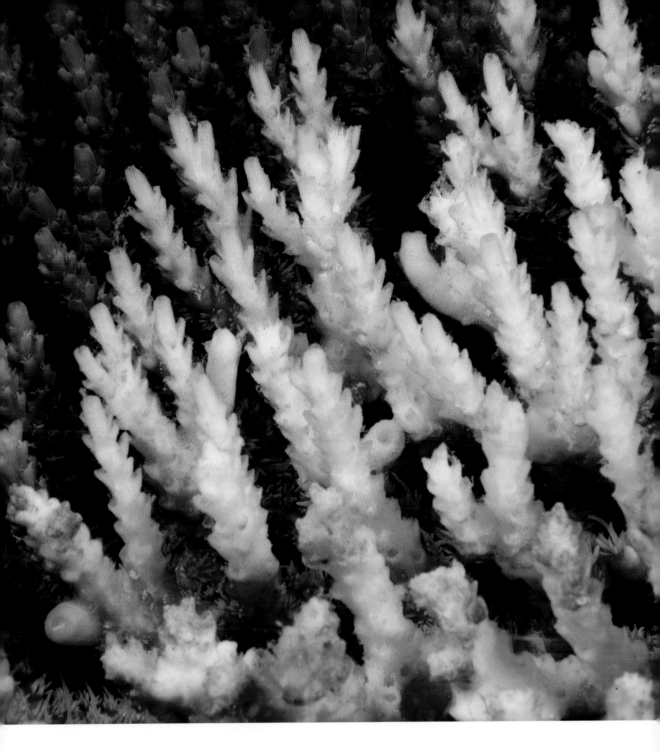

GREAT BARRIER REEF, AUSTRALIA 2010

The Great Barrier Reef, off Queensland's coast in eastern Australia, is a stretch of coral reef that spans around 2300 km (1500 mi). Unfortunately, in recent years, the entire reef has become extremely vulnerable to the effects of global warming, notably through its bleached appearance. There are multiple reasons why coral can turn white, or be 'bleached', but it is thought that climate change is a significant contributing factor.

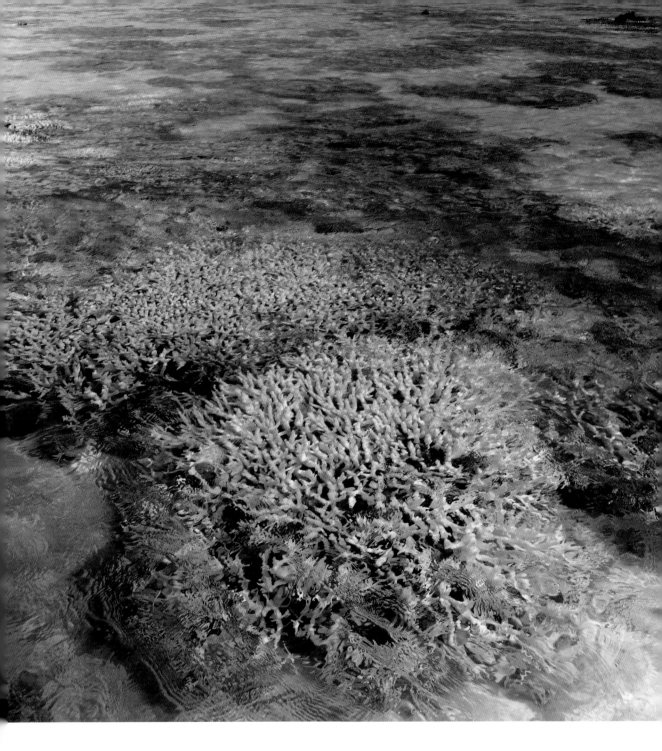

2020

By 2020, the Great Barrier Reef had experienced its third widespread bleaching in five years. Corals have a symbiotic relationship with the algae that live on them. When the algae become stressed, due to rising ocean temperatures, they leave the coral, and without this algae, the coral loses its food source and turns white. Bleaching does not mean the coral is dead, but if the sea temperature remains consistently high, the coral will eventually die, wiping out many marine species' habitats.

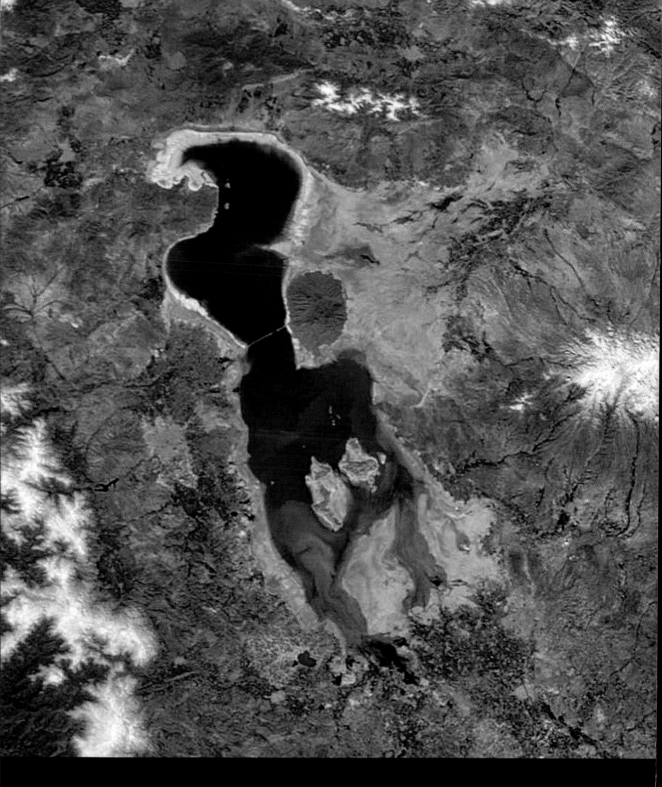

LAKE URMIA, IRAN 2016

Lake Urmia in Iran was once the sixth-largest saltwater lake in the world; however, by the end of 2017, the lake had shrunk to around 10 per cent of its original size. This can be partially attributed to Iran's persistent drought conditions, but also to abstraction and the increased use of dams on the rivers that supply Lake Urmia.

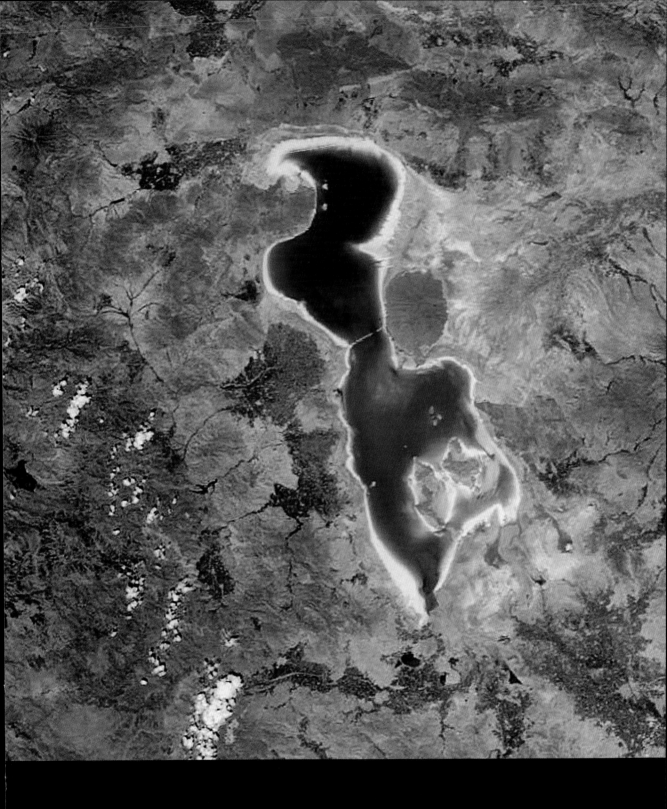

In 2016, the lake changed colour from its usual shade of green, to red. This happens during periods of dry, hot weather, which makes the water evaporate and increases the salinity of the lake. This in turn alters the combination of the lake's algae and bacteria, making it change colour.

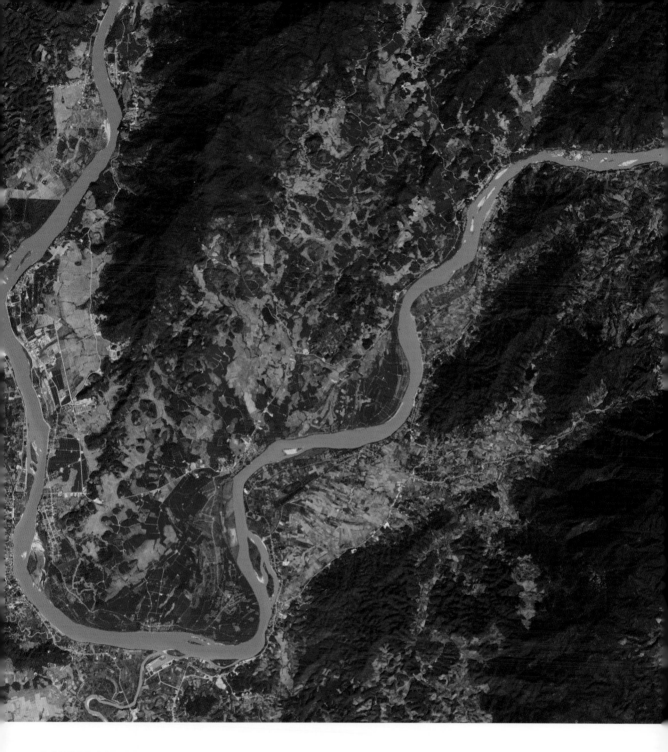

LOWER MEKONG RIVER, SOUTHEAST ASIA 2015

The Mekong River is a vital resource for southeast Asian communities. It is usually a fast-flowing river with a healthy supply of fish, and it also moves sediments across the region, which improves the quality of soil for farmers. The river is usually a muddy brown colour because of all the sediment it transports, as shown in the picture above. However, towards the end of 2019, it was noted in northern parts of Thailand that the Lower Mekong River was turning a different colour – much more turquoise.

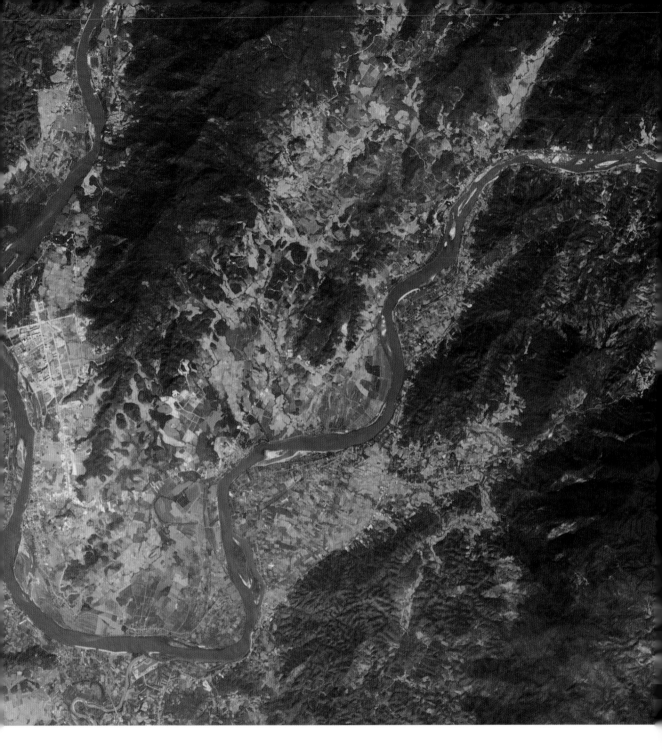

2020

This colouring then spread further along the Lower Mekong River. Scientists believe that the change in colour is due to the river being much shallower and slower-moving than usual, meaning some of the finer sediments have dropped out, making the water clearer.

This in turned created conditions that made it easier for algae to bloom. It is thought that the shallow waters were partly caused by drought, due to rising global temperatures, and partly down to major dam projects reducing water levels in the river.

BARENTS SEA, ARCTIC OCEAN 2010

When phytoplankton blooms annually in
August in the Barents Sea, off the coast of
Russia and Scandinavia, it creates colourful
patterns that can be seen from space
satellites. This is due to the different species
and the amount of phytoplankton in a given

area. While this looks pretty, scientists say
that it is a warning that something needs to
be done imminently about global warming.
If greenhouse gases continue to be emitted
at the same rate, the oceans will continue to
change colour.

There are many different species of phytoplankton, each adapted to the specific type of water it lives in. When the temperature of the sea changes, the community of phytoplankton will also change, as some species will decline, some will thrive and some will migrate to areas with conditions that better suit their needs. As a result, with the rising sea temperatures, we will also see a change in sea colour.

UNUSUAL TRENDS

communities, areas and nations experiencing unique trends
and changes, whether intentional or by chance

Clearer canals during the coronavirus lockdown in Venice, Italy

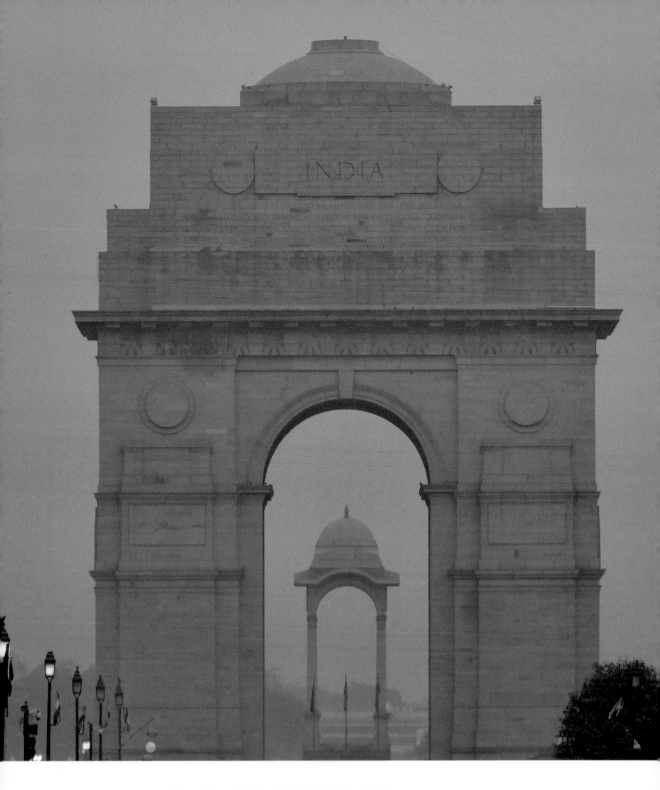

INDIA GATE, NEW DELHI, INDIA NOVEMBER 2019

India imposed national lockdown at the end of March 2020 in an attempt to slow and prevent the spread of the Covid-19 coronavirus. Halting the activity of around 1.3 billion people not only helped reduce the numbers of people that would contract the virus, but also reduced pollution levels across the country.

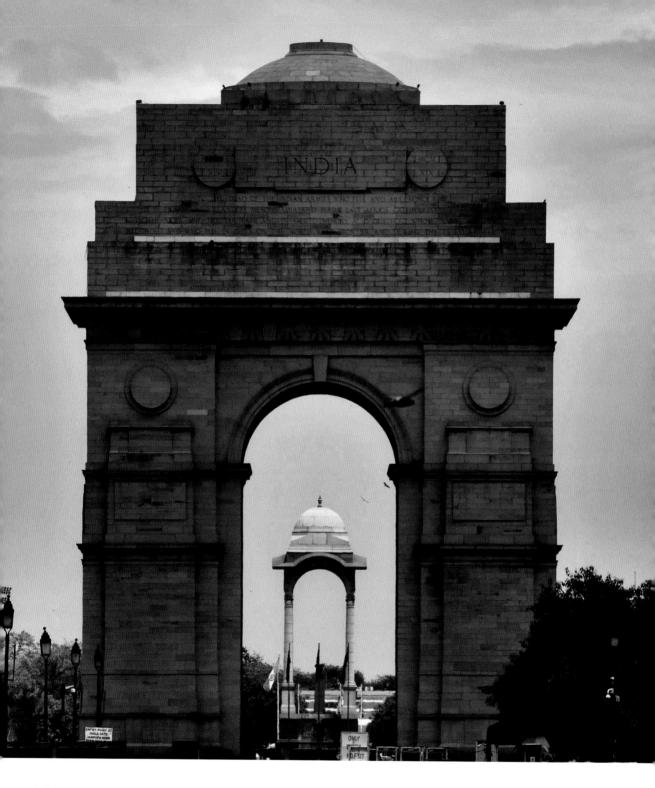

APRIL 2020

When New Delhi went into lockdown, a temporary reduction in the levels of air pollution meant that landmarks could be seen much more clearly in the capital city, as is illustrated here in the images of the India Gate before (left) and during (right) the coronavirus pandemic.

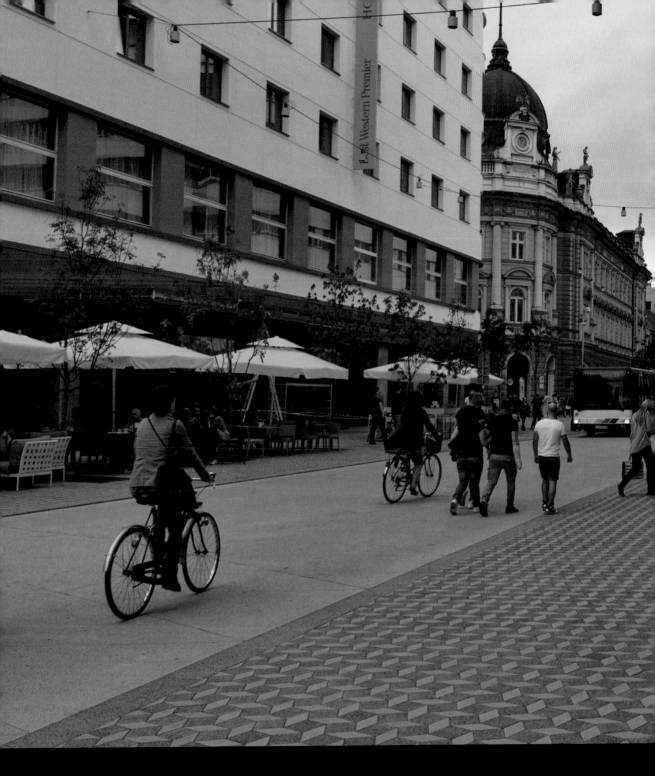

SLOVENSKA STREET, LJUBLJANA, SLOVENIA 2015

In 2007, Ljubljana introduced a programme
that would drive its city towards being a
sustainable environment to live in by 2025.
Like many cities in the world, in an attempt

created pedestrian zones in the city centre
in order to reduce congestion and therefore
harmful vehicle emissions that can lead to
global warming and atmospheric pollution

Since 2007, the pedestrian zone in Ljubljana's city centre has been increased by 620 per cent, now covering around 100 000 m² (1 000 000 ft²). Slovenska Street, above, is one of the city's projects that resulted in the complete refurbishment of a arterial city road, banning access to vehicles other than bicycles and public transport.

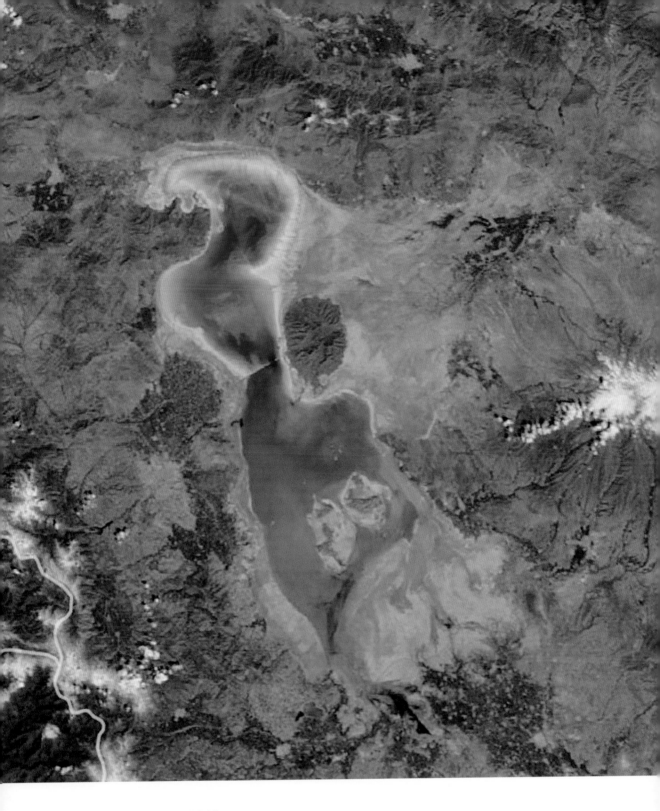

LAKE URMIA, IRAN 2018

Lake Urmia has been in decline since the mid-1990s. The UN Environment Programme reported that during its periods of high water, the lake's surface area stood at 6100 km² (2400 mi²), but in 2013 it had shrunk to about 700 km² (270 mi²).

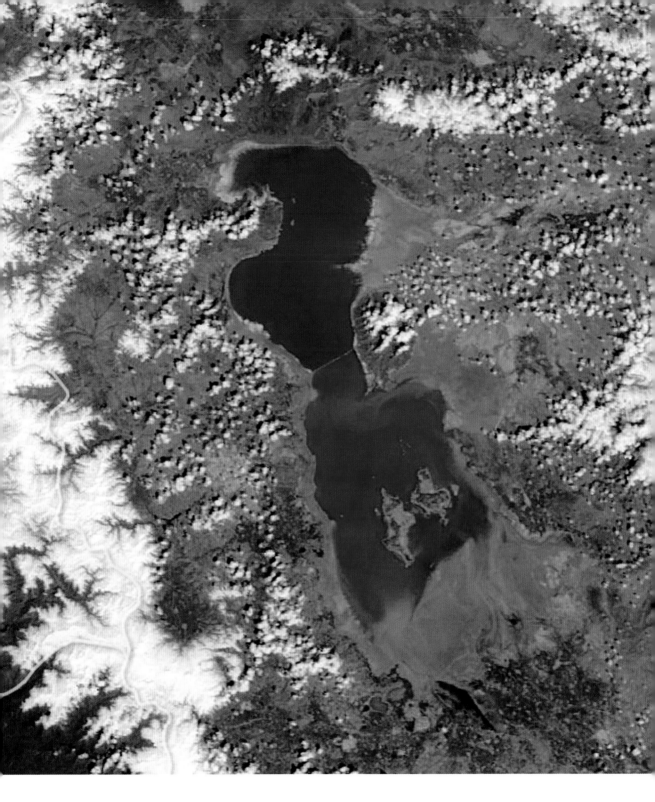

2019

Extreme changes in weather, however, are becoming more common, and the torrential rains of autumn 2018 and spring 2019 that began refilling Lake Urmia and devastated many Iranian communities are likely to have been influenced by global warming.

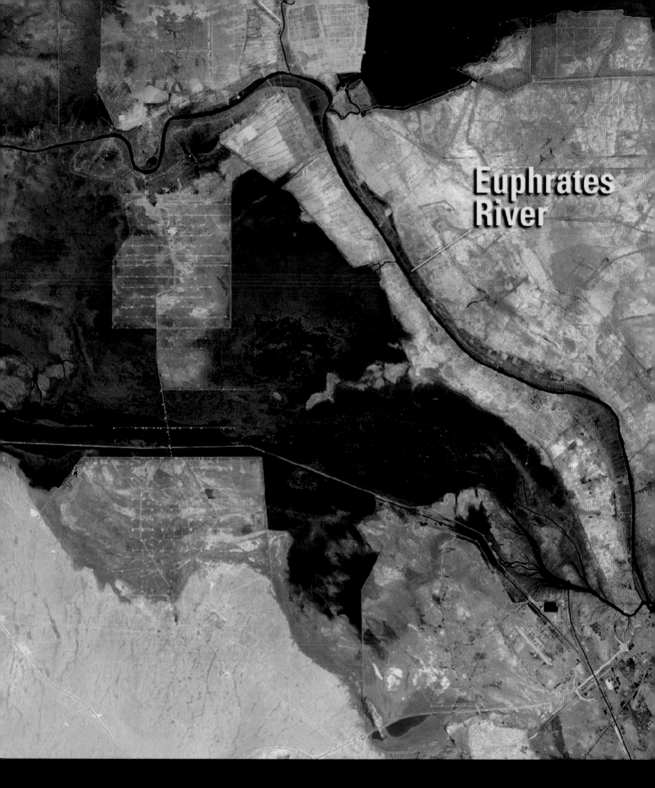

Euphrates
River

SOUTHERN IRAQ 1986

Marshland in the south of Iraq has been declared as a World Heritage Site by UNESCO and as a result, in recent years,

thanks to efforts to restore its wetlands. Until the 1970s, southern Iraq's marshlands around the Euphrates River covered around

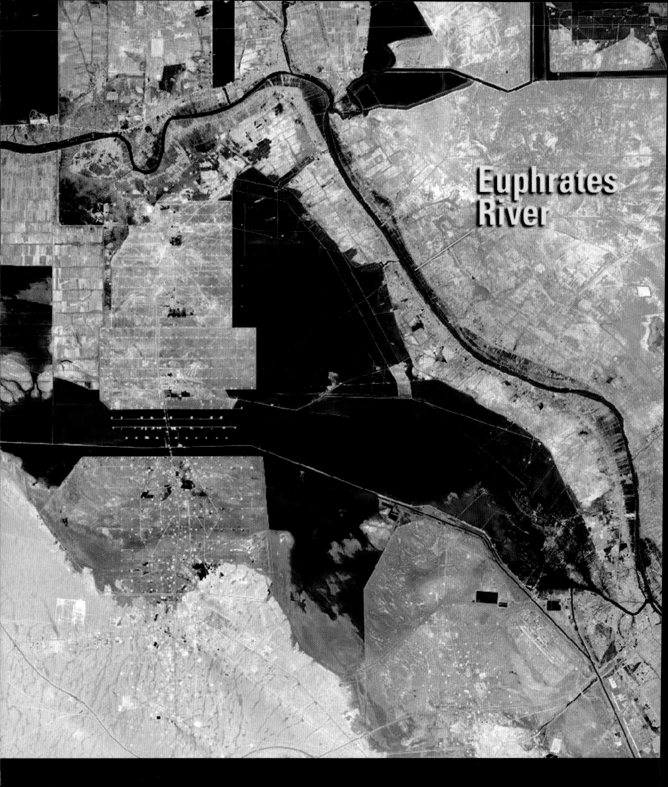

Euphrates
River

2019

Between the 1980s and 2001, however, projects funded by the government had a big impact on the supply of water to the area, meaning that by the 2000s the marshlands occupied less than a tenth of their original coverage. With continuing restoration efforts, one day the marshlands may return to their former state.

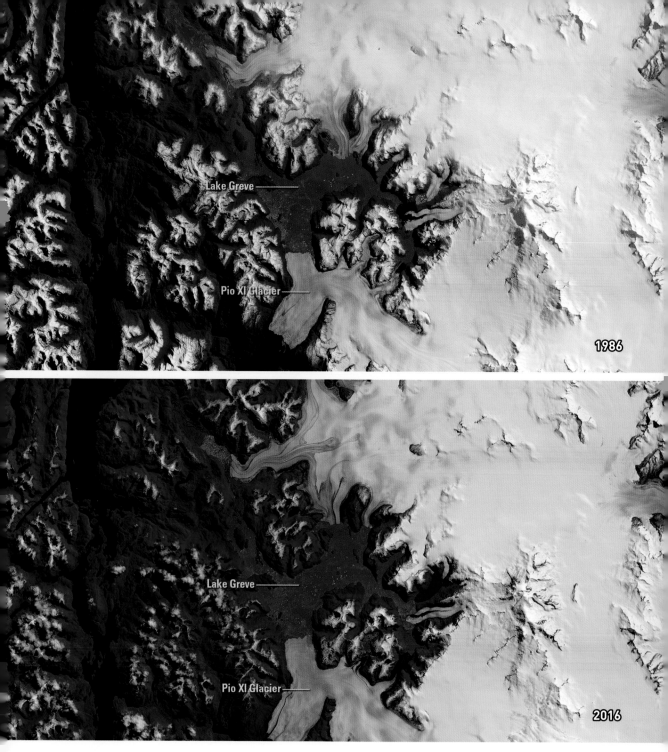

Lake Greve

Pio XI Glacier

1986

Lake Greve

Pio XI Glacier

2016

BRÜGGEN GLACIER, SOUTH PATAGONIAN ICEFIELD, CHILE 1986, 2016

As demonstrated in the earlier section on shrinking glaciers (pages 54–77), the vast majority of glaciers on planet Earth are shrinking in volume, and receding, normally as a direct result of the planet's rising temperatures. However, the Brüggen Glacier (also named Pio XI Glacier) in the South Patagonian Icefield is defying trends set by other glaciers and seems to be advancing.

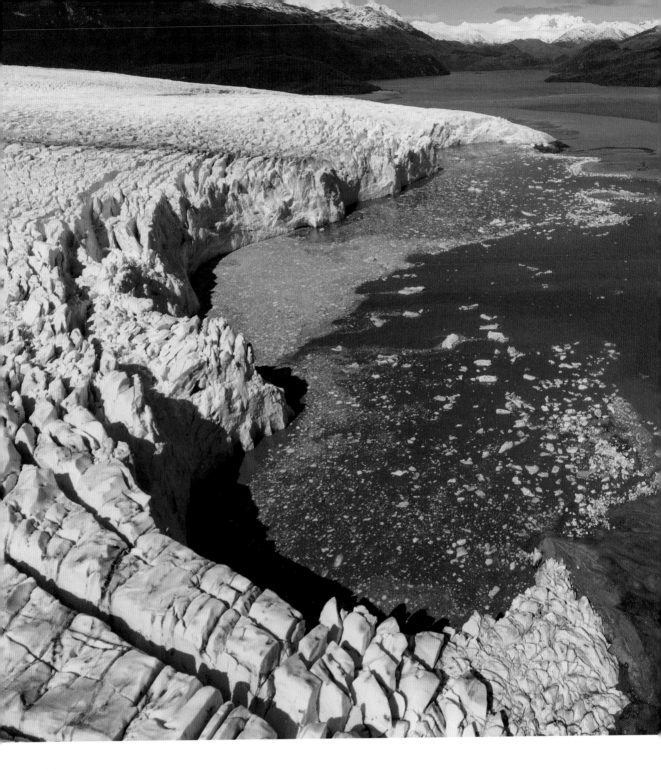

2016

Between 1998 and 2014, the southern front of the glacier advanced 593 m (1945 ft), and the northern front, flowing into Lake Greve, advanced 107 m (351 ft). Scientists are not quite sure why the glacier is advancing, but suspect that it is related to the activity inside or beneath the glacier. It could also be related to the speed of the glacier's flow, and the depth of Lake Greve.

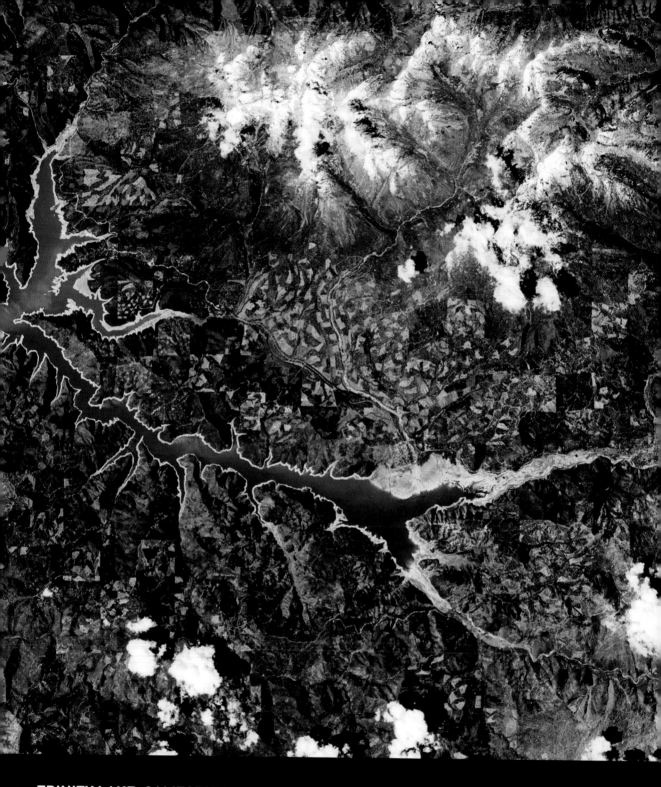

TRINITY LAKE, CALIFORNIA, US 2015

Trinity Lake is the third biggest reservoir
in California. Over the last ten years or so,
it has suffered the effects of California's

California was in the middle of a five-year
drought and the reservoir was at only 59 per
cent capacity for its historical average at that

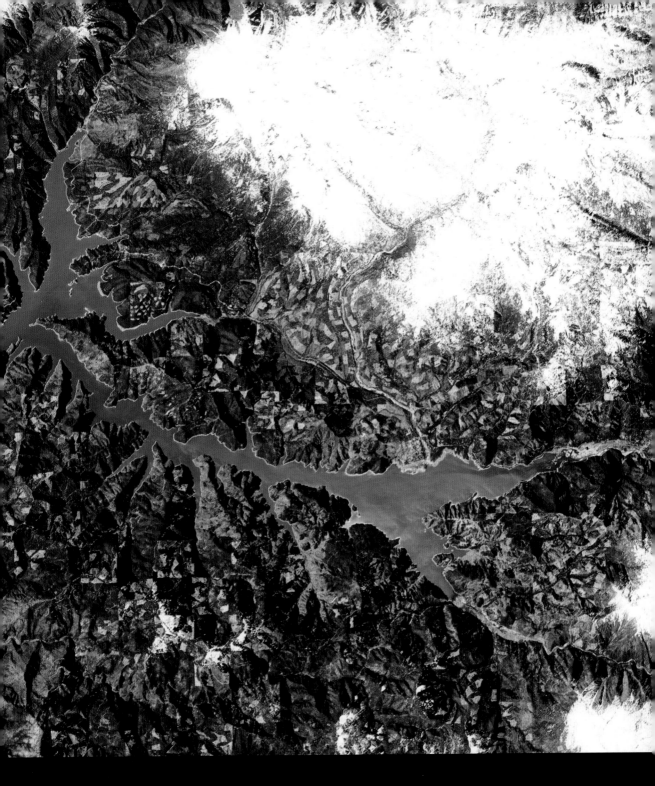

2017

The beige-coloured bands around the
reservoir that are more prominent in the
2015 image show the sediment and sands
that were left exposed when the reservoir

shrank. This image, however, was taken
in April 2017, after rainfall had refilled the
reservoir. At this point it was at 114 per cent
of its historical average level.

INDEX

ACKNOWLEDGEMENTS

6–7 Gail Johnson / Shutterstock

8 Newscom / Alamy Stock Photo

9 Xinhua / Alamy Stock Photo

10 Claudia Weinmann / Alamy Stock Photo

11 ZUMA Press, Inc. / Alamy Stock Photo

12 Newscom / Alamy Stock Photo

13 SOPA Images Limited / Alamy Stock Photo

14 NASA Earth Observatory

15 APFootage / Alamy Stock Photo

16–17 NASA

18 Grzegorz Gajewski / Alamy Stock Photo

19 NASA Earth Observatory

20–21 Cammie Czuchnicki / Shutterstock

22–23 Charlie Riedel / AP / Shutterstock

24 ZUMA Press, Inc. / Alamy Stock Photo

25 US Army Photo / Alamy Stock Photo

26–27 Tasos Katopodis / Stringer / Getty Images

28–29 imageBROKER / Alamy Stock Photo

30–31 Omer koclar / Shutterstock

32–33 WENN Rights Ltd / Alamy Stock Photo

34 NASA Image Collection / Alamy Stock Photo

35 redbrickstock.com / Alamy Stock Photo

36 John Sirlin / Alamy Stock Photo

37 Tom Bean / Alamy Stock Photo

38–39 Science History Images / Alamy Stock Photo

40–41 Andrei Kovin / Shutterstock

42 UPI / Alamy Stock Photo

43 kab / Stockimo / Alamy Stock Photo

44 NASA Earth Observatory / Joshua Stevens

45 Karim Bouchetata / Alamy Stock Photo

46 NASA Earth Observatory

47 Marina Taylor / Shutterstock

48–49 NASA Earth Observatory

50 NASA / NOAA

51 eddtoro / Shutterstock

52 Bartosz Luczak / Alamy Stock Photo

53 Peter Worth / Stockimo / Alamy Stock Photo

54–55 Oleg Senkov / Shutterstock

56 NASA

57 Maridav / Shutterstock

58 Science History Images / Alamy Stock Photo

59 NASA Earth Observatory

60–61 robertharding / Alamy Stock Photo

62–63 NASA Earth Observatory / Joshua Stevens

64–65 Science History Images / Alamy Stock Photo

66–67 NASA Earth Observatory

68–69 NASA Earth Observatory / Joshua Stevens / Lauren Dauphin

70–71 NASA Earth Observatory

72–73 Eric Middelkoop / Alamy Stock Photo

74–75 NASA Earth Observatory

76–77 NASA Earth Observatory

78–79 Stephen Coyne / Alamy Stock Photo

80 peace portal photo / Alamy Stock Photo

81 Steven J. Kazlowski / Alamy Stock Photo

82 Design Pics Inc / Alamy Stock Photo

83 Nature Picture Library / Alamy Stock Photo

84 NASA Earth Observatory / NSIDC

85 MARK RALSTON / Getty Images

86–87 Alan Gordon / Scottish Viewpoint / Shutterstock

88 NASA Earth Observatory

89 MJ Photography / Alamy Stock Photo

90–91 vladsilver / Shutterstock

92 NASA Earth Observatory

93 Lee Adamson / Alamy Stock Photo

94–95 US Geological Survey

96–97 NASA Earth Observatory

98–99 NASA Earth Observatory

100–101 NASA Earth Observatory / NASA Scientific Visualization Studio

102–103 RealyEasyStar/Paolo Bolla / Alamy Stock Photo

104–105 Global Warming Images / Alamy Stock Photo

106 Iqro Rinaldi / Shutterstock

107 ZUMA Press, Inc. / Alamy Stock Photo

108–109 frans lemmens / Alamy Stock Photo

110 Photofusion Picture Library / Alamy Stock Photo

111 Jon Arnold Images Ltd / Alamy Stock Photo

112–113 TRAVELSCAPES / Alamy Stock Photo

114–115 Fabio Lamanna / Shutterstock

116 Global Warming Images / Alamy Stock Photo

117 Xinhua / Alamy Stock Photo

118–119 mauritius images GmbH / Alamy Stock Photo

120–121 Thierry Berrod, Mona Lisa Production / Science Photo Library

122–123 Stephen Foote / Alamy Stock Photo

124–125 Adwo / Alamy Stock Photo

126 Rick Rycroft / AP / Shutterstock

127 SAEED KHAN / Getty Images

128–129 NASA / US Geological Survey

130–131 Forest Service / US Department of Agriculture / Science Photo Library

132–133 NPS Photo / Alamy Stock Photo

134 David Lichtneker / Alamy Stock Photo

135 Cliff Green / Alamy Stock Photo

136–137 Quintanilla / Shutterstock

138–139 Rodger Tamblyn / Alamy Stock Photo

140–141 NASA Earth Observatory

142–143 NASA Earth Observatory

144 Selfwood / Alamy Stock Photo

145 Universal Images Group North America LLC / DeAgostini / Alamy Stock Photo

146–147 Radoslaw Lecyk / Shutterstock

148–149 John Warburton-Lee Photography / Alamy Stock Photo

150 US Geological Survey / EROS Data Center

151 NASA

152–153 NASA Earth Observatory

154–155 NASA Earth Observatory / US Geological Survey

156–157 California Department of Water Resources

158–159 California Department of Water Resources

160–161 NASA Earth Observatory

162–163 NASA Earth Observatory

164–165 NASA Earth Observatory

166–167 NASA Earth Observatory / US Geological Survey / Lauren Dauphin

168 Sergey Kuznetsov / Alamy Stock Photo

169 PhotoStock-Israel / Alamy Stock Photo

170–171 NASA Earth Observatory

172–173 Angela Crowley / Shutterstock

174–175 Global Warming Images / Alamy Stock Photo

176–177 NASA Earth Observatory

178–179 © Mike Page / www.mike-page.co.uk

180–181 RooM the Agency / Alamy Stock Photo

182 Aerial Archives / Alamy Stock Photo

183 ZUMA Press, Inc. / Alamy Stock Photo

184–185 Nature Picture Library / Alamy Stock Photo

186 (t) Doug Blane / Alamy Stock Photo

186 (b) Henry Ciechanowicz / Alamy Stock Photo

187 Premium Stock Photography GmbH / Alamy Stock Photo

188–189 Peter Lopeman / Alamy Stock Photo

190–191 Geoff Robinson / Shutterstock

192 (t) S-F / Shutterstock

192 (b) Philip Bird LRPS CPAGB / Shutterstock

193 M Barratt / Shutterstock

194–195 zakir hossain chowdhury / Alamy Stock Photo

196 Chris Boswell / Alamy Stock Photo

197 NASA Earth Observatory

198–199 NASA Earth Observatory

200 (t) Werner Otto / Alamy Stock Photo

200 (b) pa picture alliance archive / Alamy Stock Photo

201 (t) Peter Widmann / Alamy Stock Photo

201 (b) dpa picture alliance / Alamy Stock Photo

202–203 NASA Earth Observatory

204–205 NASA Earth Observatory

206 NASA Earth Observatory

207 MOHAMED ABDIWAHAB / Getty Images

208–209 Andrius Kaziliunas / Shutterstock

210–211 Andrius Kaziliunas / Shutterstock

212 NASA / MODIS / Jeff Schmaltz

213 axz700 / Shutterstock

214–215 Izel Photography - A / Alamy Stock Photo

216 Maciej Bledowski / Alamy Stock Photo

217 mauritius images GmbH / Alamy Stock Photo

218 ZUMA Press, Inc. / Alamy Stock Photo

219 Neil Cooper / Alamy Stock Photo

220–221 Tatsiana Hendzel / Shutterstock

222–223 © Copernicus Sentinel data (2019) CC BY-SA 3.0 IGO

224 UPI / Alamy Stock Photo

225 US Geological Survey / NASA

226–227 Universal Images Group North America LLC / Alamy Stock Photo

228–229 Christian Loader / Alamy Stock Photo

230–231 Emmanuel LATTES / Alamy Stock Photo

232 imageBROKER / Alamy Stock Photo

233 Suzanne Long / Alamy Stock Photo

234–235 NASA Earth Observatory

236–237 NASA Earth Observatory

238–239 NASA / Ocean Color Group / Norman Kuring

240–241 Â©mbtarget / IPA / Shutterstock

242 Bloomberg / Getty Images

243 Hindustan Times / Getty Images

244–245 Sergiy Palamarchuk / Alamy Stock Photo

246–247 NASA Earth Observatory

248–249 US Geological Survey / NASA

250 US Geological Survey / NASA

251 National Geographic Image Collection / Alamy Stock Photo

252–253 NASA Earth Observatory